BRICK LANE

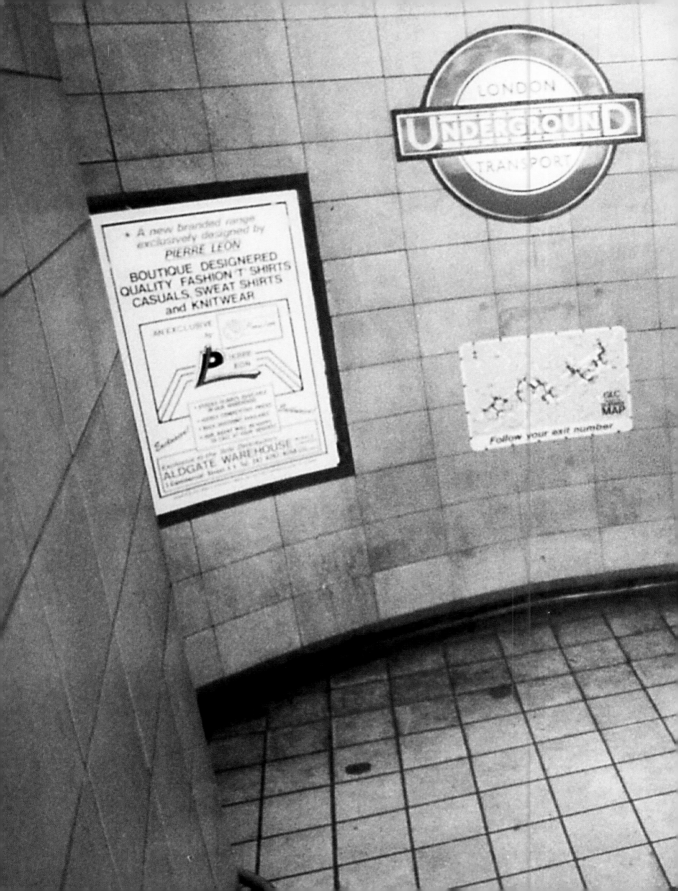

BRICK LANE

PHIL MAXWELL

SPITALFIELDS LIFE BOOKS

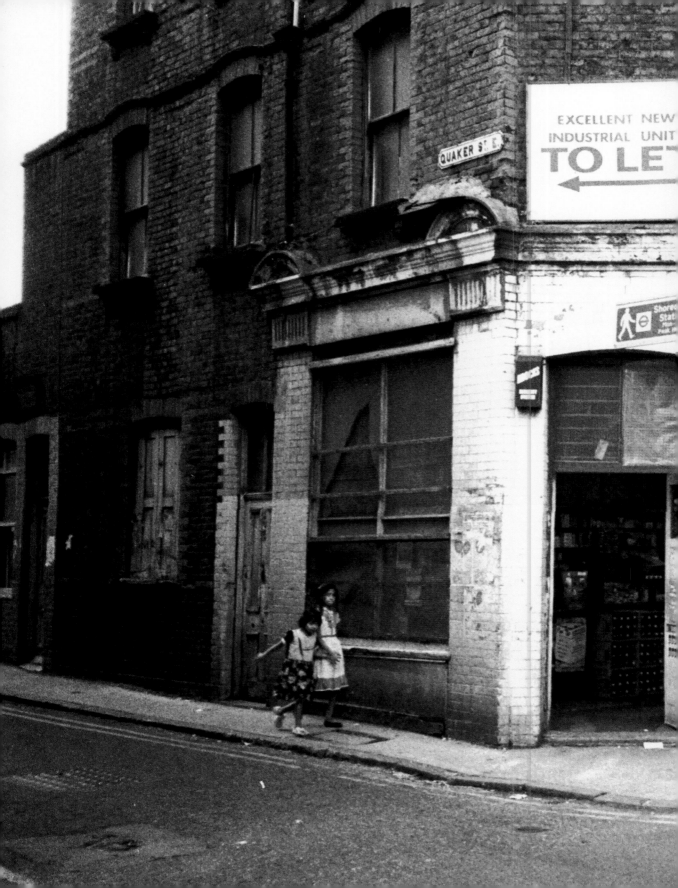

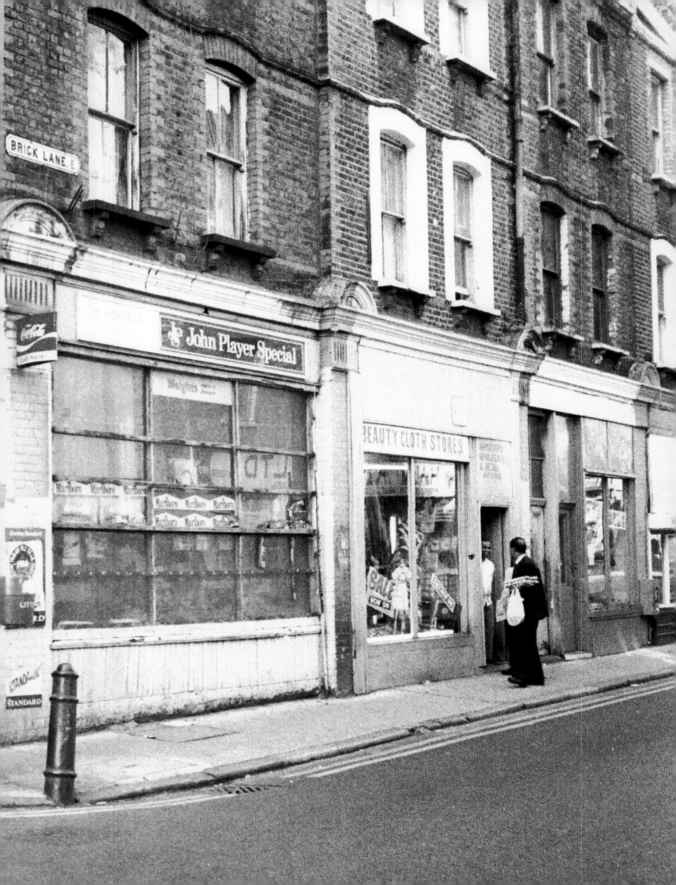

PHIL MAXWELL is the photographer of Brick Lane. Over the last thirty years, no-one has taken more pictures there than he and his astonishing body of work stands unparalleled in the canon of street photography, both in its range and in the quality of human observation that informs these eloquent images.

"More than anywhere else in London, Brick Lane has the quality of being constantly changing, even from week to week," Phil told me when I asked him to explain his enduring fascination. "Coming into Brick Lane is like coming into a theatre, where they change the scenery every time a different play comes in – a stage where each new set reflects the drama and tribulations of the wider world."

In 1981, when Phil Maxwell moved to London from Liverpool, he found himself living in a council flat off Brick Lane where he lives to this day. "They told me, 'You won't find people in London as friendly, they don't have the Scouse humour,'" Phil recalled, "But when I moved here I found that Liverpool humour and East End humour were almost the same – developed out of hardship, in which people were able to laugh at their own demise. The East End was a small world and a wonderful place in those days. The area was a desert, so much corrugated iron, so many bombed out buildings, and many old Jewish people with a great sense of humour."

Phil's work is distinguished by a strong empathy, drawing the viewer closer. In particular, he succeeded in winning the trust of Bengali people and portraying their community with relaxed intimacy. "That's because I live on the other side of the tracks and the vast majority of my neighbours are Bengalis," Phil revealed, "The main problem Bengali families face is overcrowding, with parents and kids living in tiny flats where they cannot socialise freely, and so Brick Lane became the place where they could be themselves in a way they couldn't at home."

When I confided to Phil that the lyrical quality of his portraits of older people appealed to me especially, he pointed out the woman with white hair, enfolding herself in her pale overcoat. "She seems bemused by what is happening round her, but in her appearance she is very much part of the built environment that surrounds her," he said, thinking back over the years, "I find older people have a kind of demeanour which derives from the environment they've been living in and that makes them interesting to photograph."

In its mutable nature, Brick Lane presents an ideal subject for photography – offering an endless source of fleeting moments that expose a changing society within a changing environment and, since the early eighties, Phil Maxwell has made it the focus of his life's work.

Yet, as well as recording the changes in Brick Lane itself, these pictures also capture many of Phil's friends. His long-term involvement with his subjects means that he is never merely taking photographs, he is always recording life happening. Thus, every single image is another frame in an ongoing drama, with the same people and places recurring over three decades. For this reason, Phil's pictures never contain anonymous faces in the street, because these were the people he lived among every day.

It is this affectionate yet unsentimental relationship with his subjects that gives Phil Maxwell's photographs their special quality. As Phil admitted open-heartedly, "I would be nowhere without these people, they are my constant inspiration. I always have a camera in my pocket and whenever I go out I always see something I have never seen before. I love the different cultures and histories that are on my doorstep. Wherever I travel in the world, I always come back and find a little of it here. I couldn't live anywhere else now – such a mixture of class, race, cultures, and aspirations and it's all here in one go."

The Gentle Author
Spitalfields, April 2014

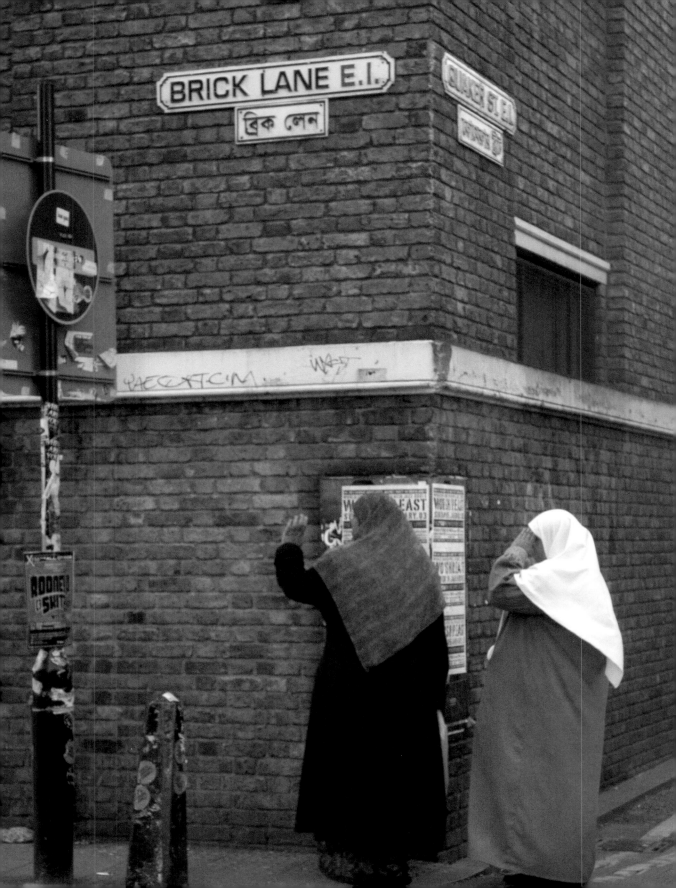

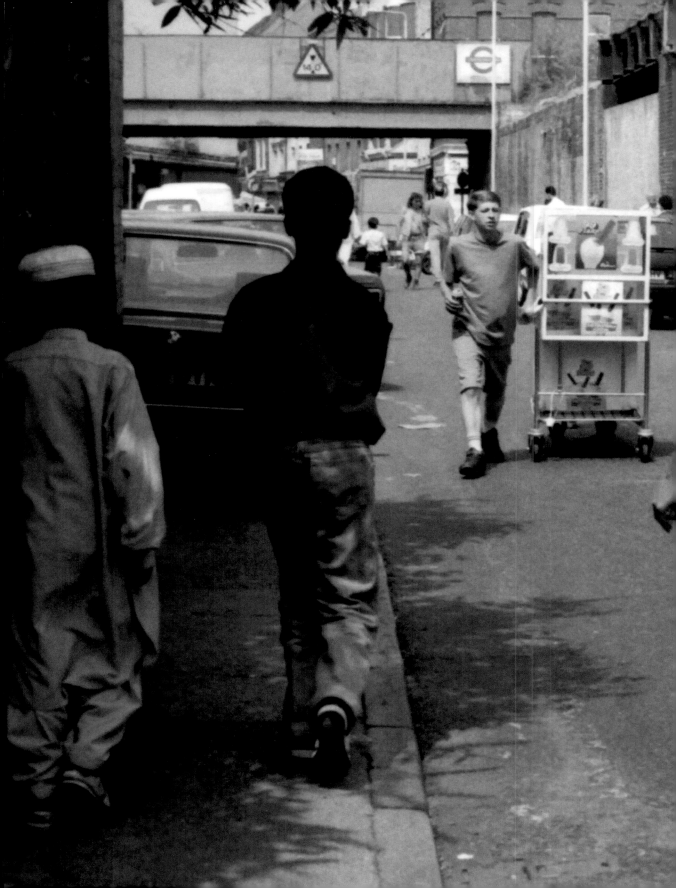

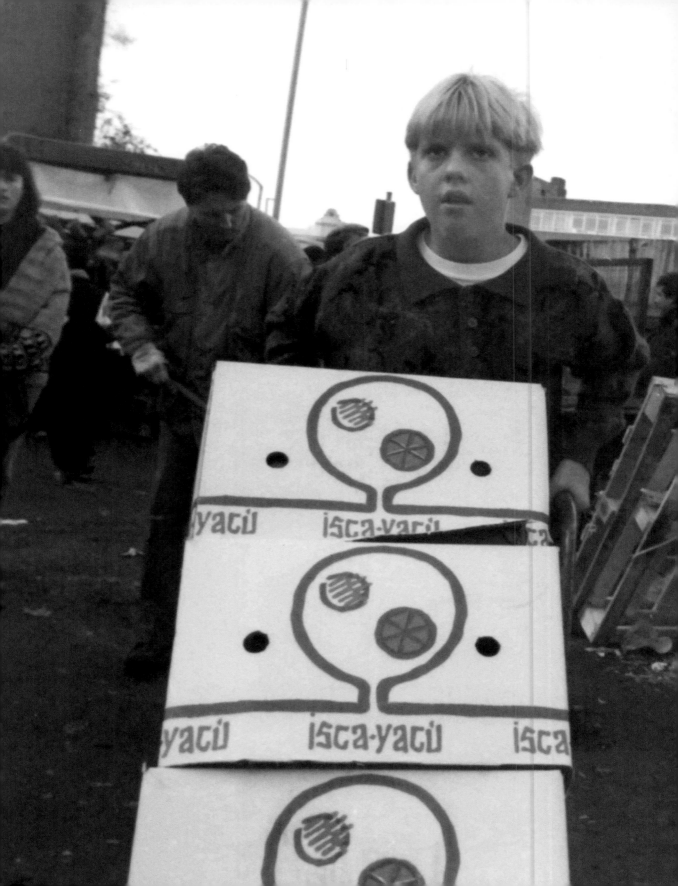

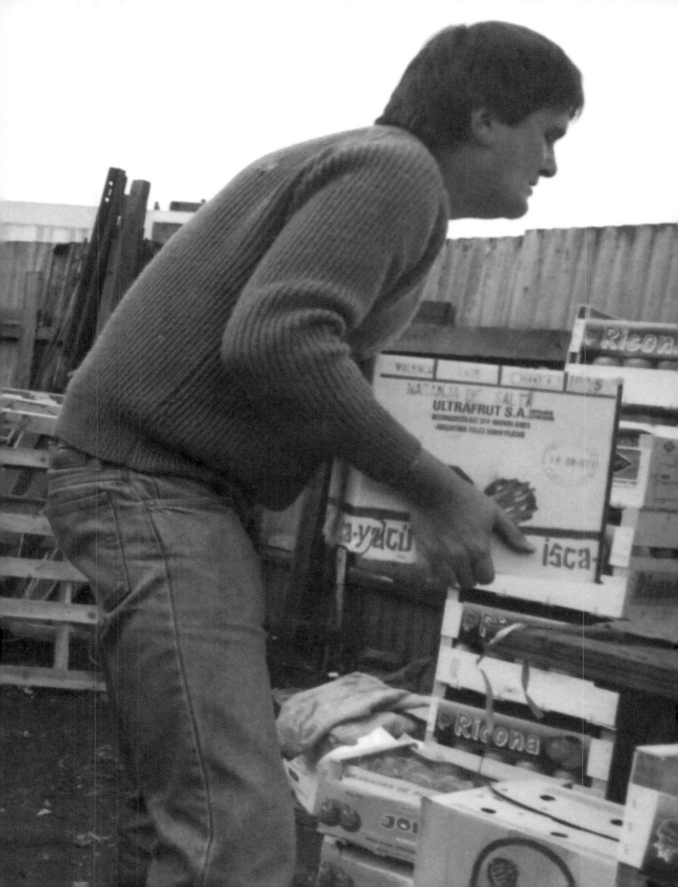

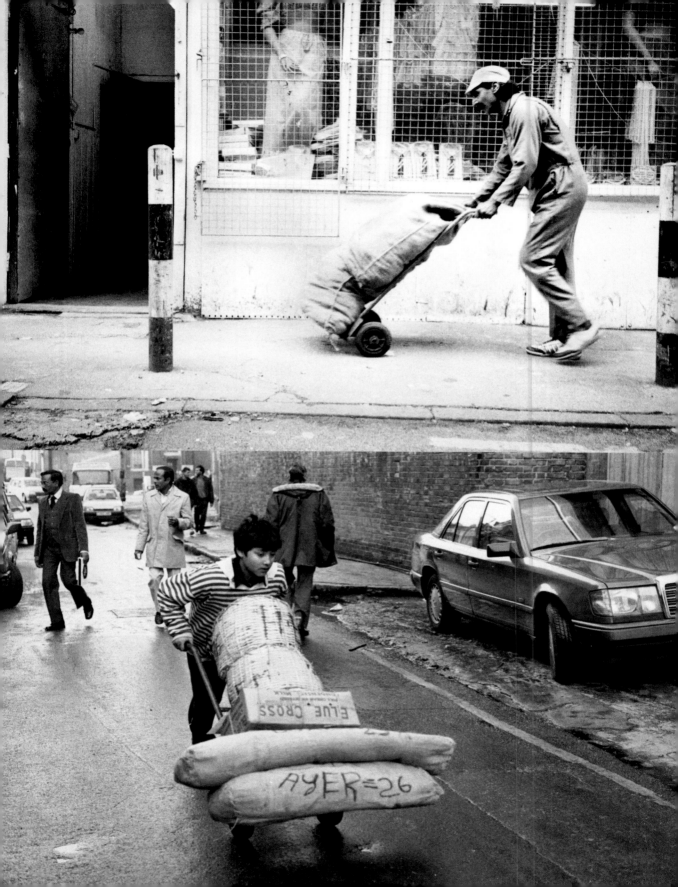

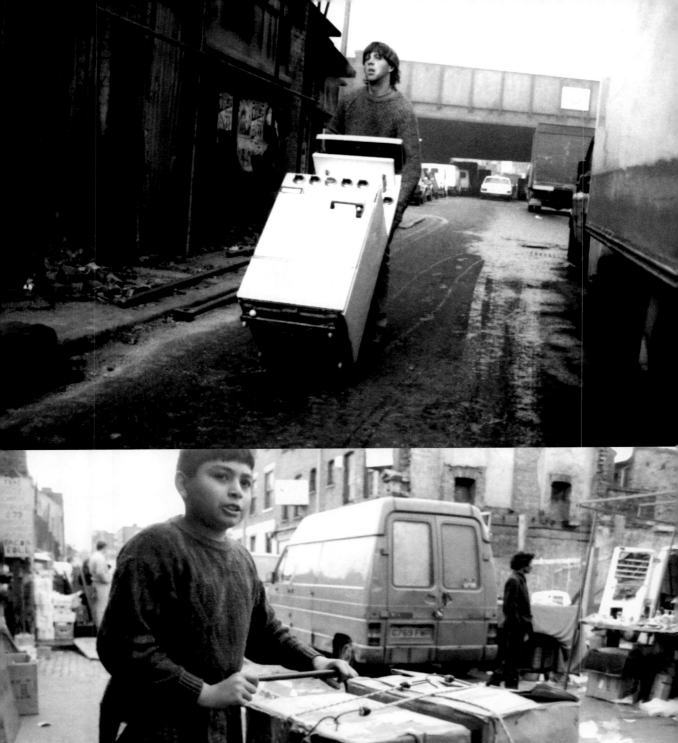

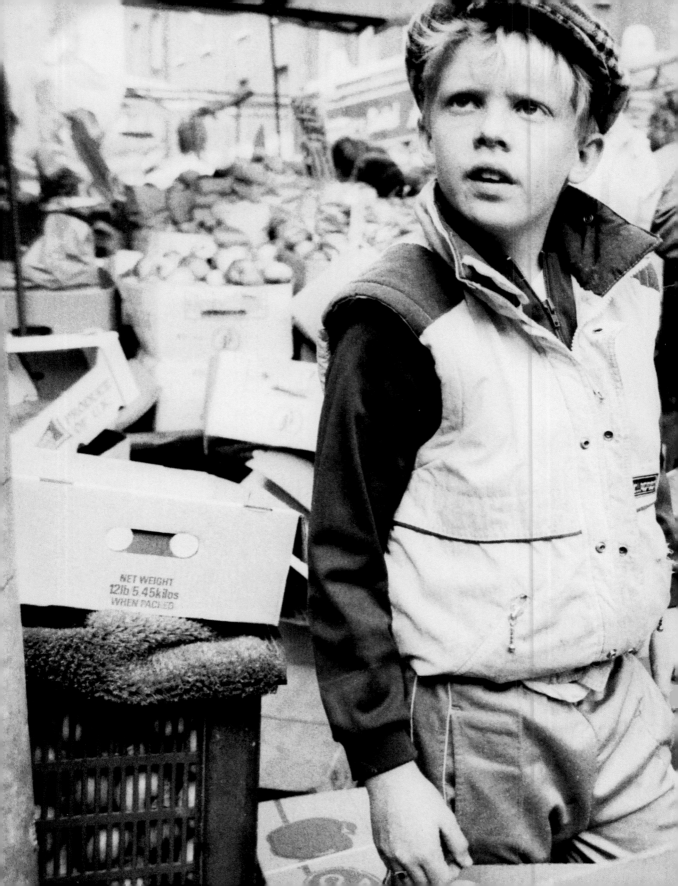

NET WEIGHT
12lb 5.45kilos
WHEN PACKED

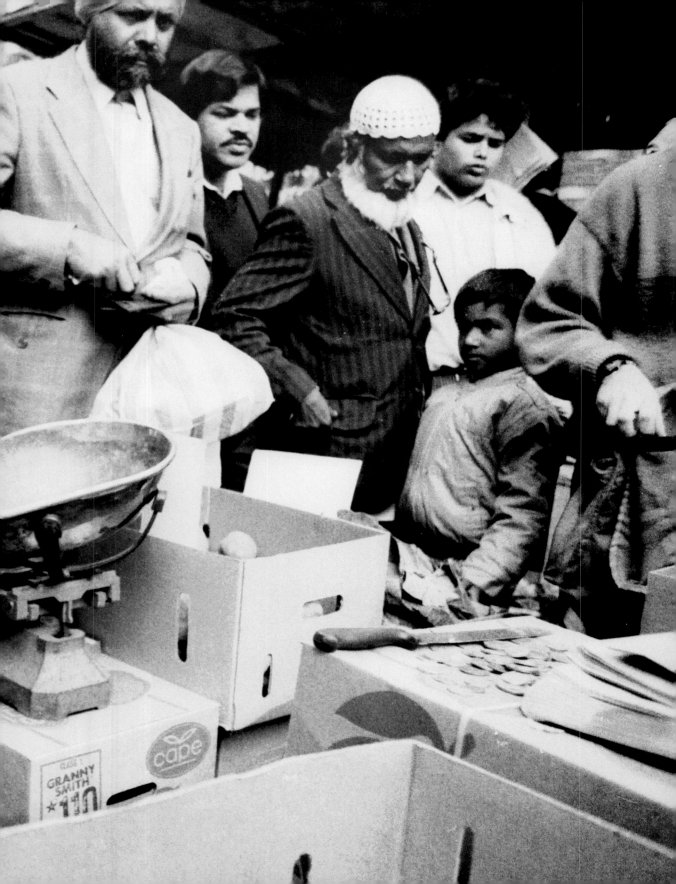

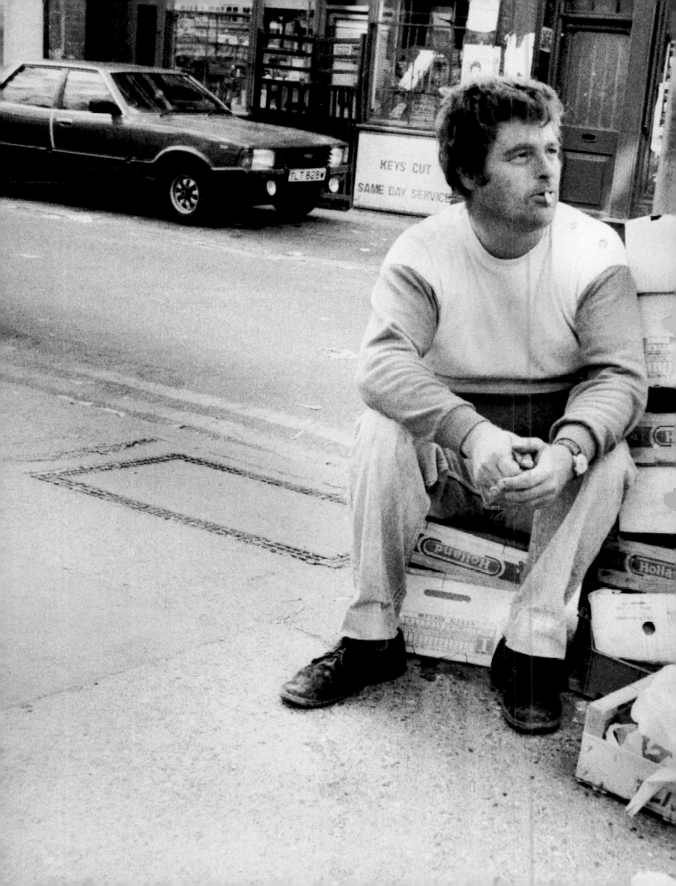

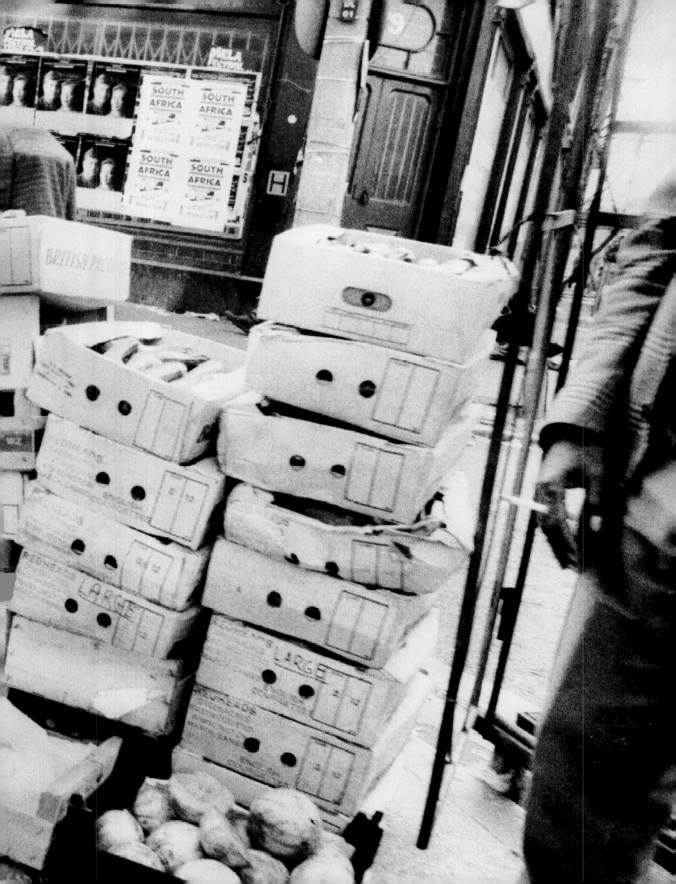

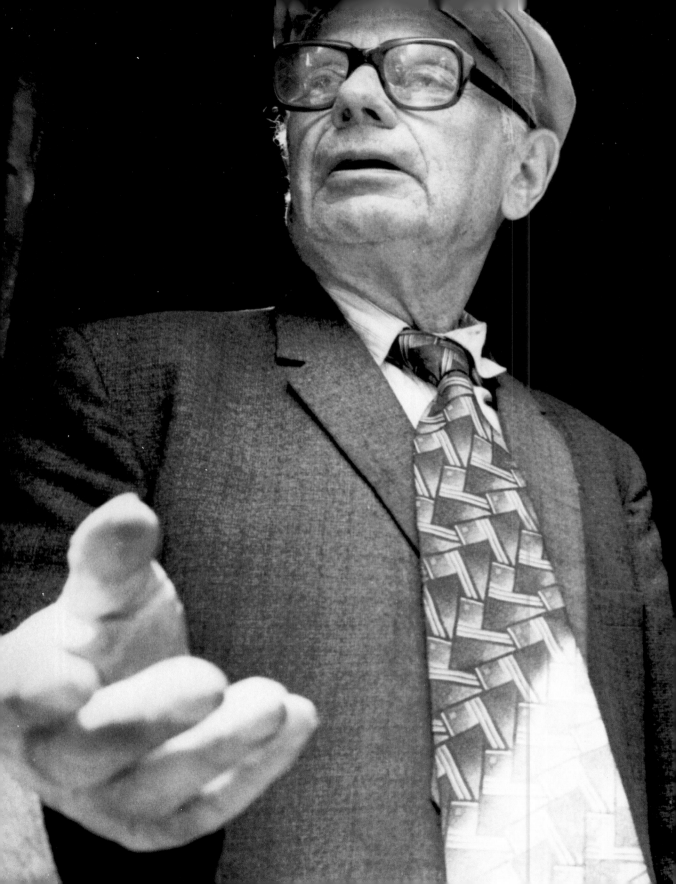

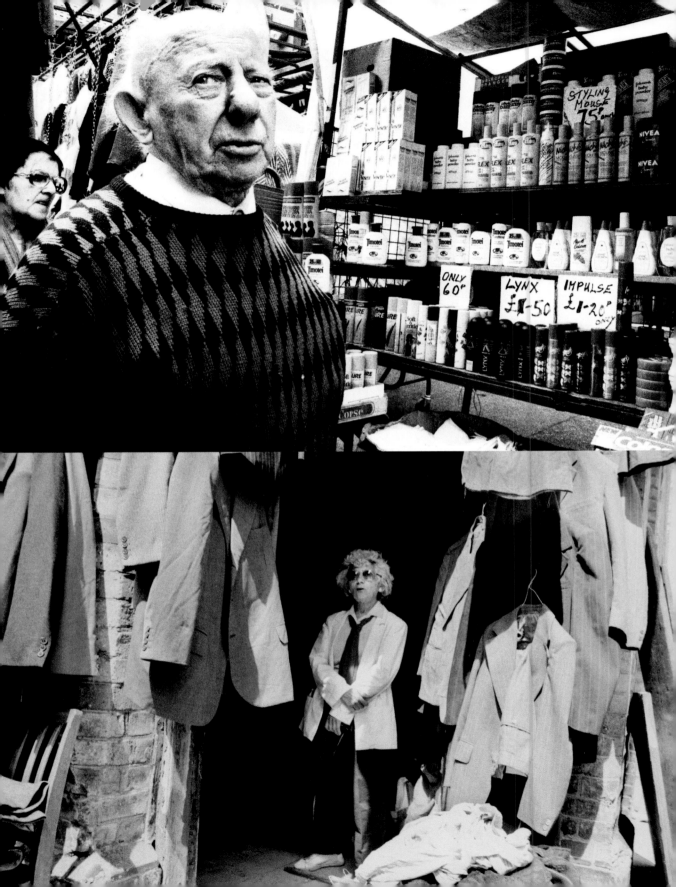

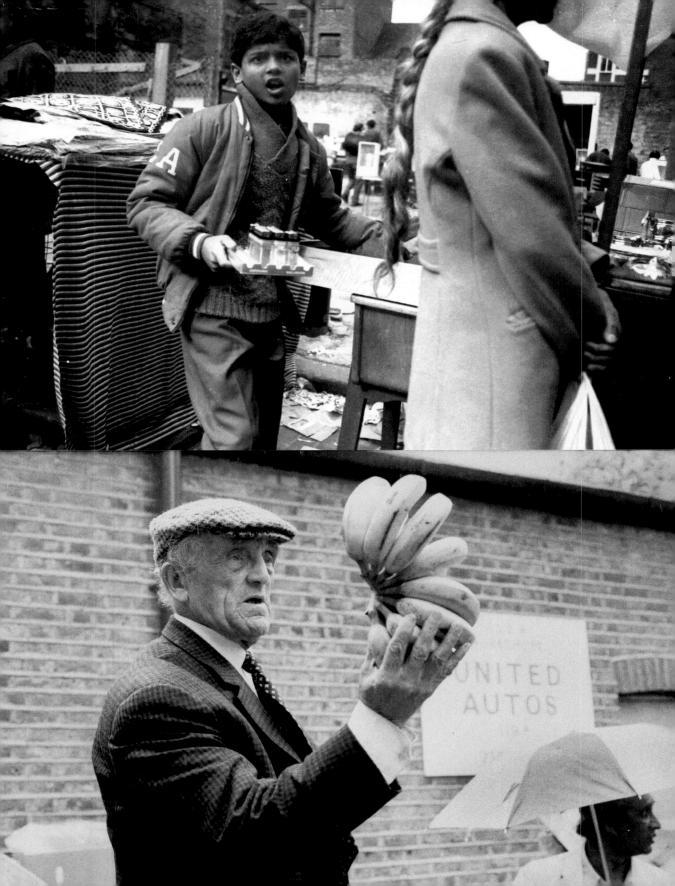

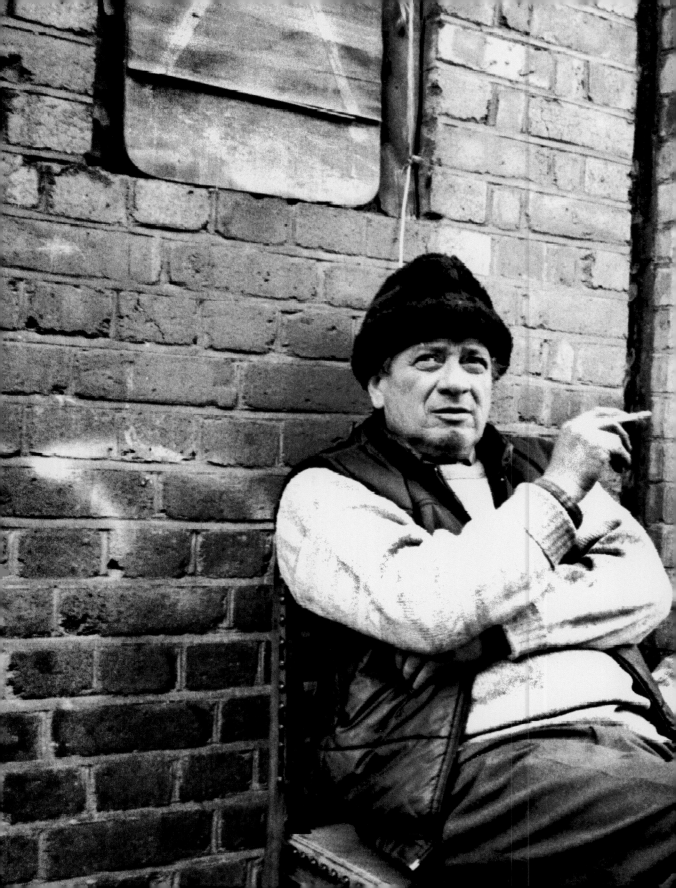

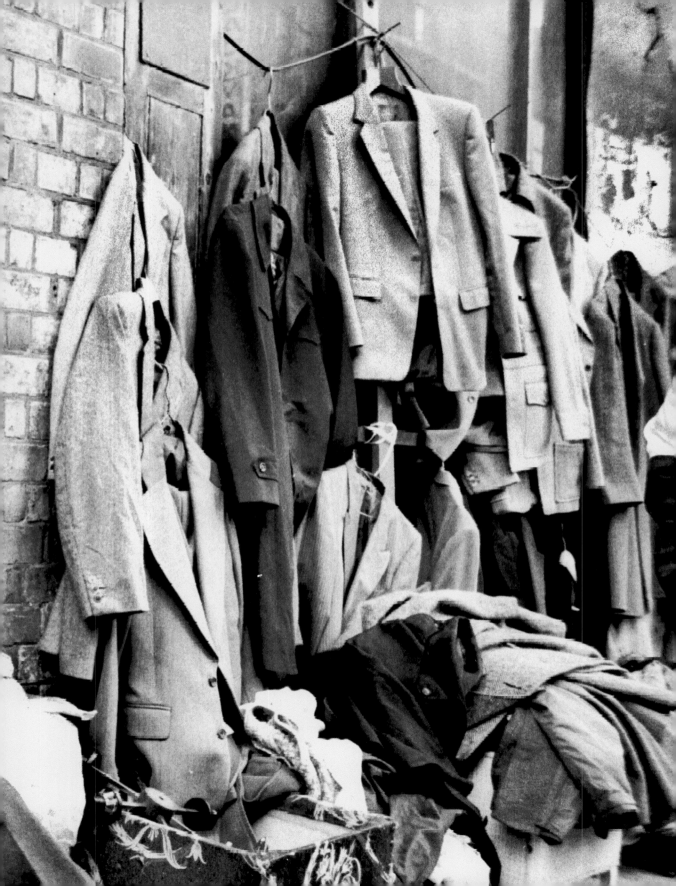

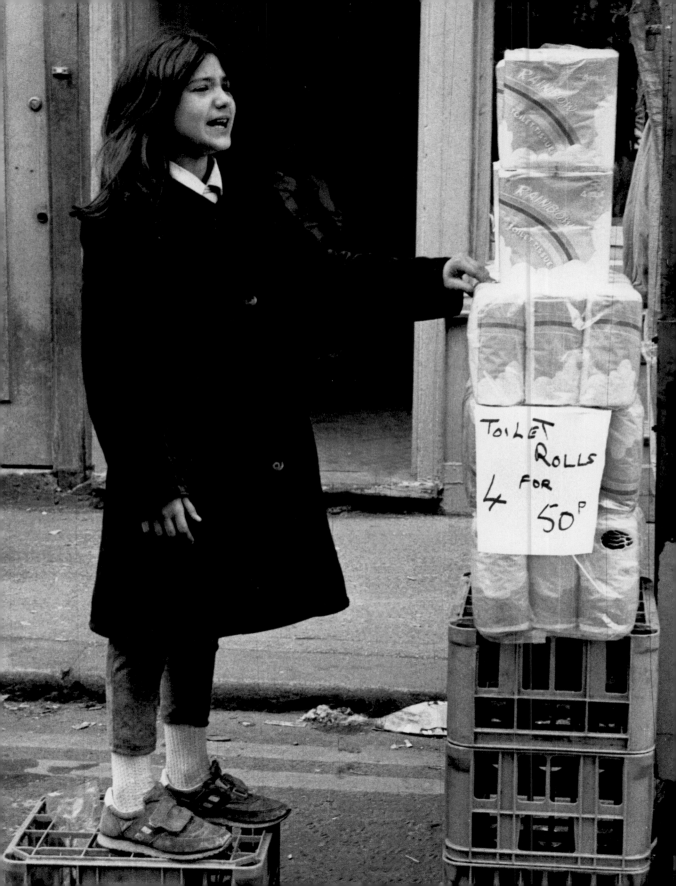

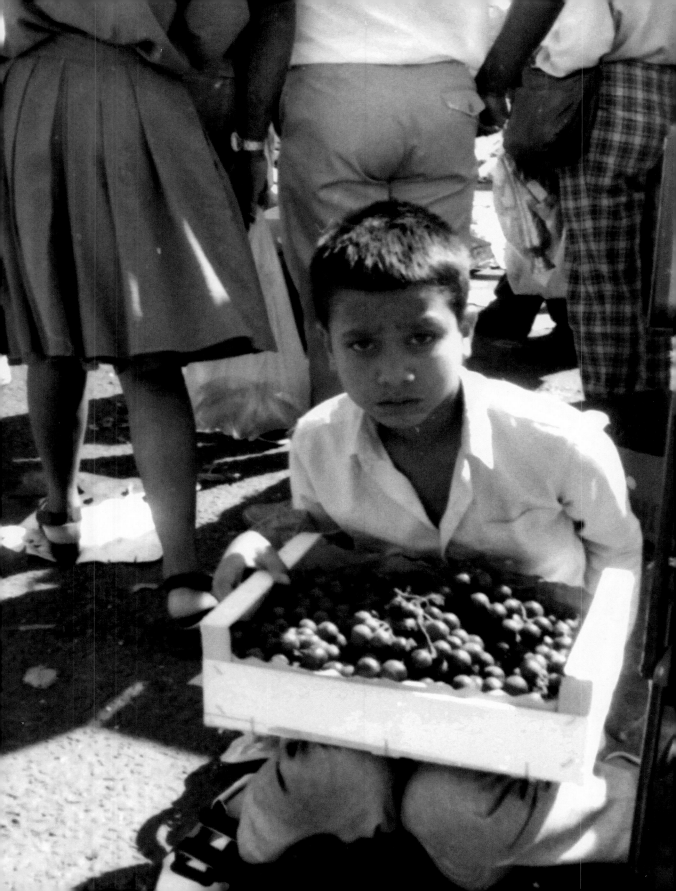

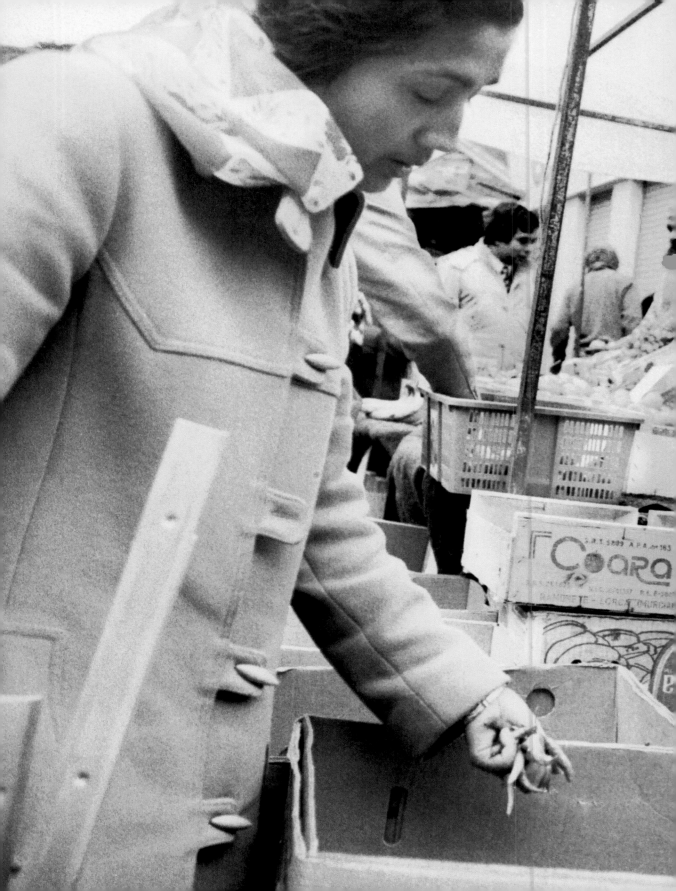

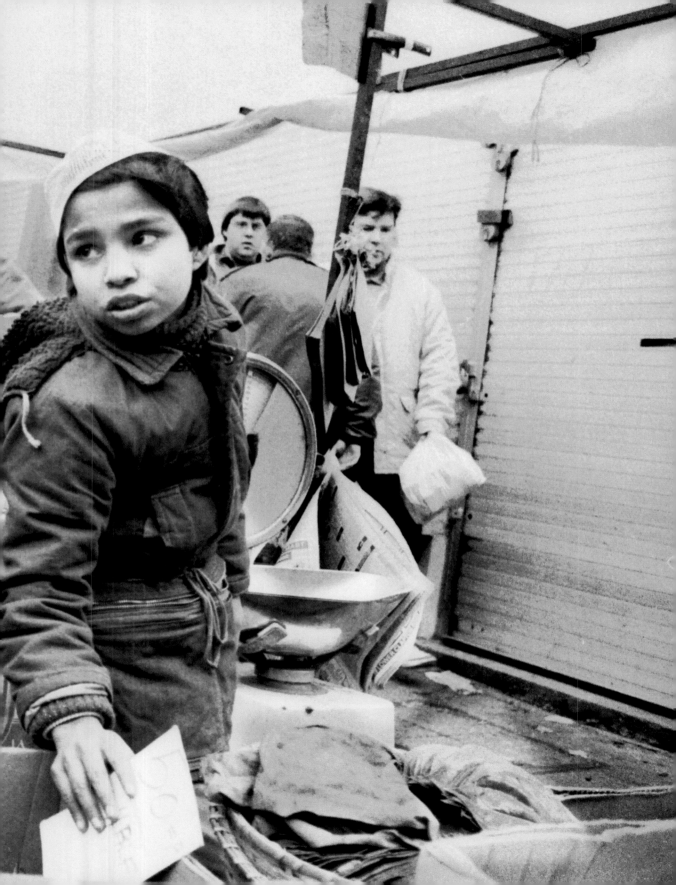

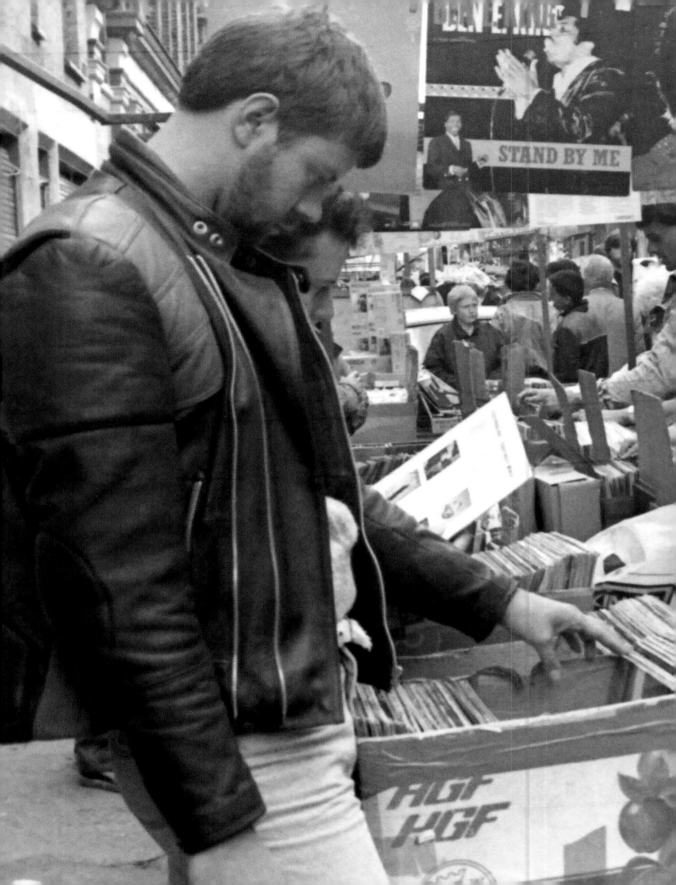

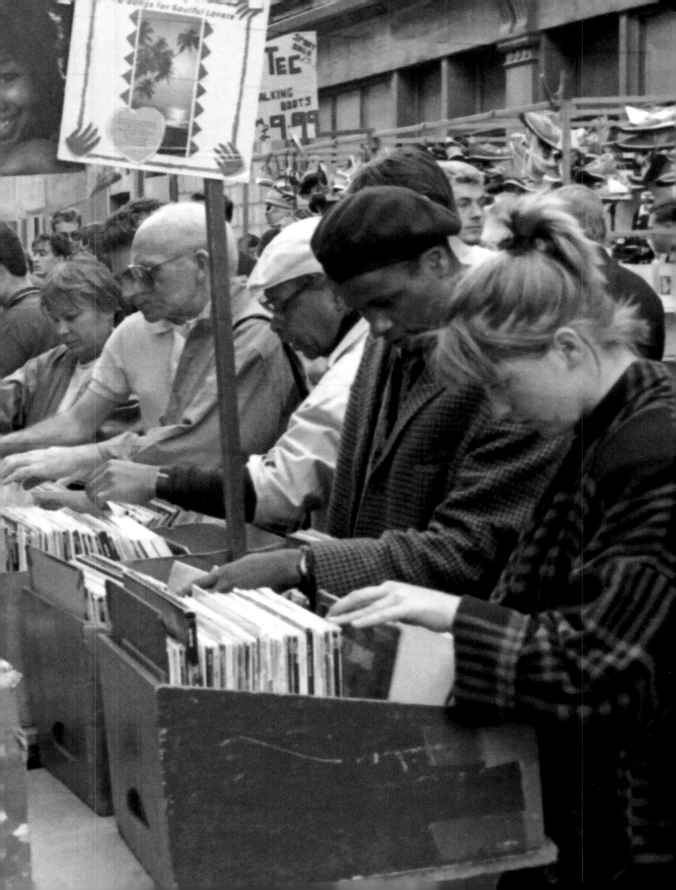

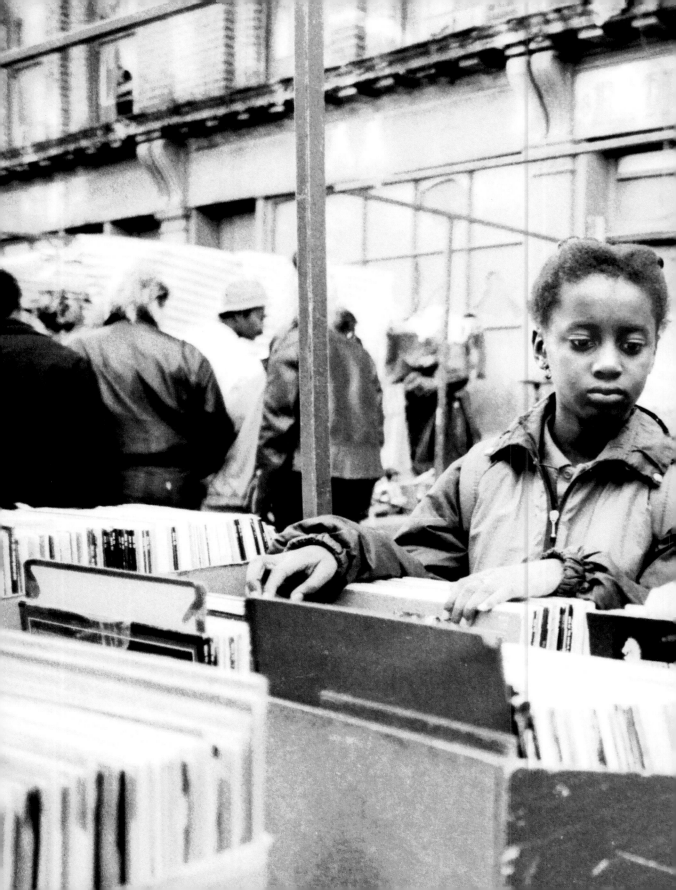

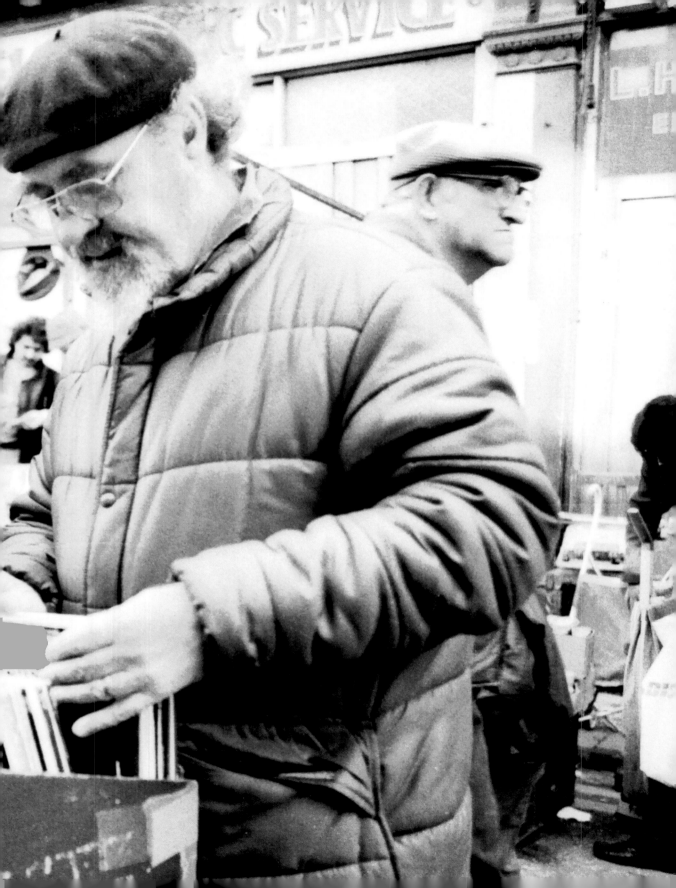

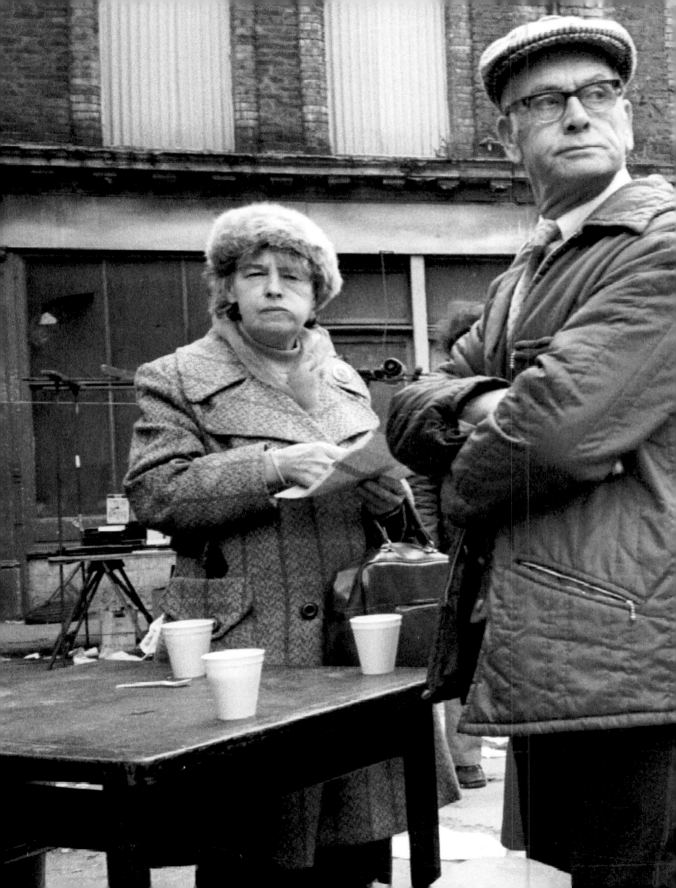

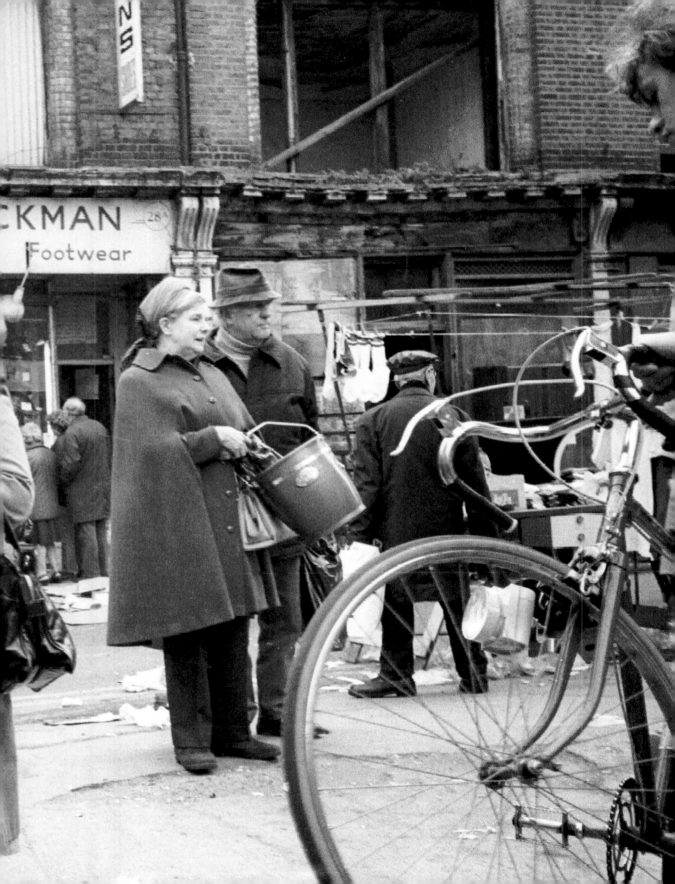

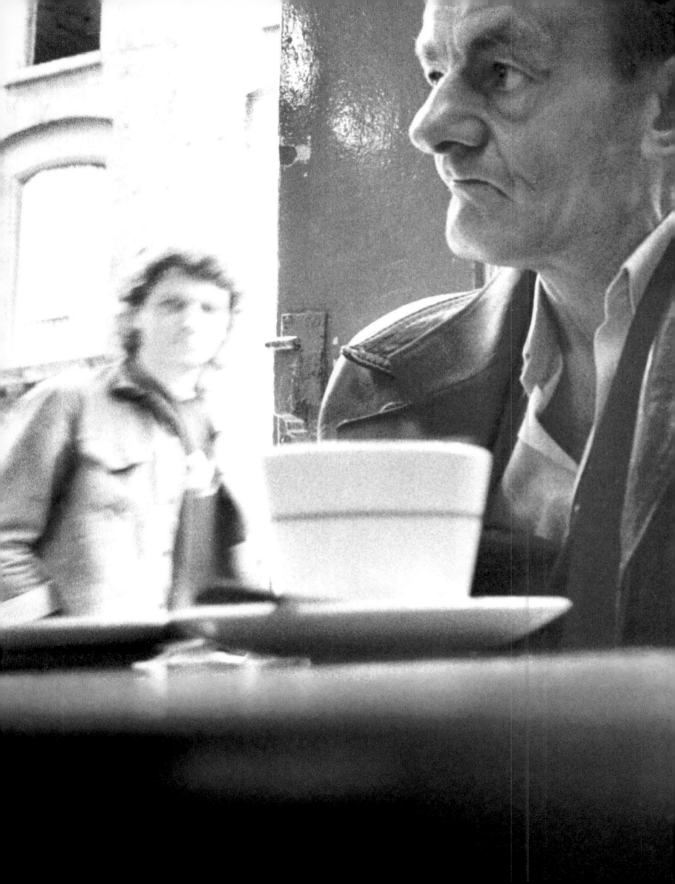

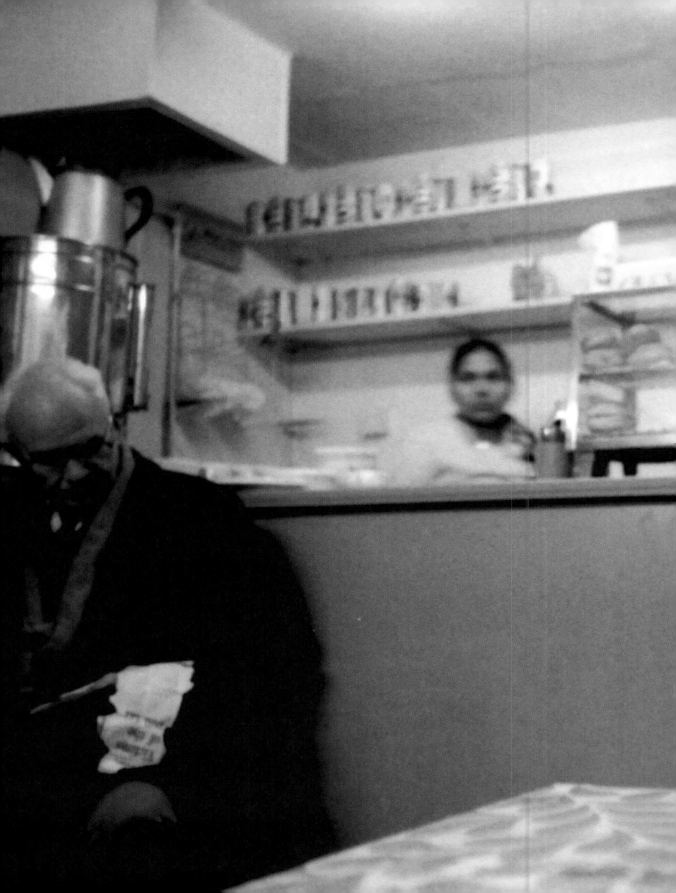

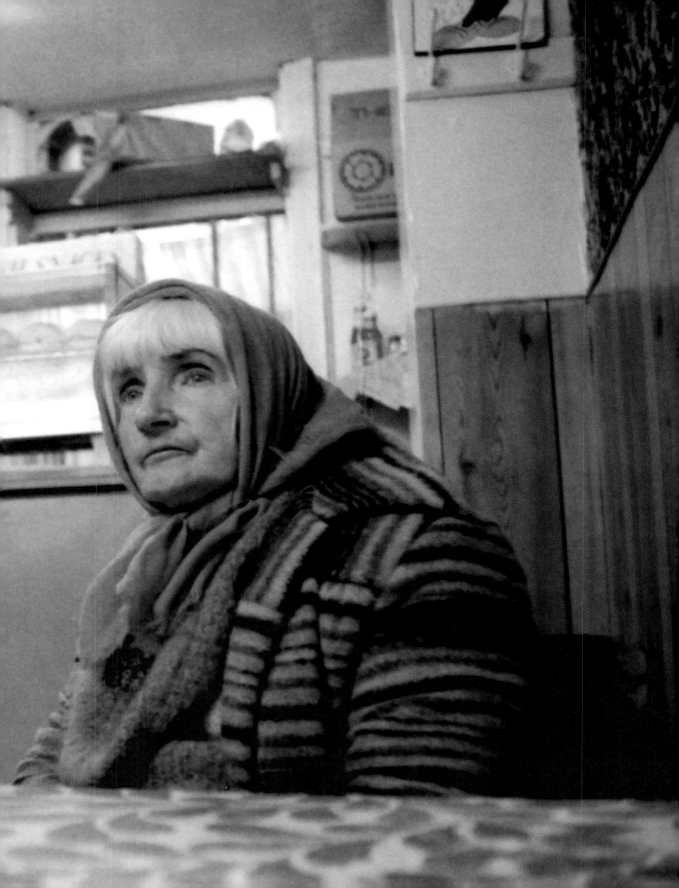

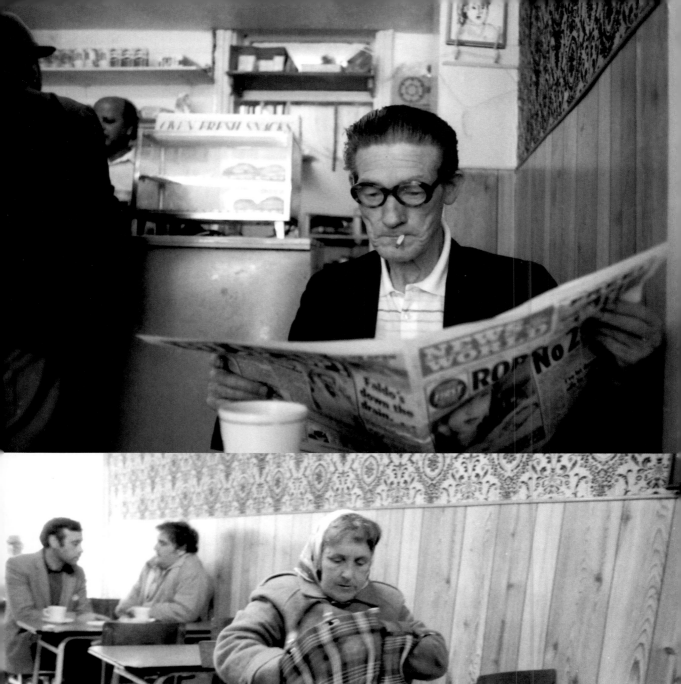
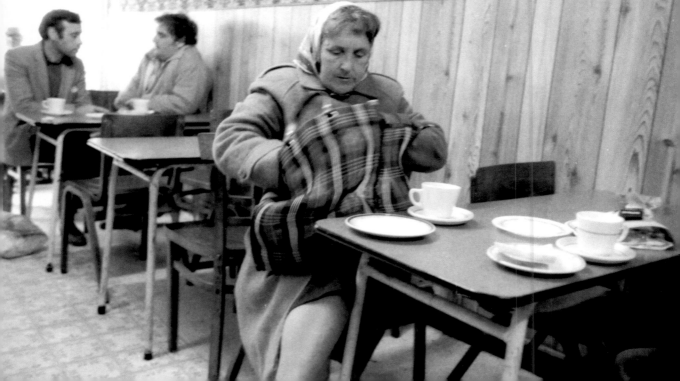

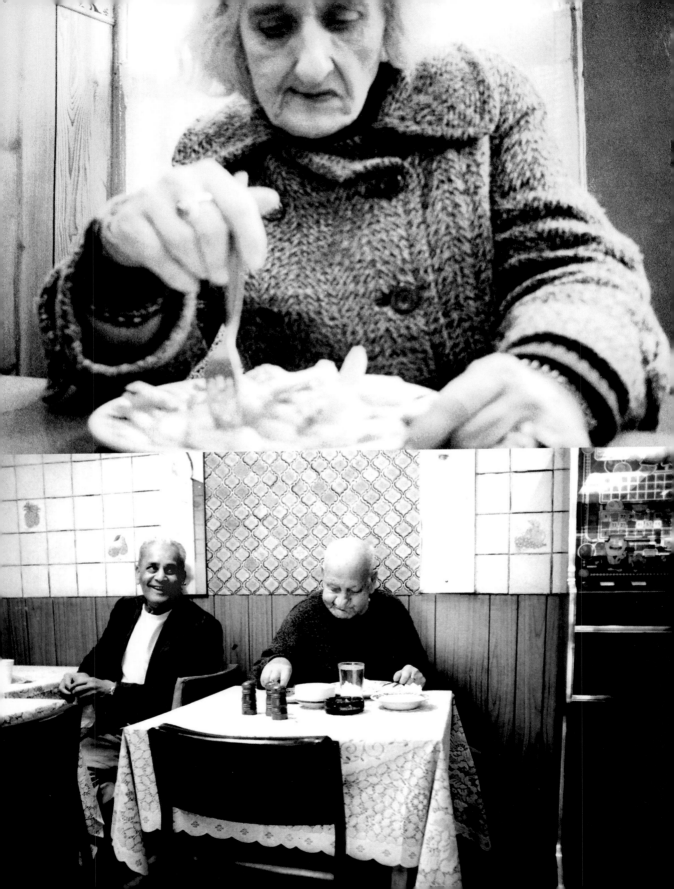

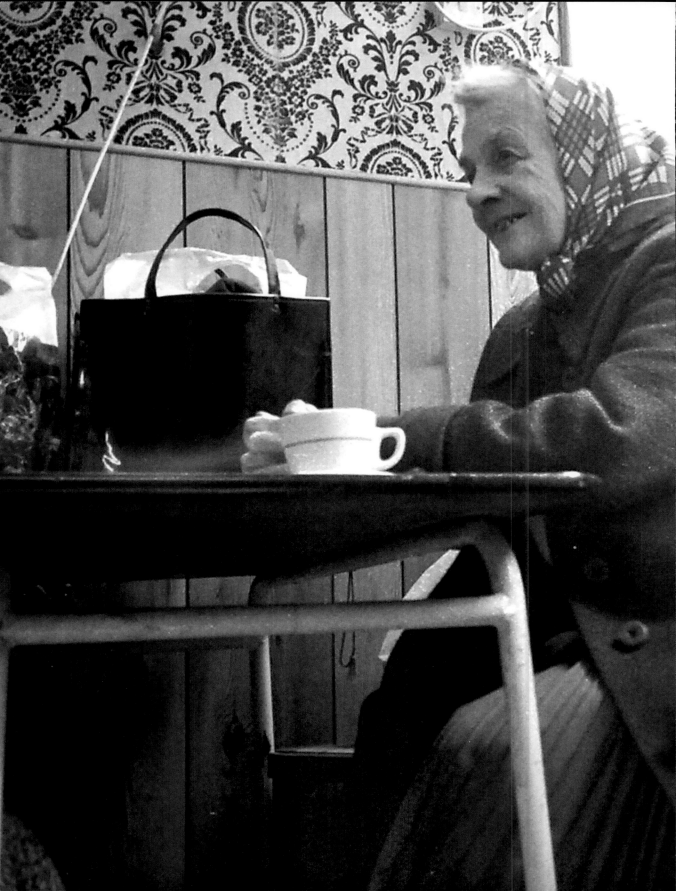

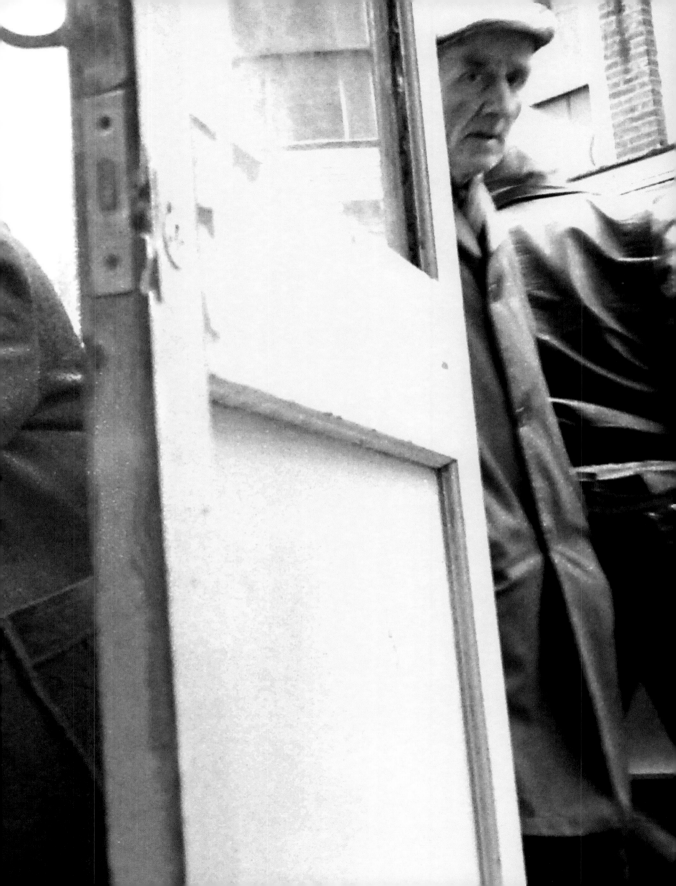

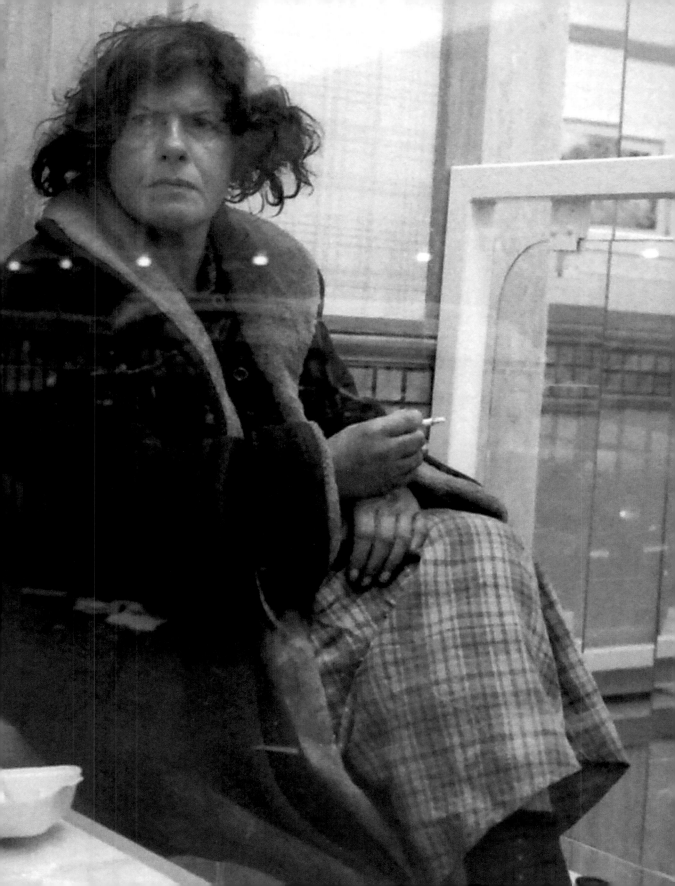

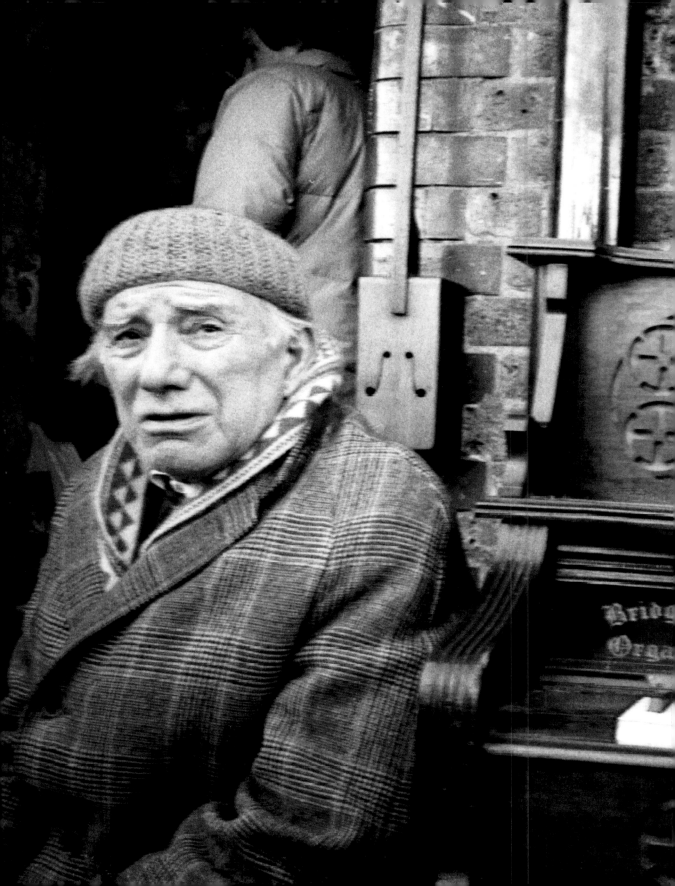

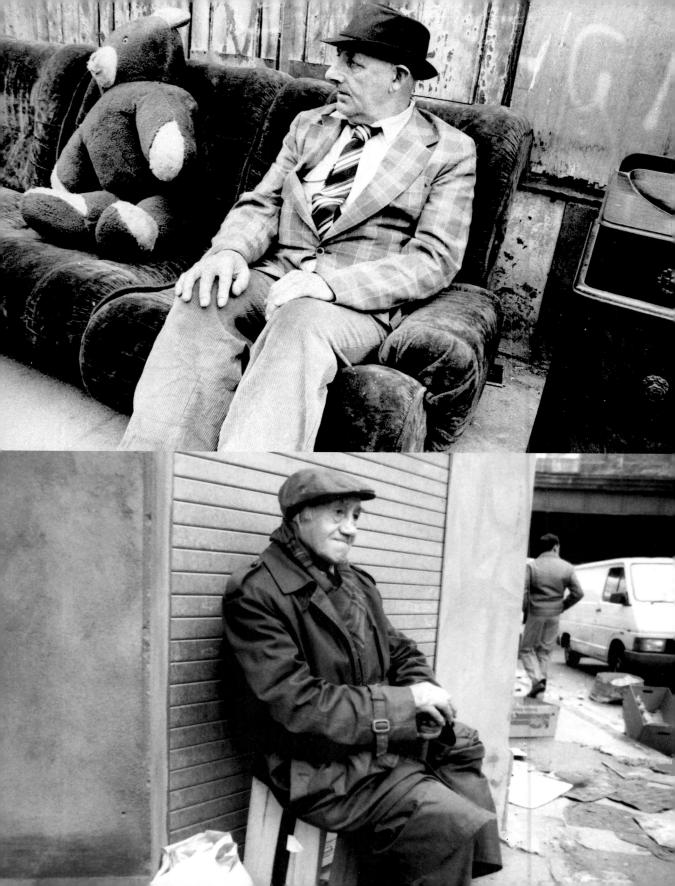

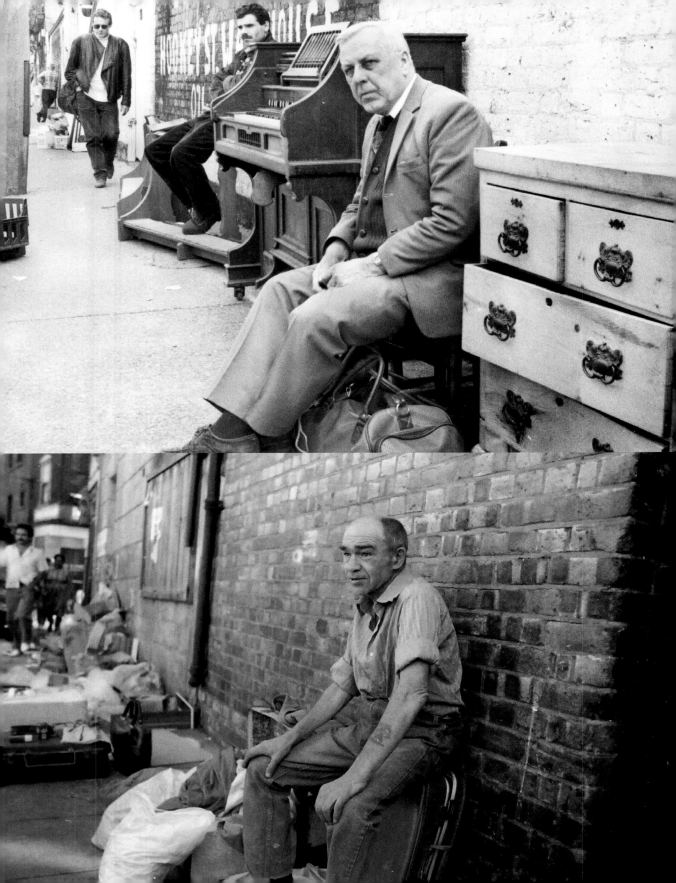

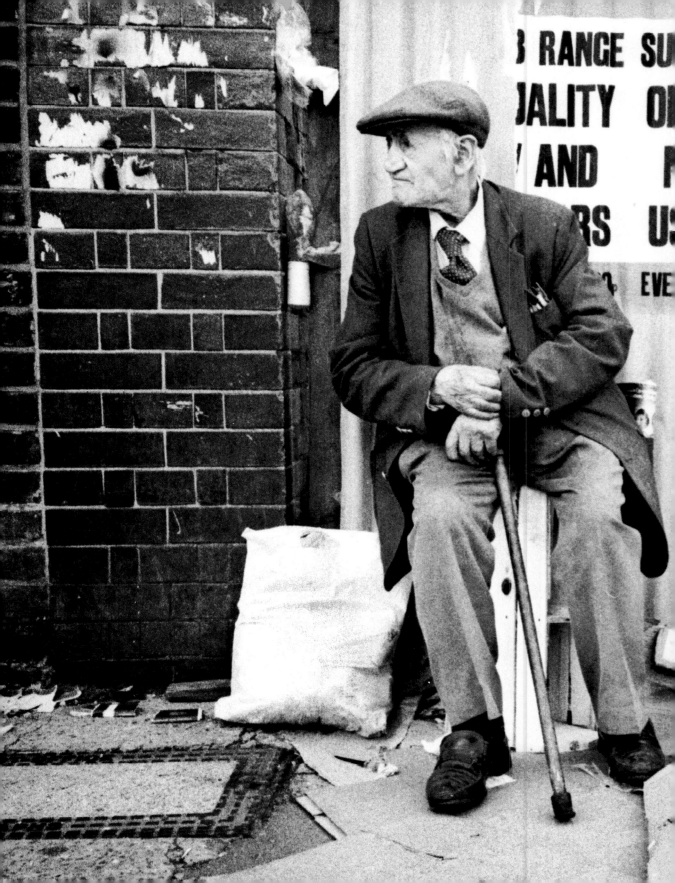

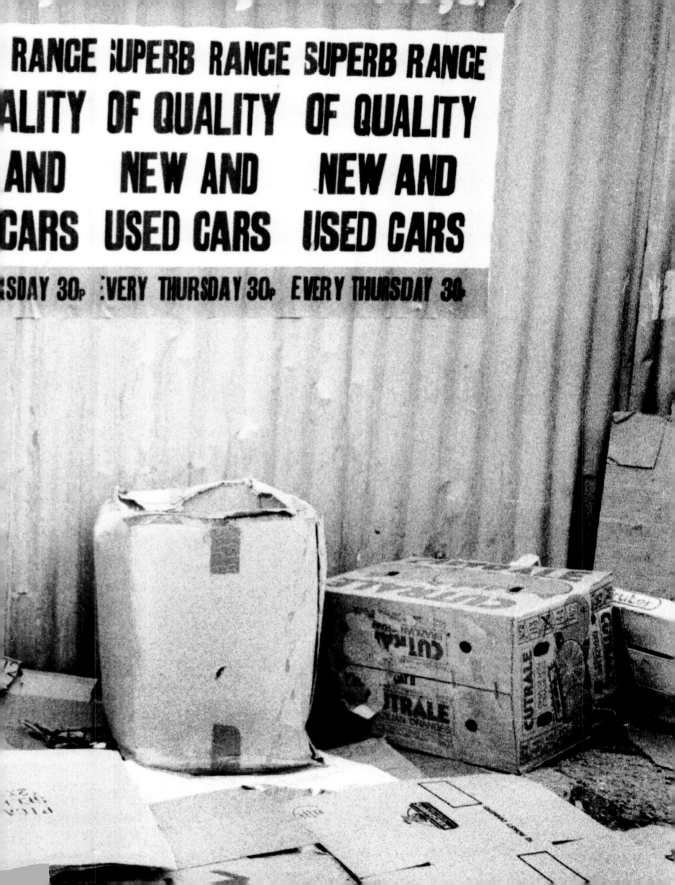

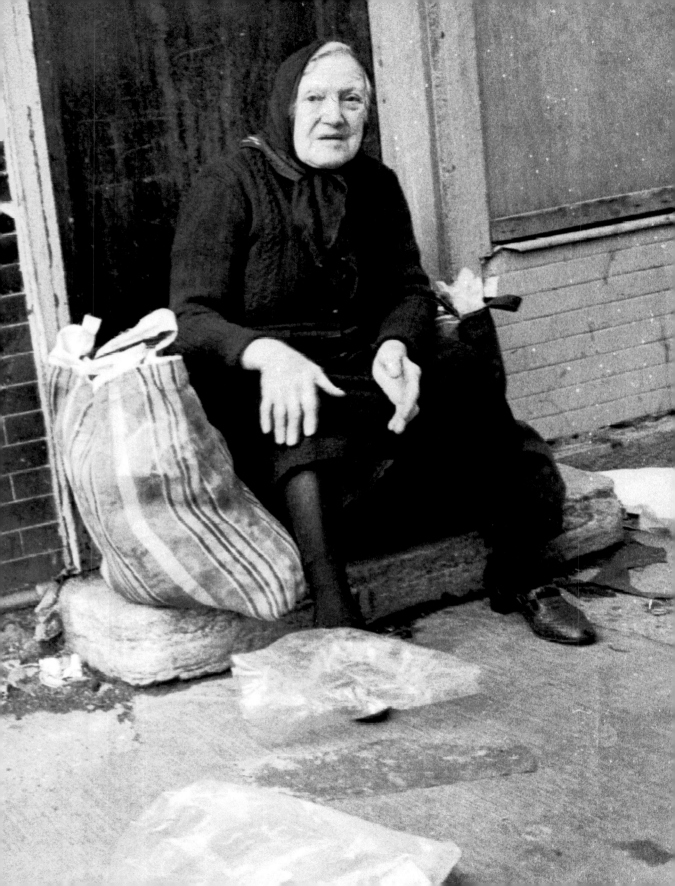

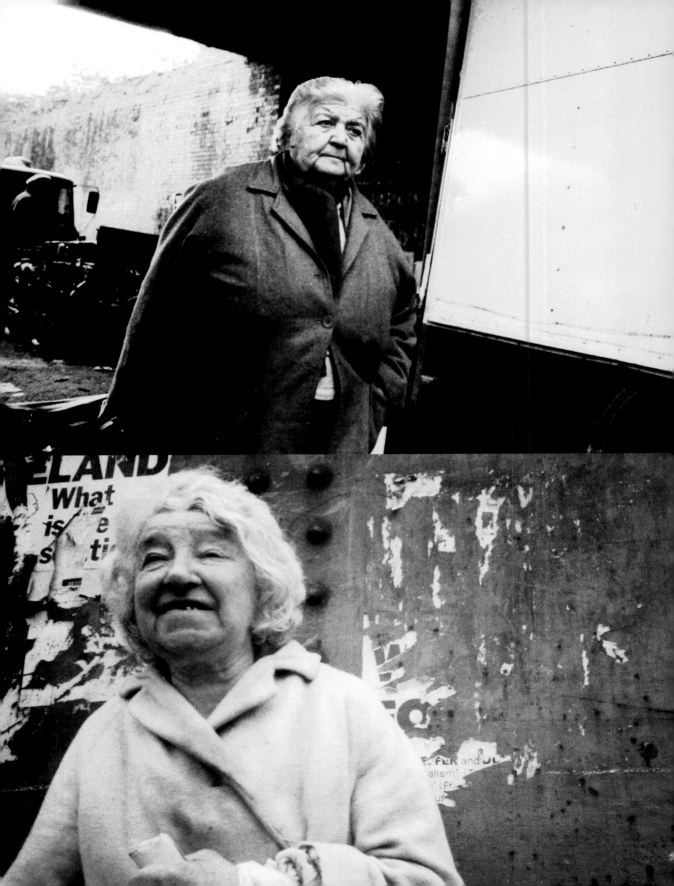

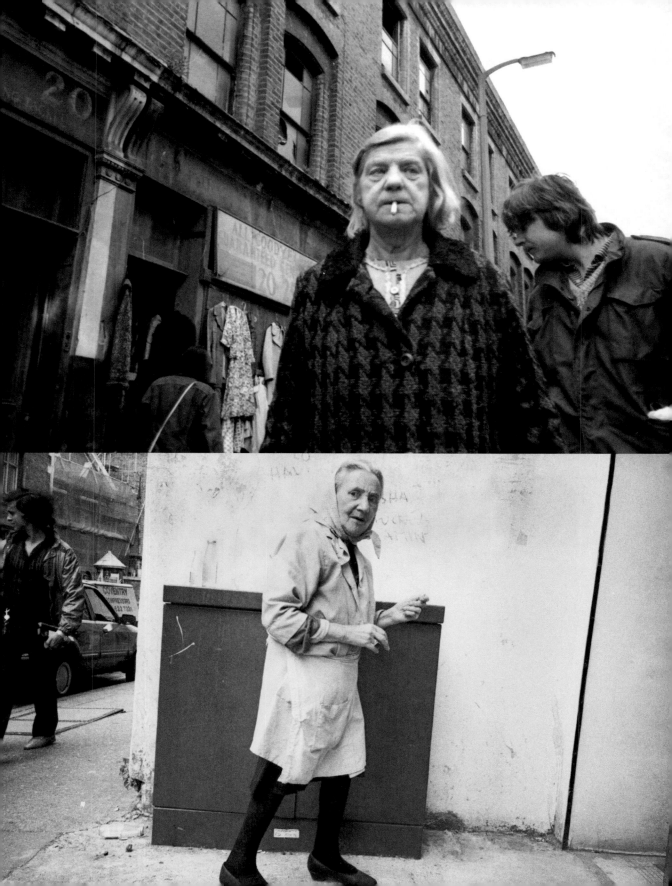

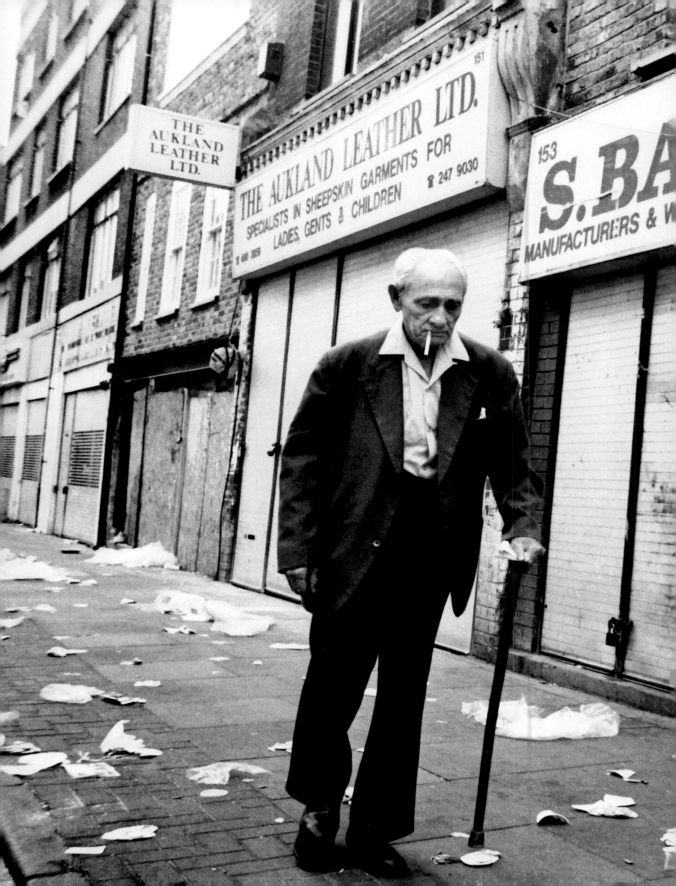

RA & S

ALERS OF MEN'S, LADIES & CHILDREN'S

WATCH
AND
CLOCK
REPAIRS
ENQUIRE
WITHIN

Who's
got
YOUR bag?

Be sure
it's safe,
Always!

METROPOLITAN POLICE
CRIME PREVENTION ARCHIVE

The Canada Dry
Mixer Range

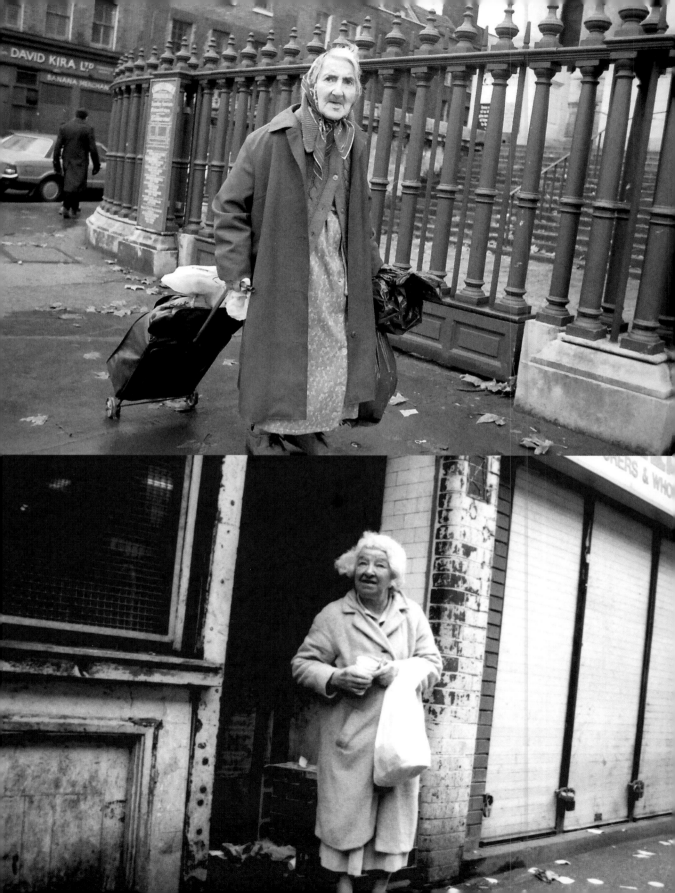

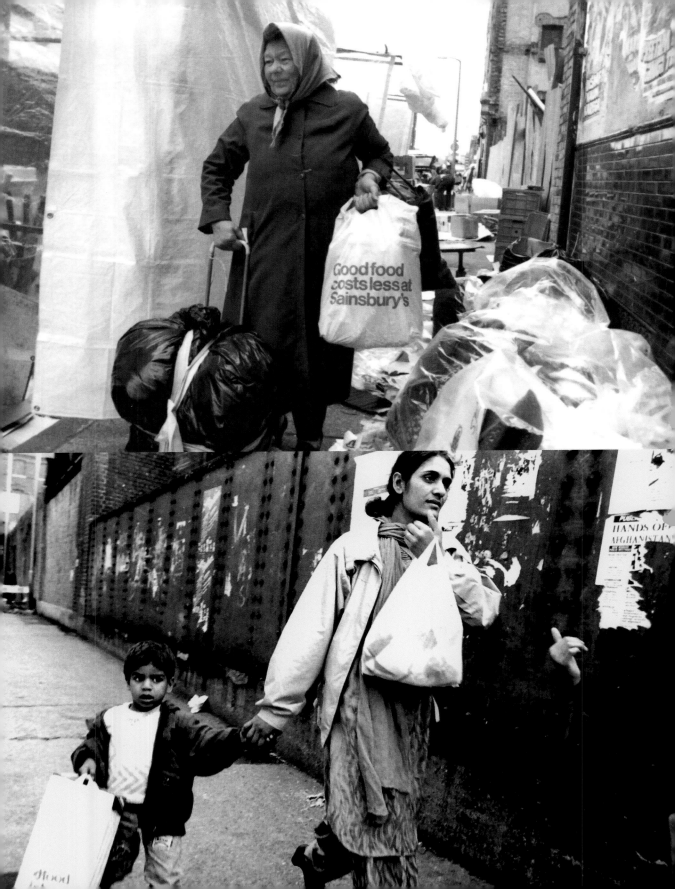

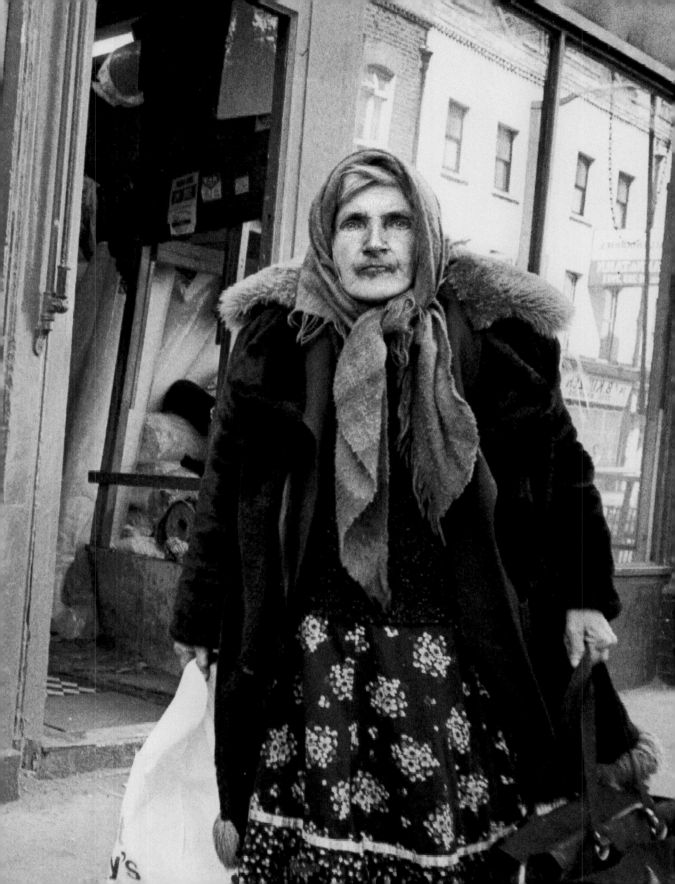

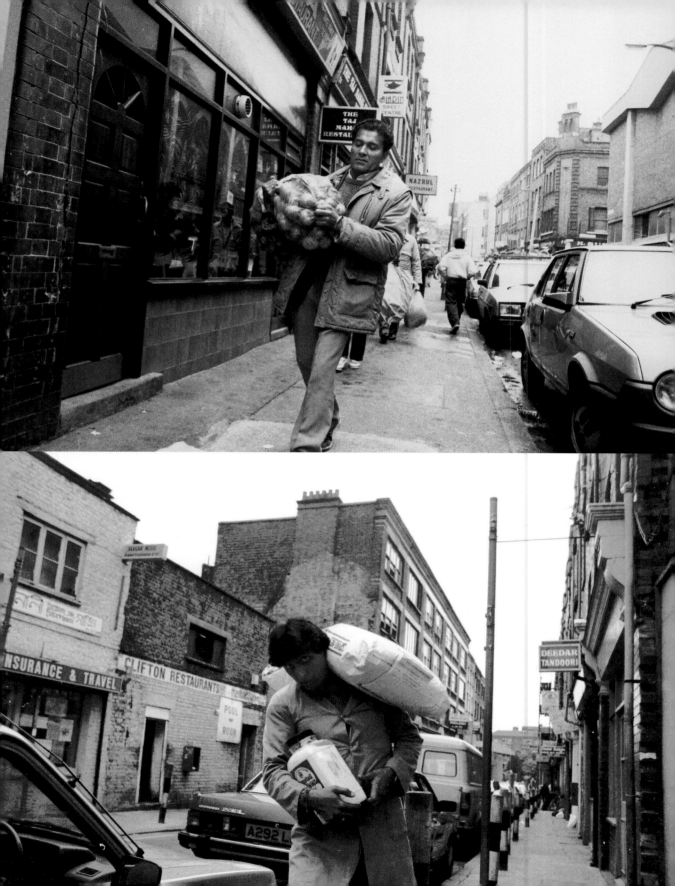

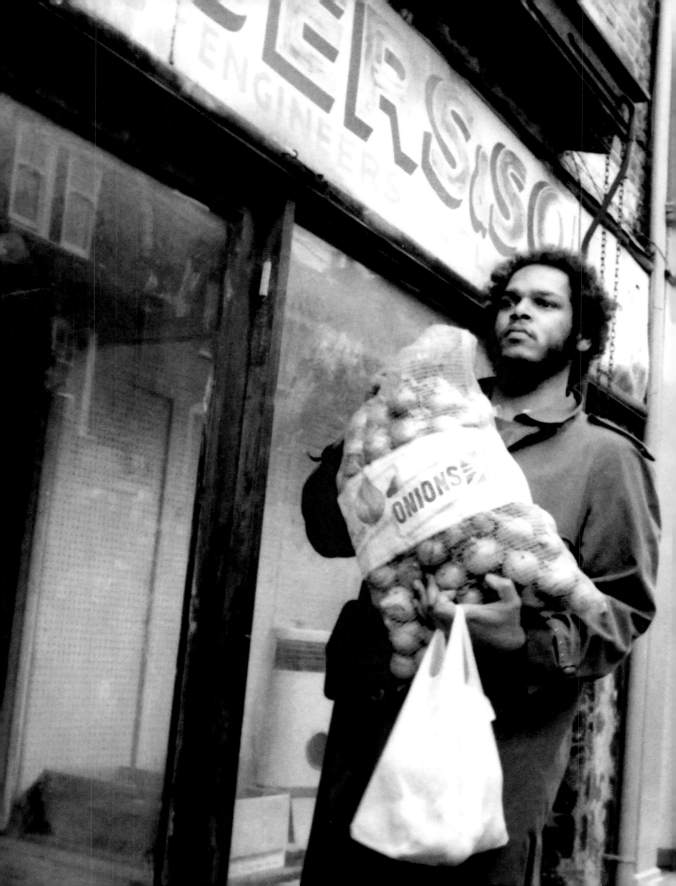

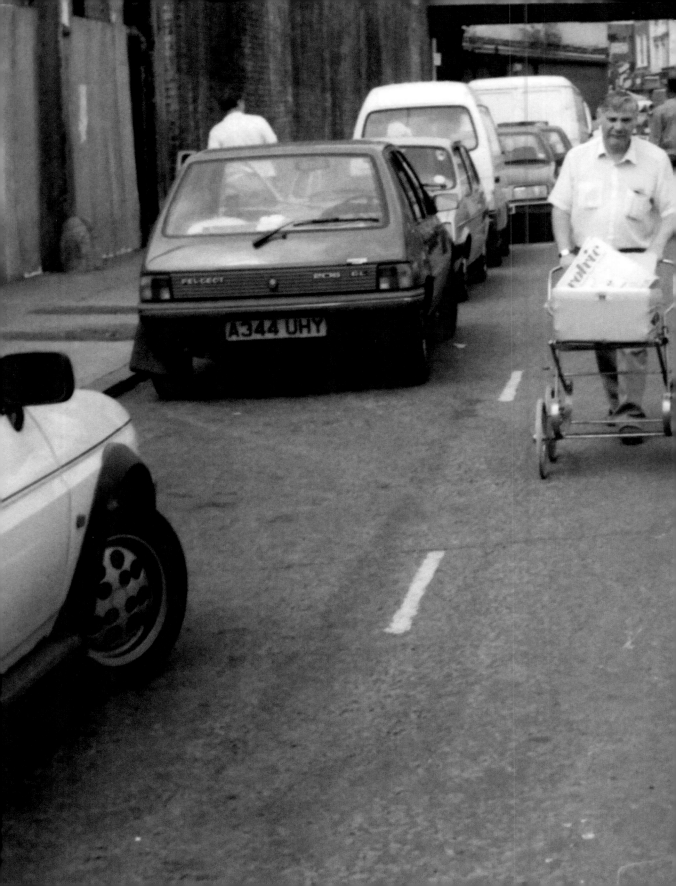

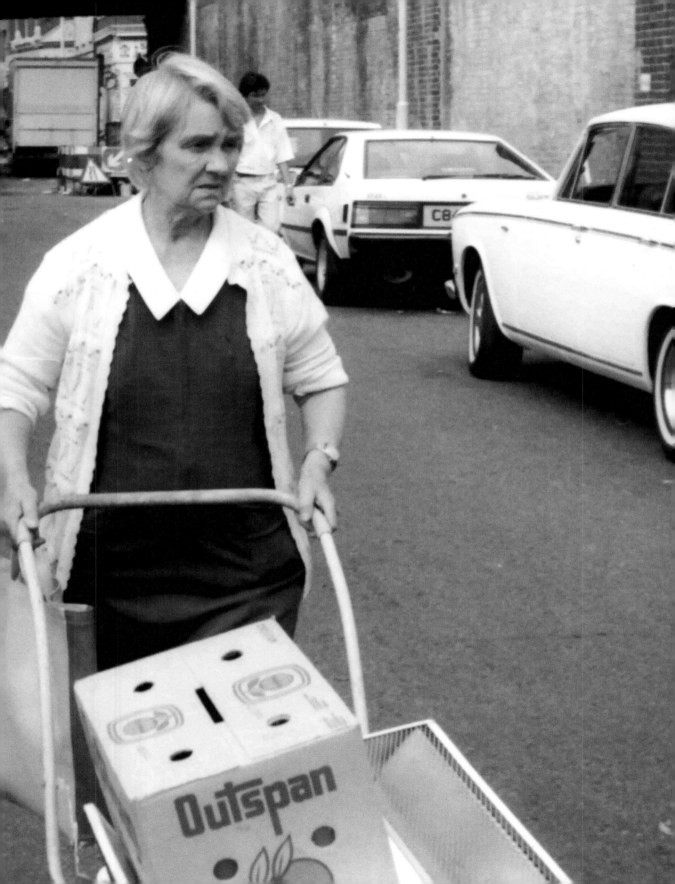

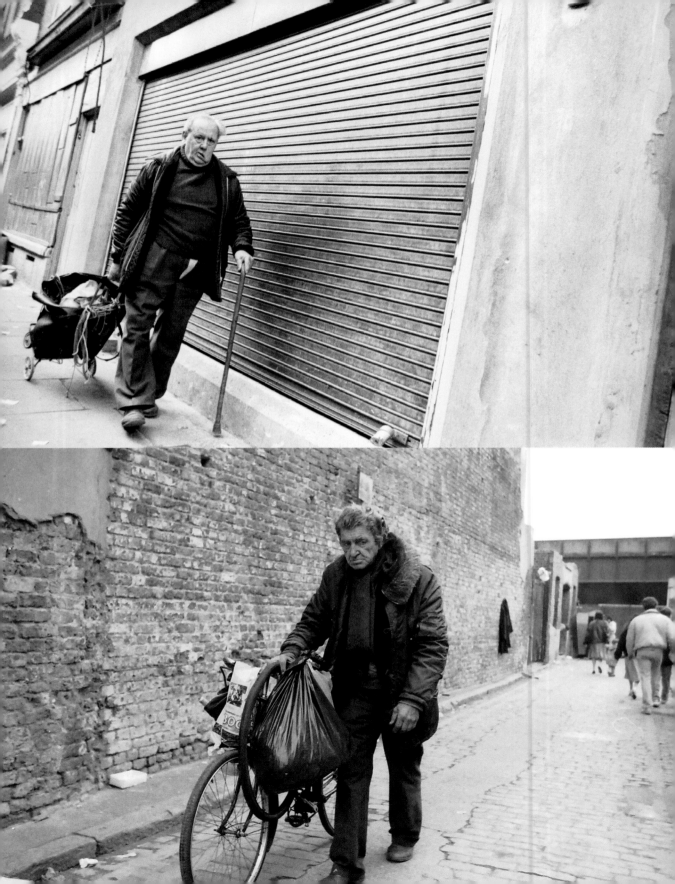

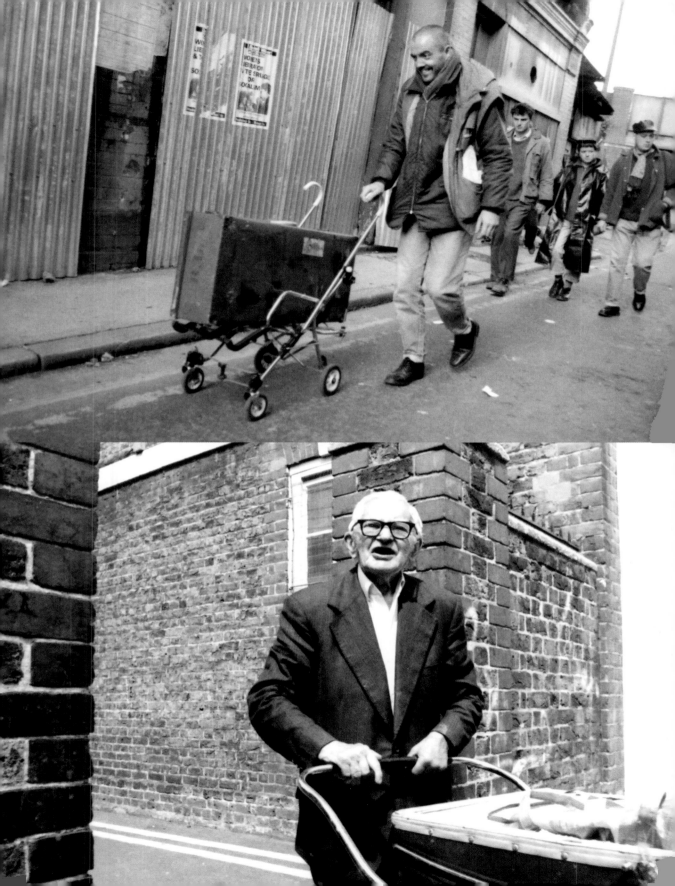

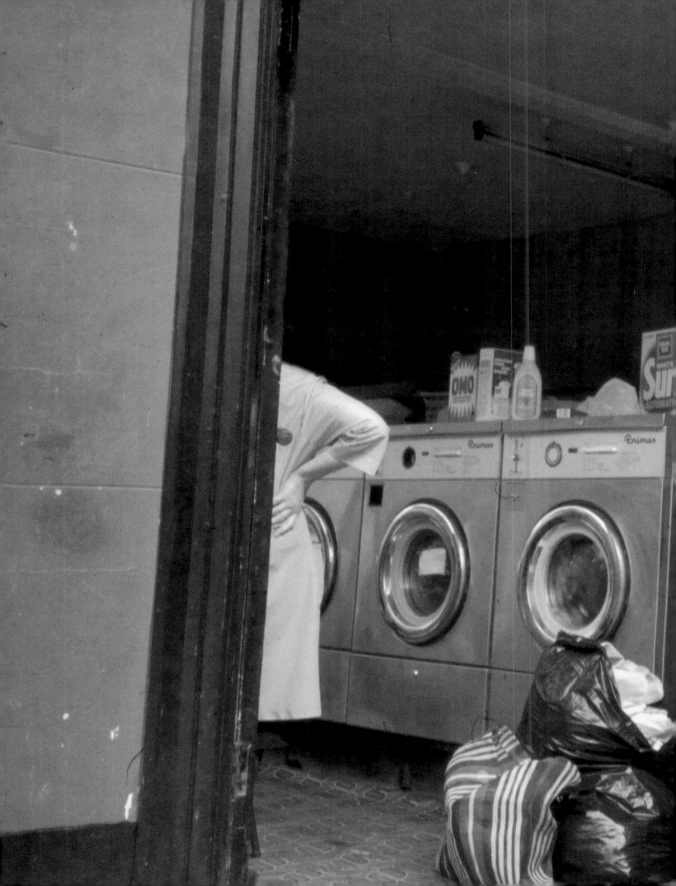

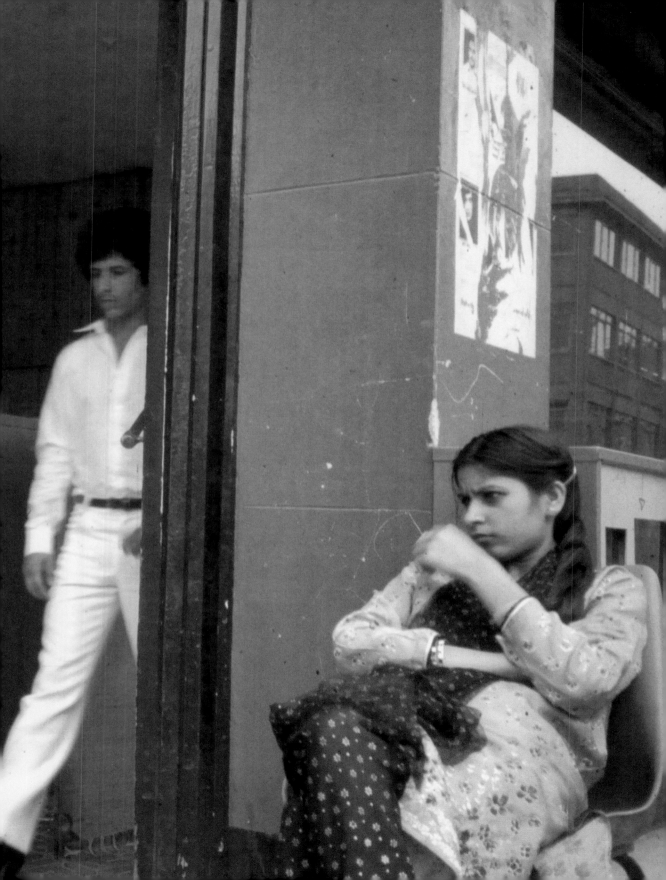

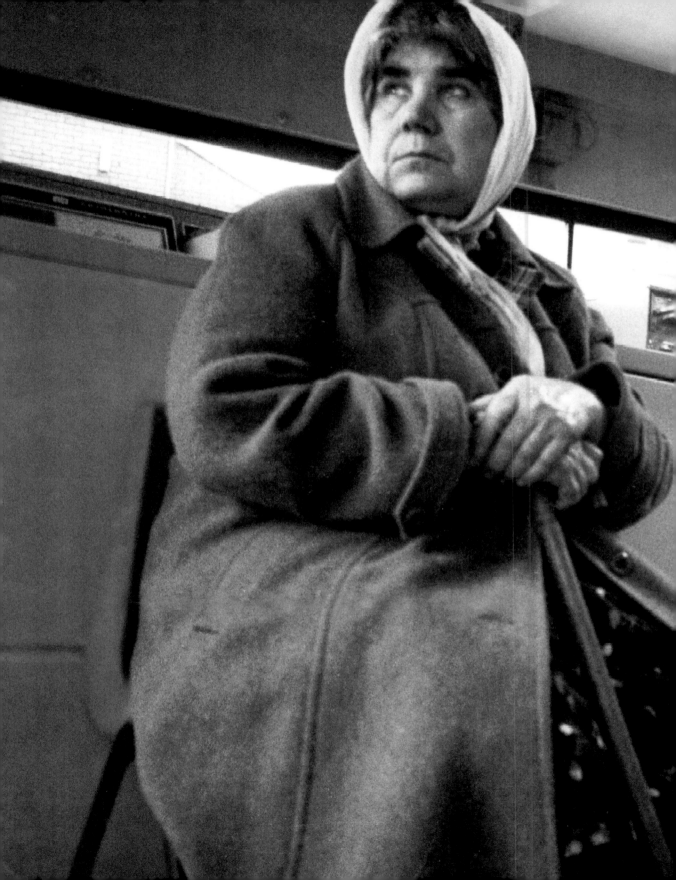

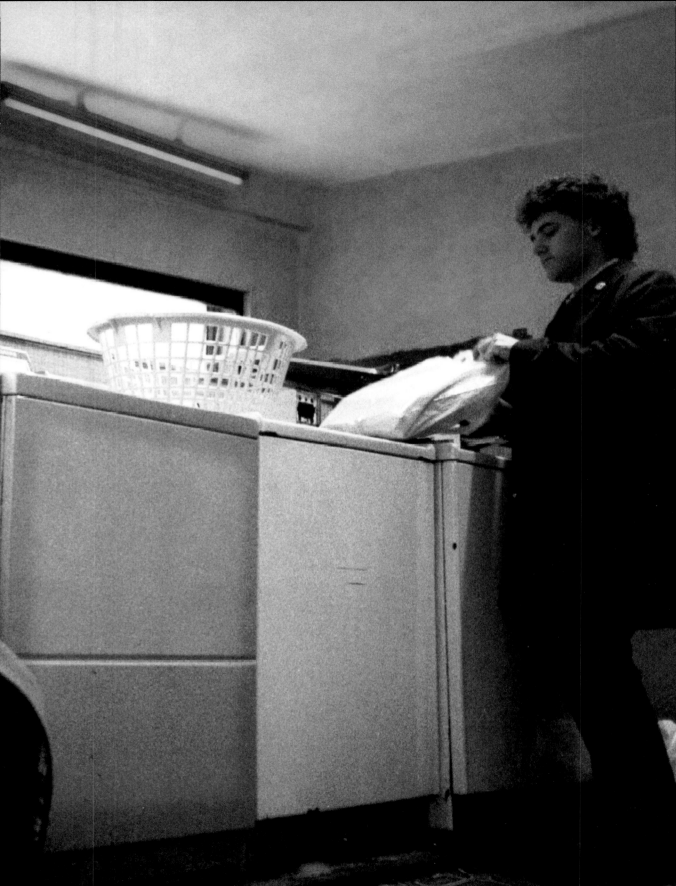

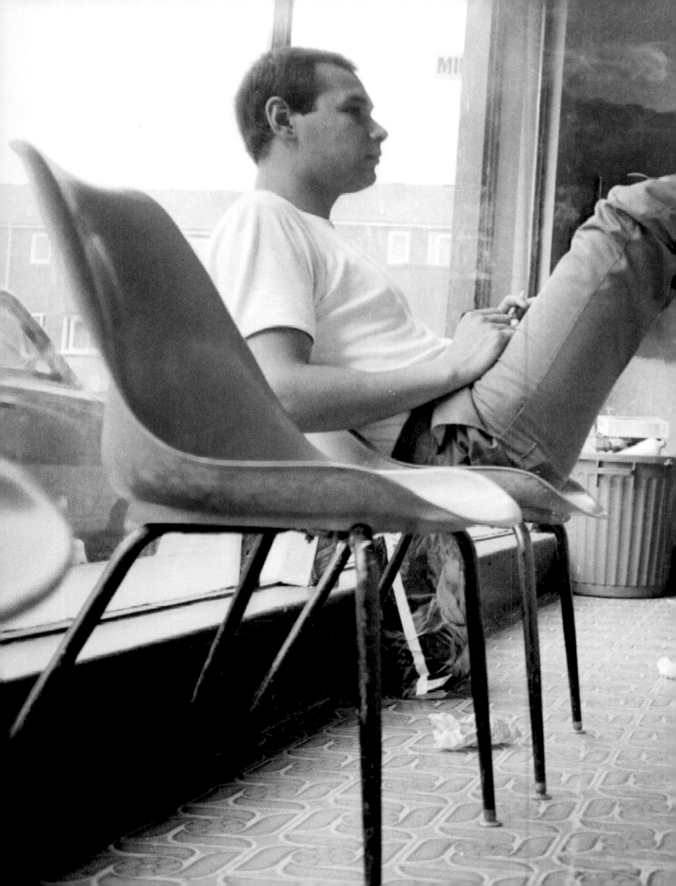

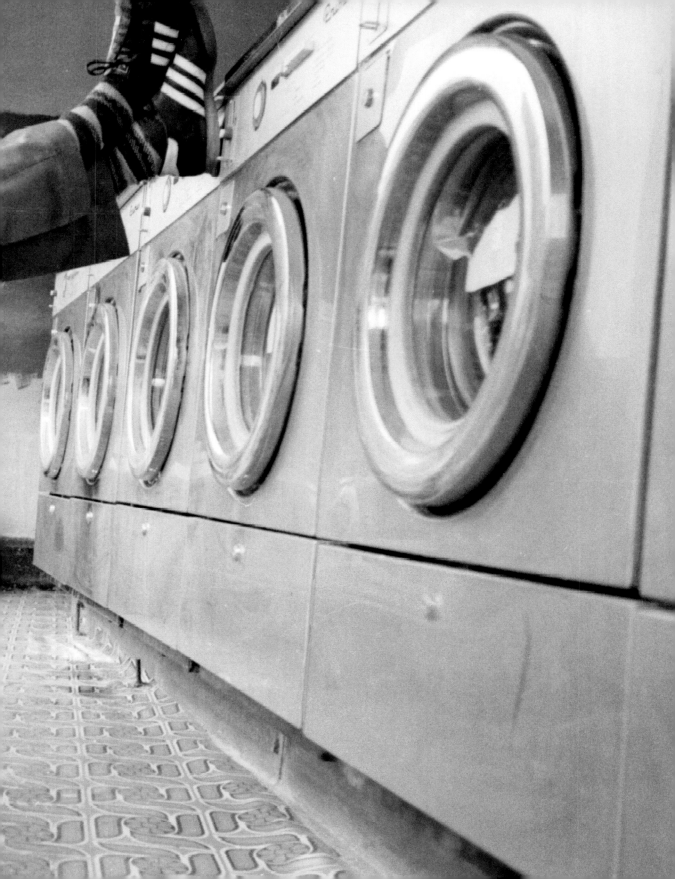

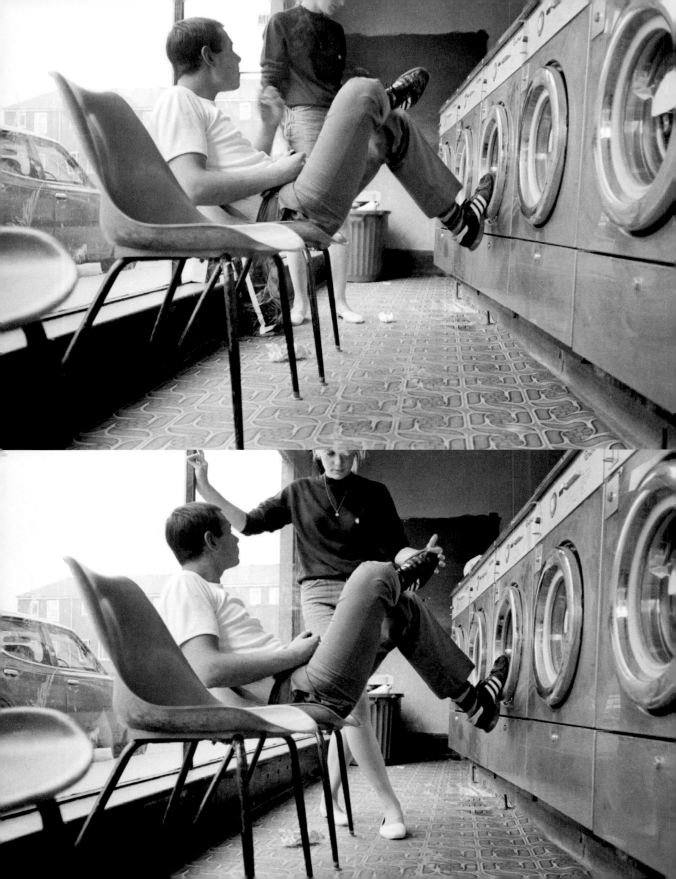

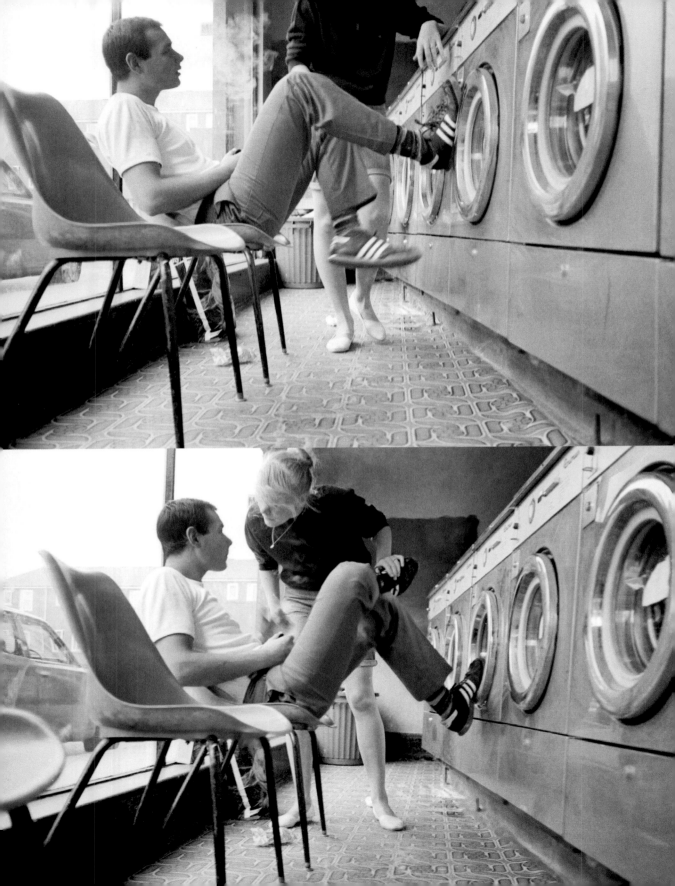

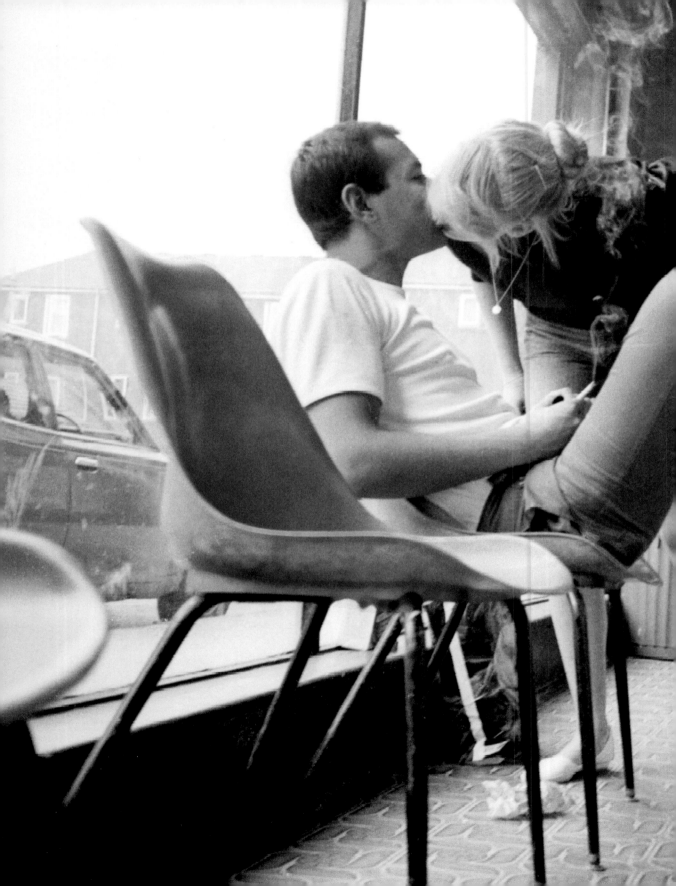

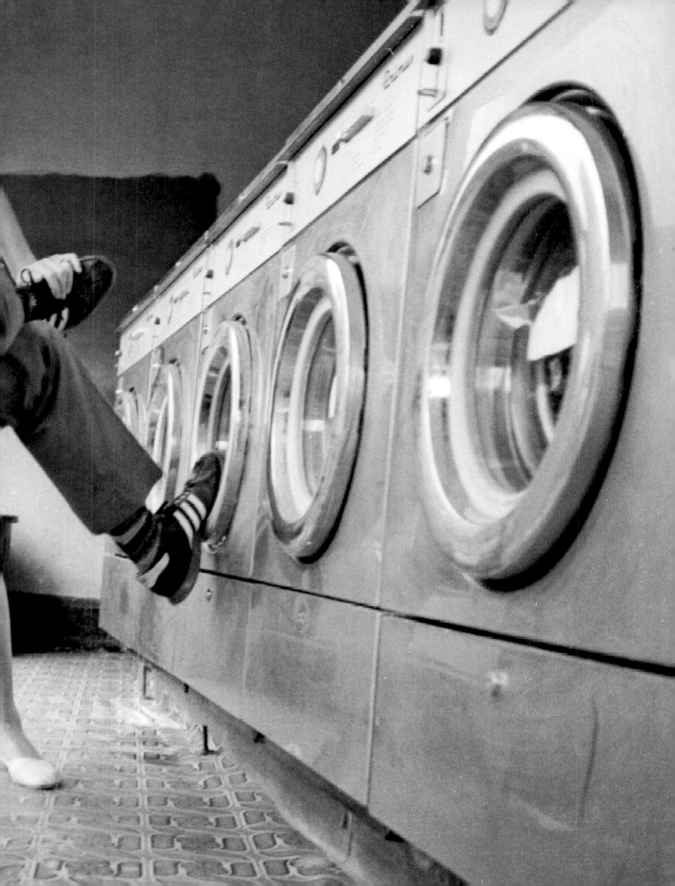

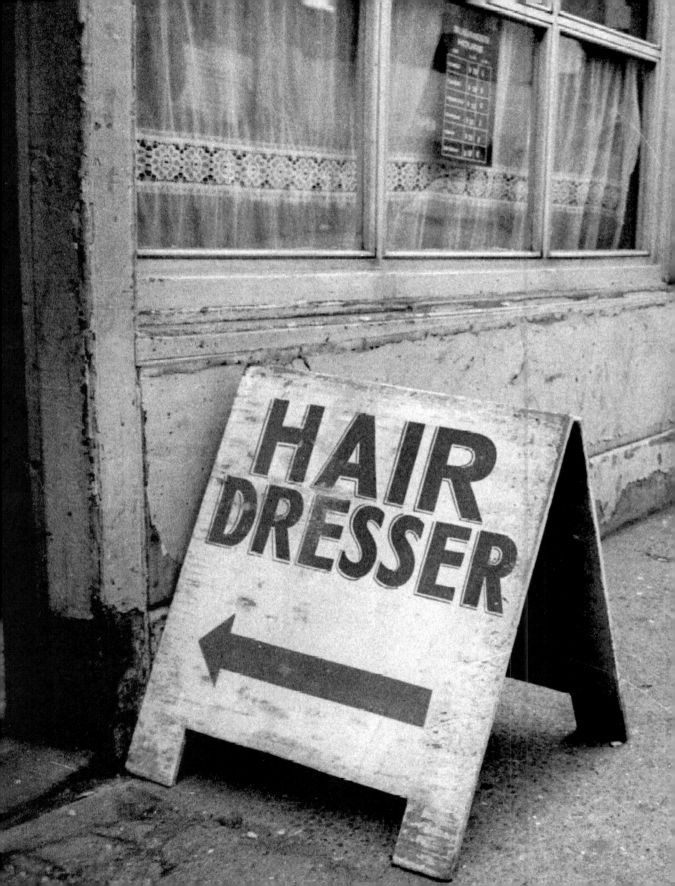

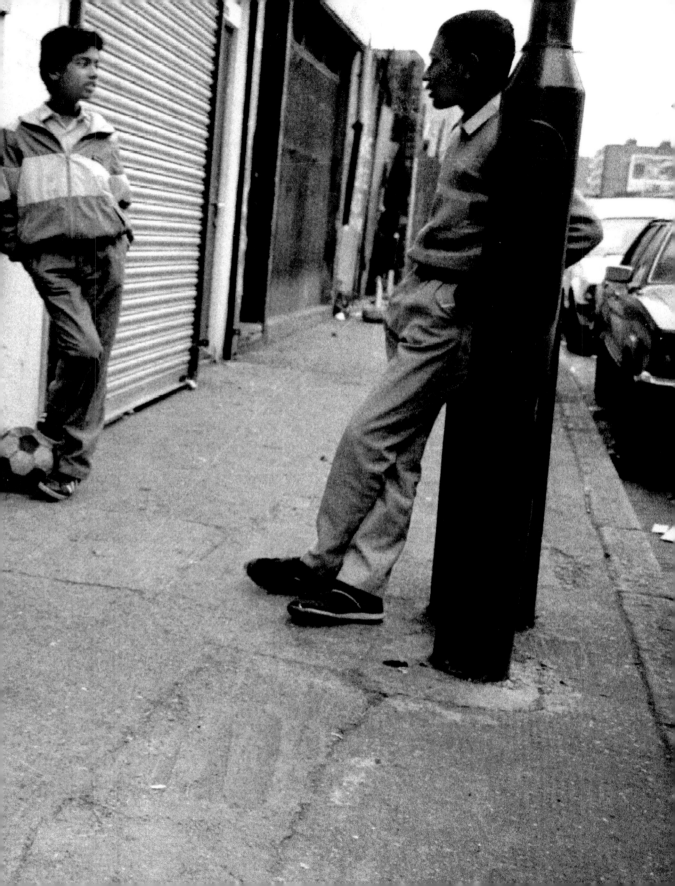

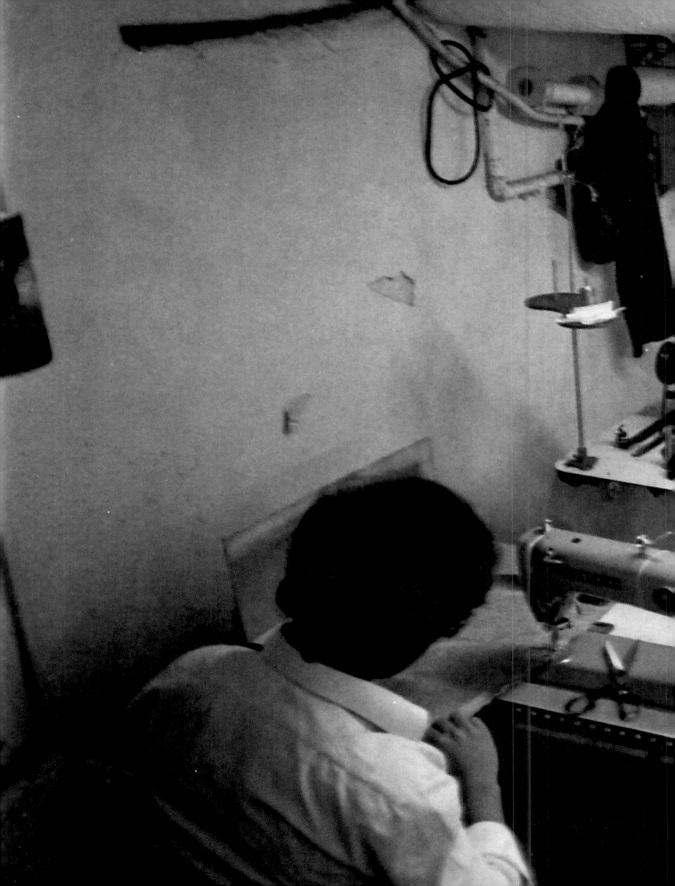

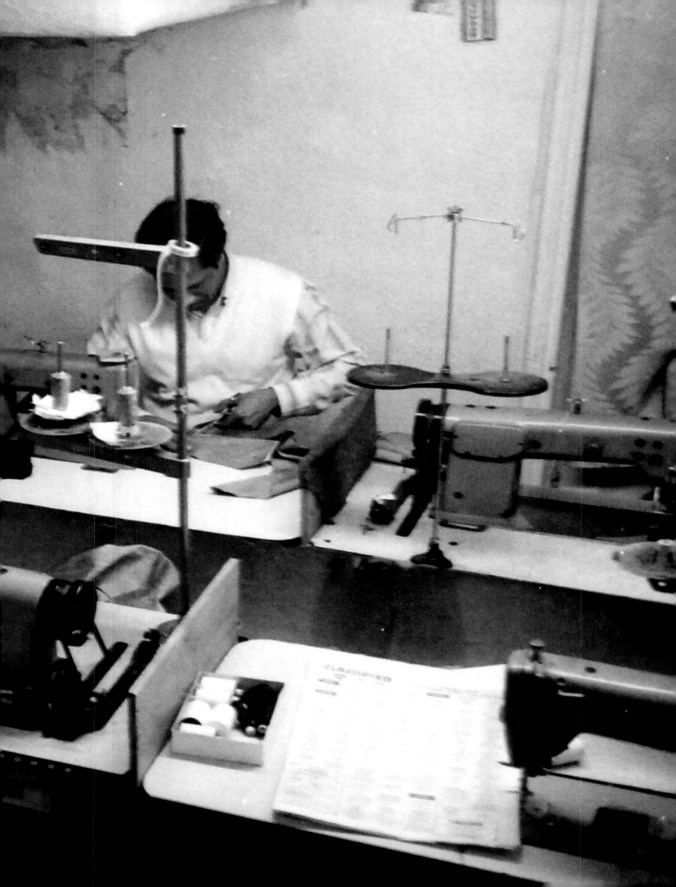

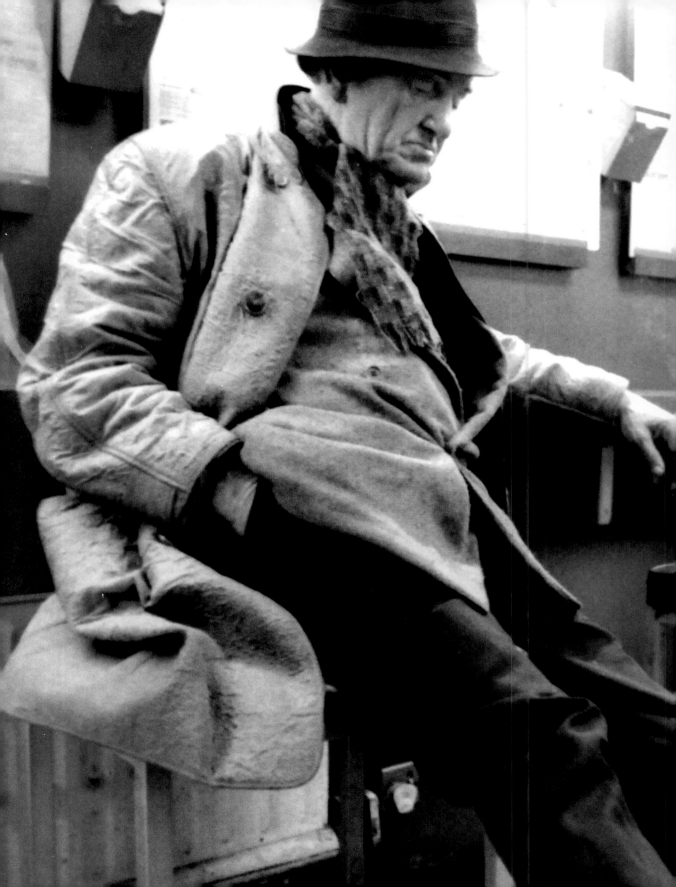

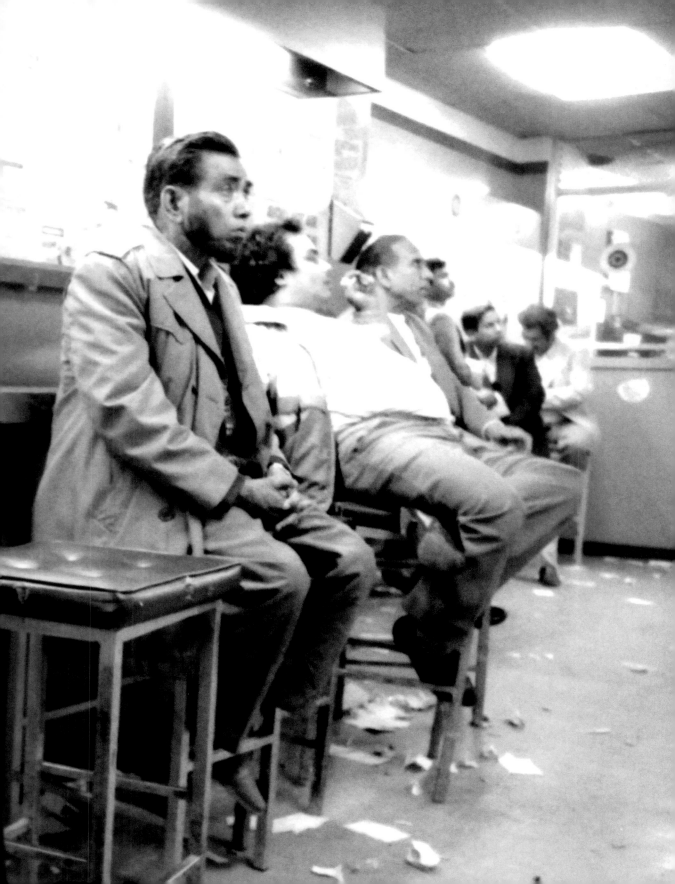

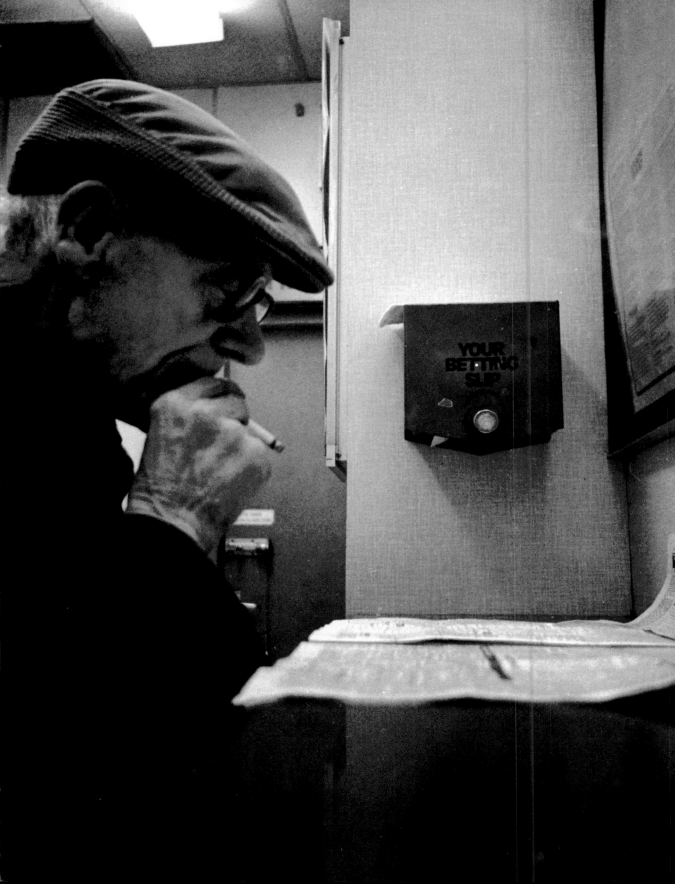

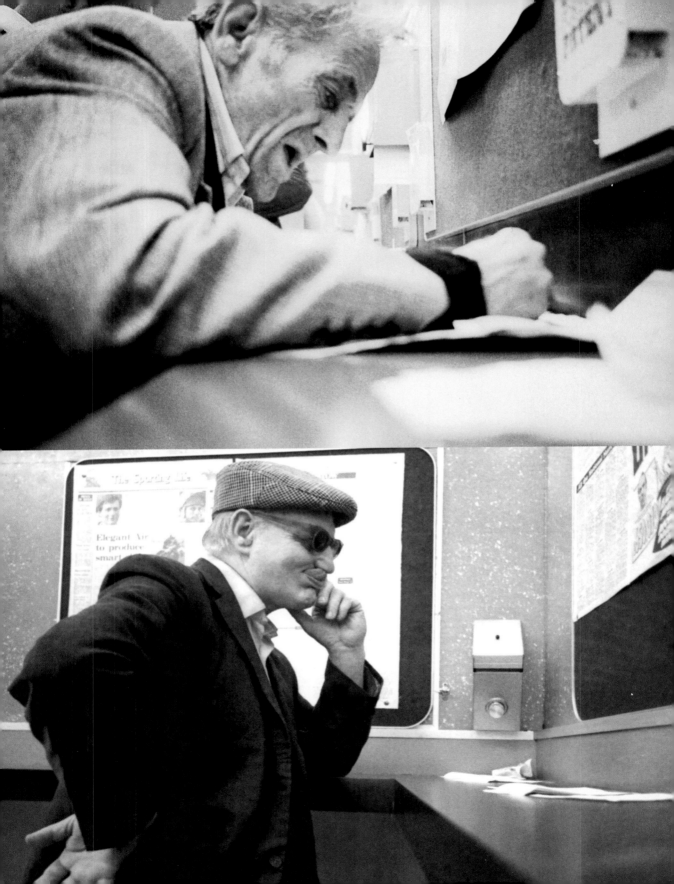

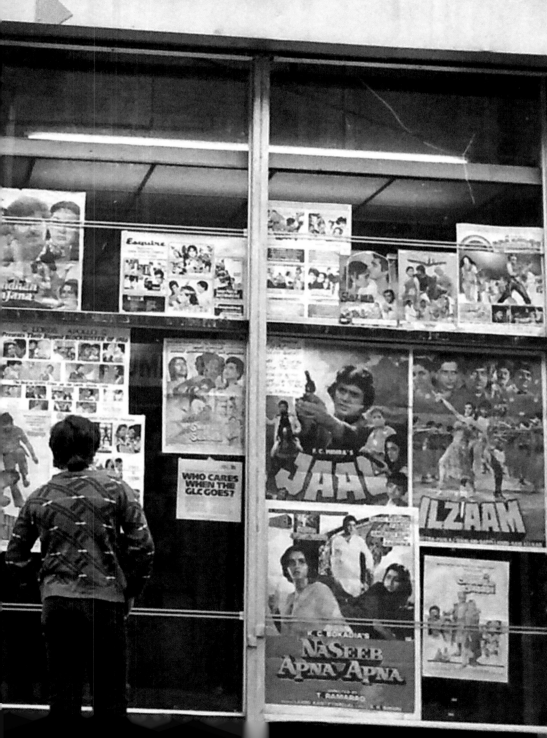

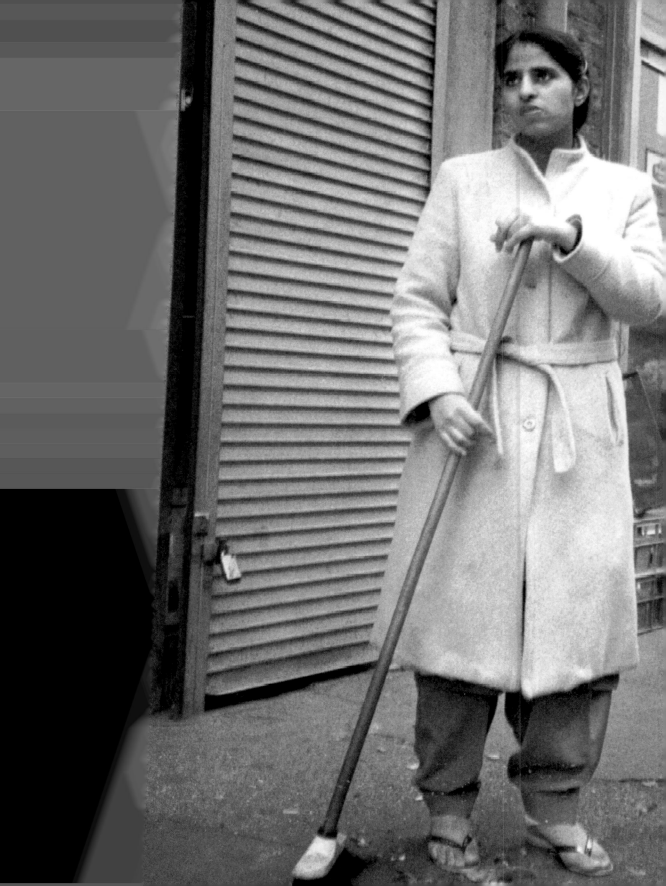

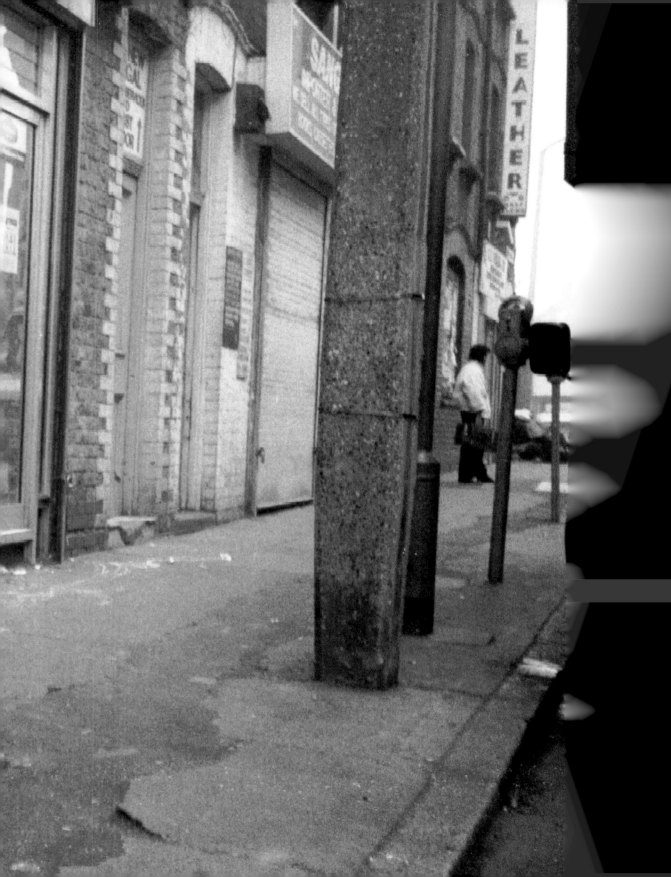

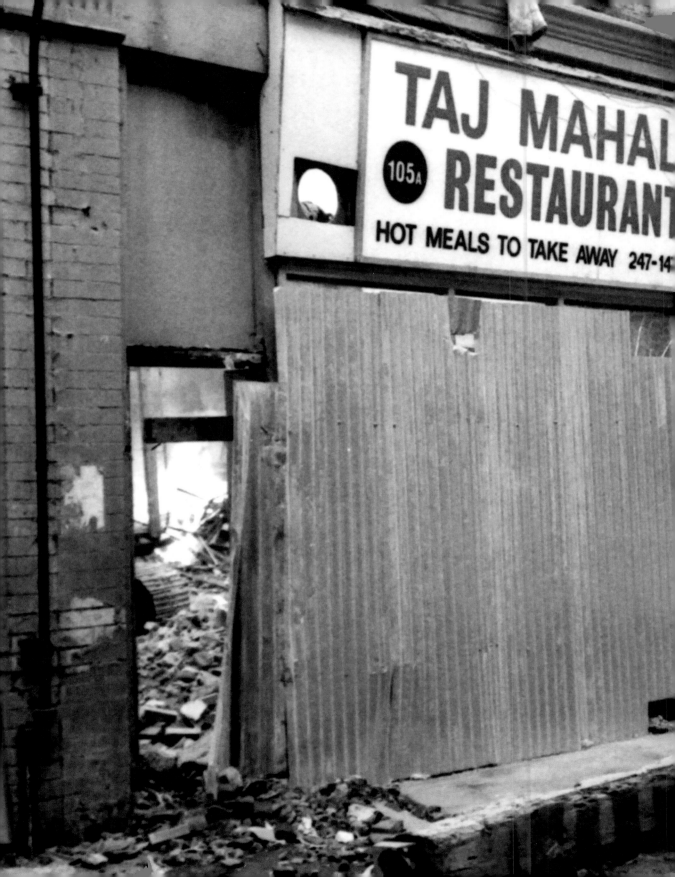

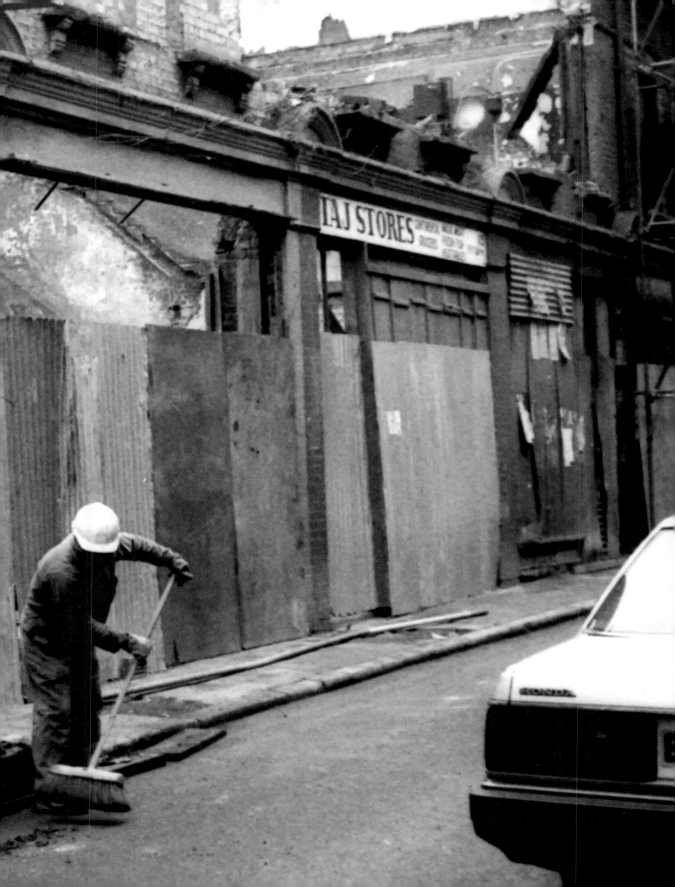

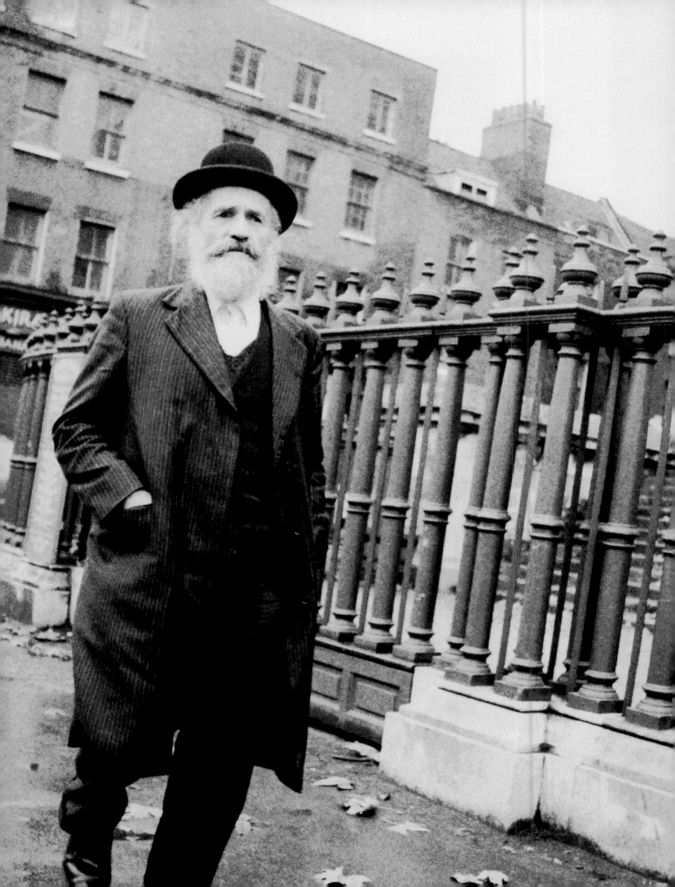

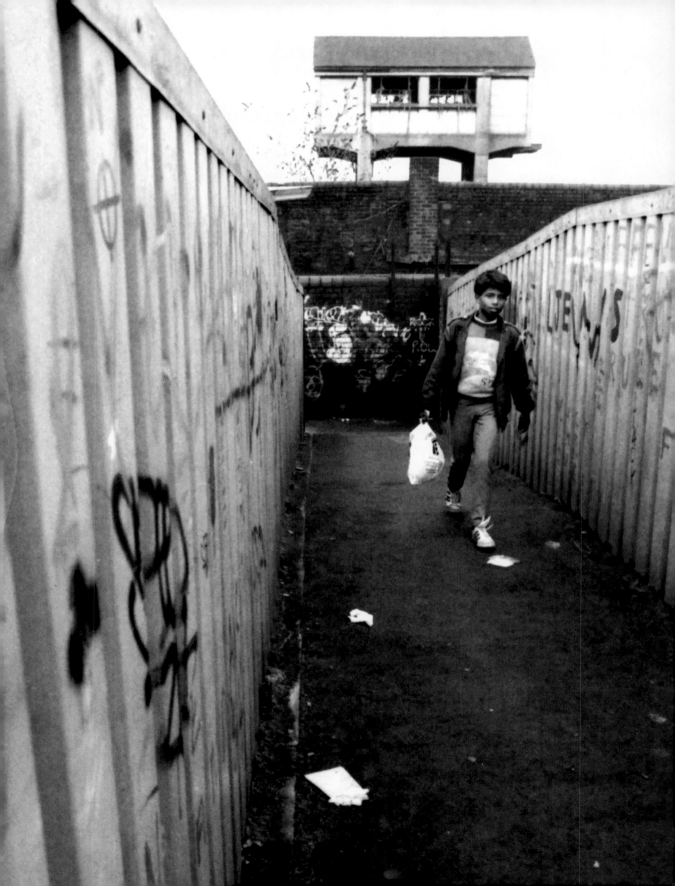

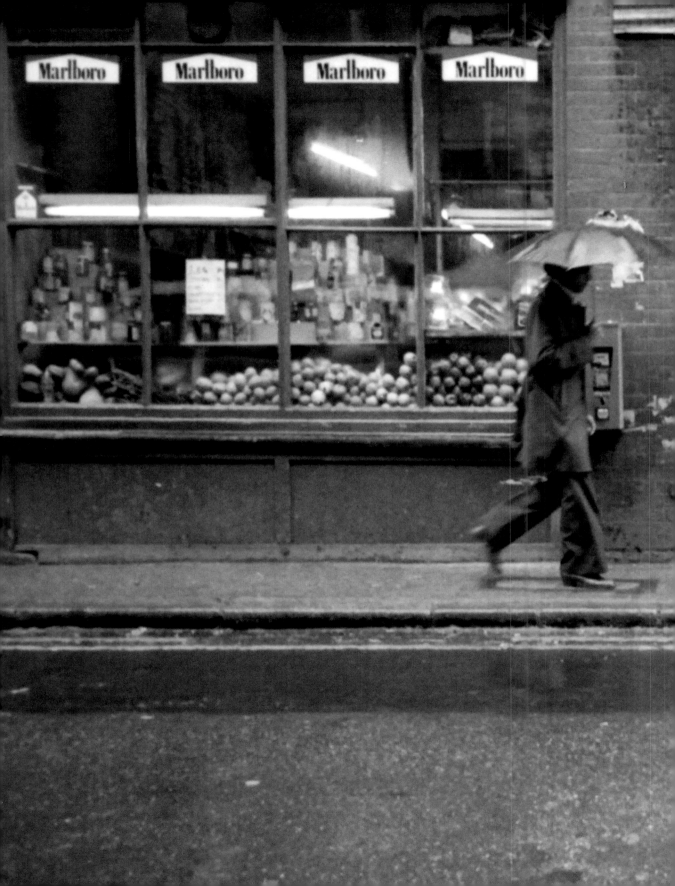

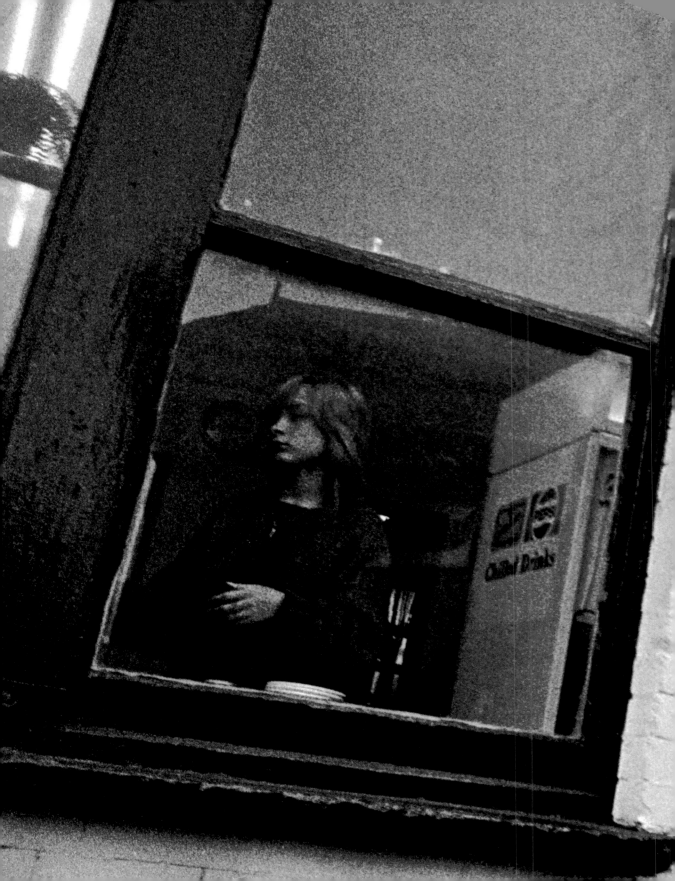

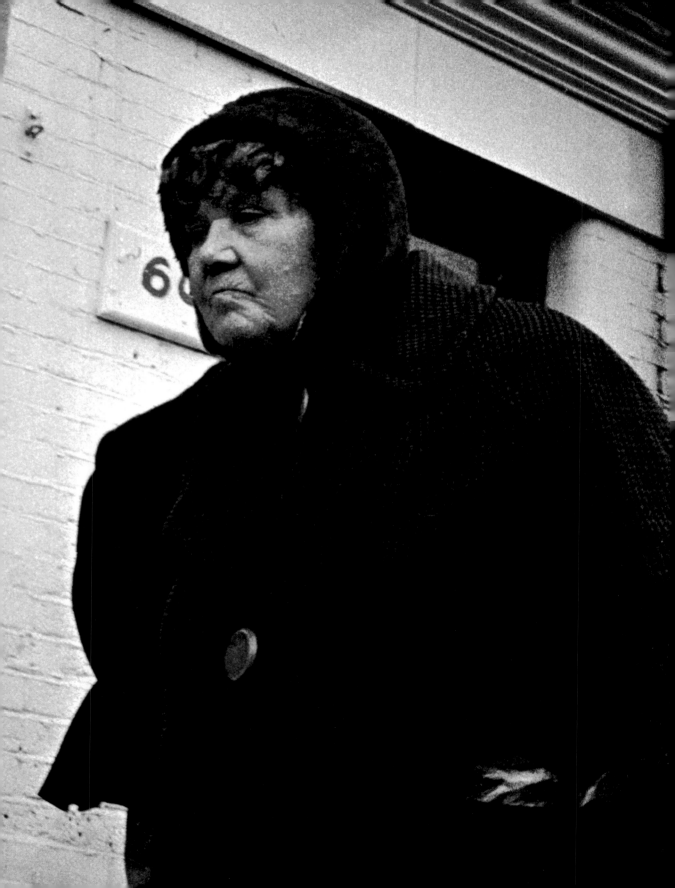

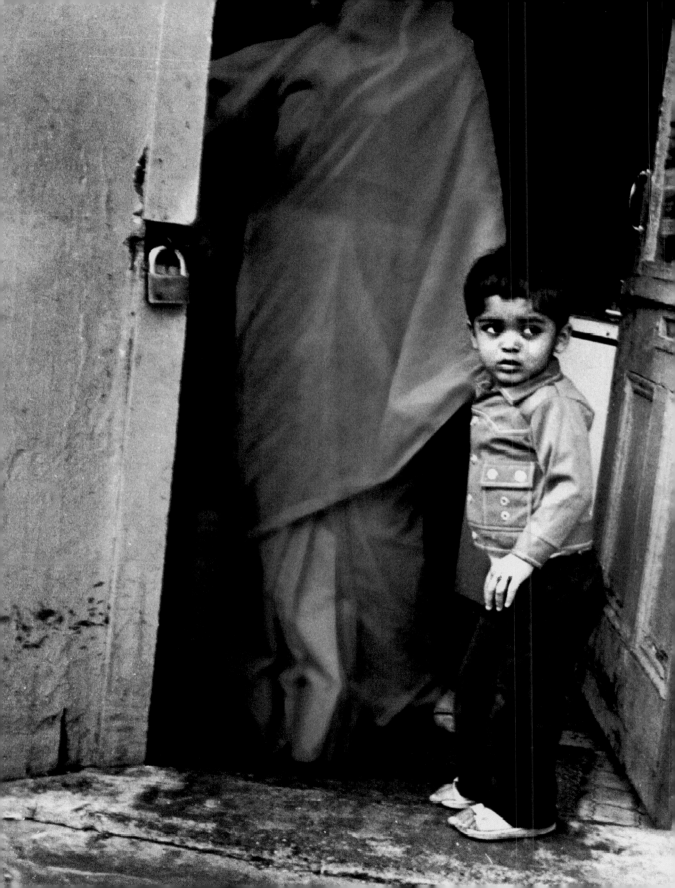

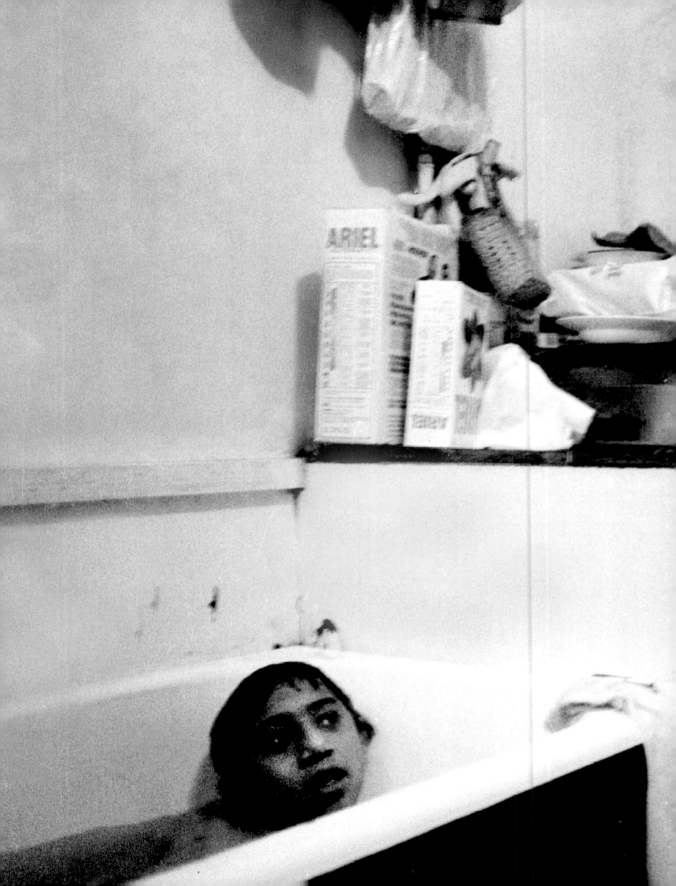

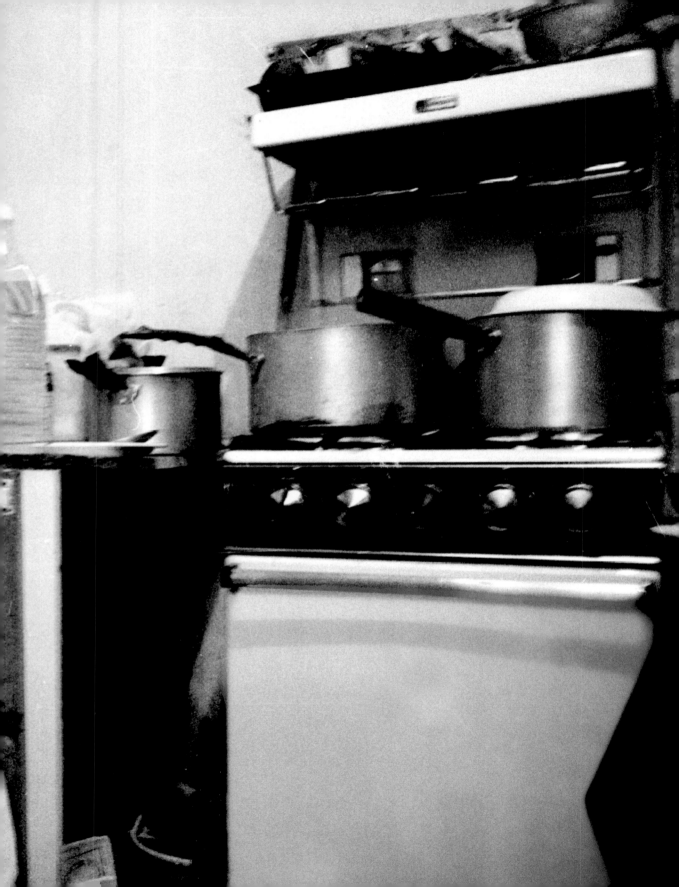

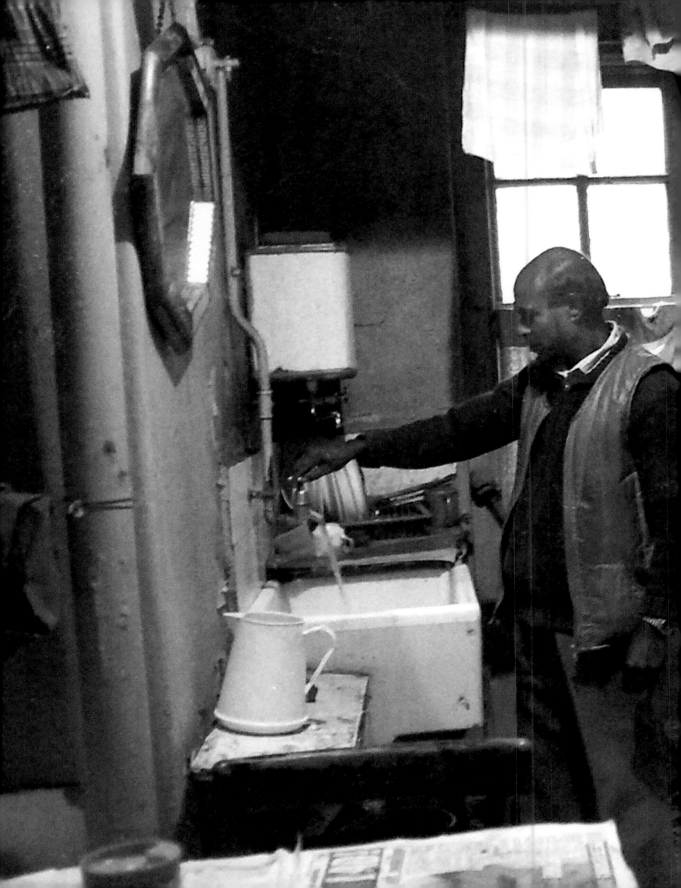

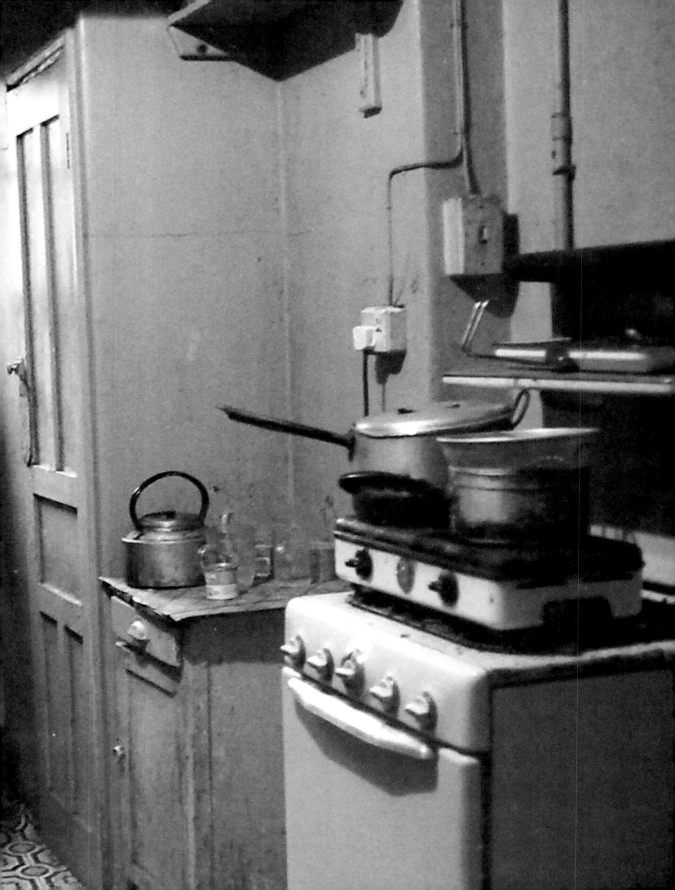

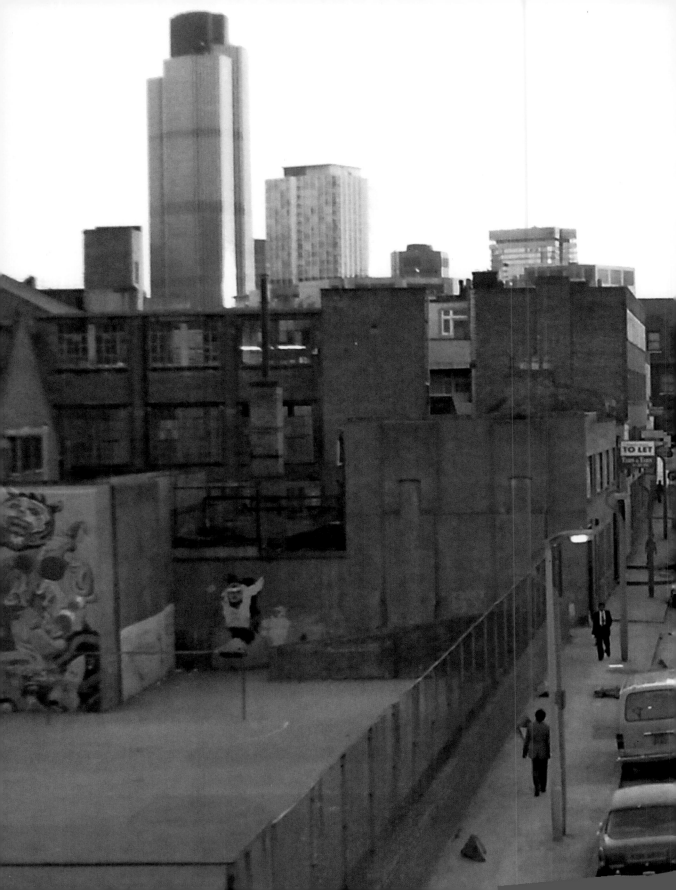

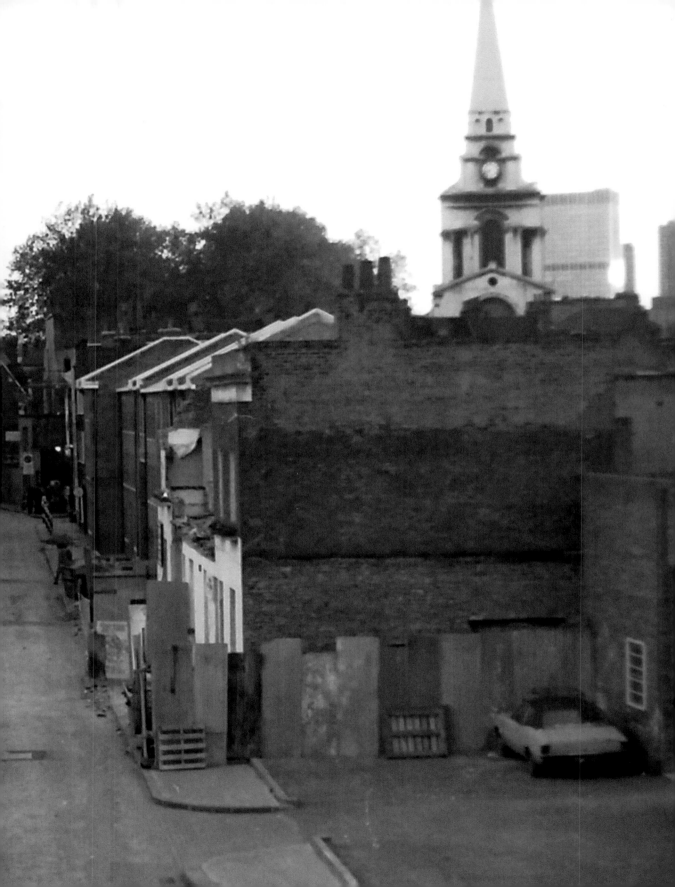

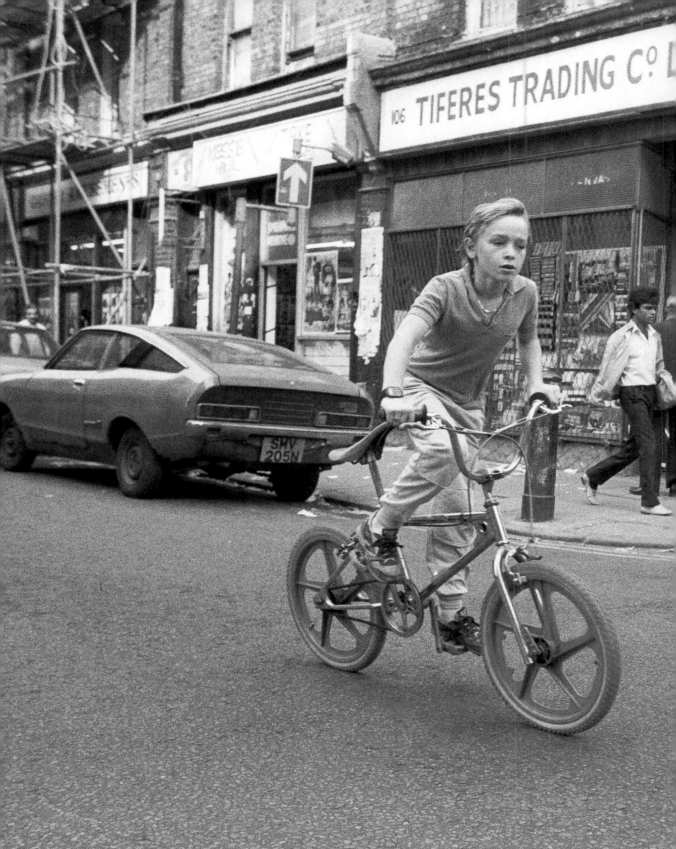

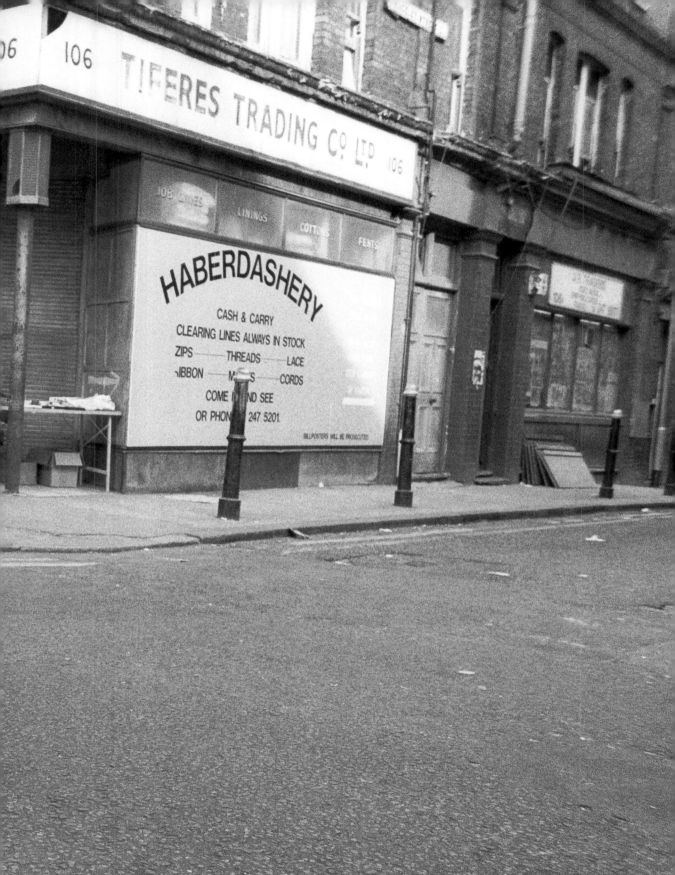

SOVA TRADING
CO
TEXTILES NYLON FABRICS
FENTS etc.

SOVA TRADING

73 B. WEIN

YMG 517T

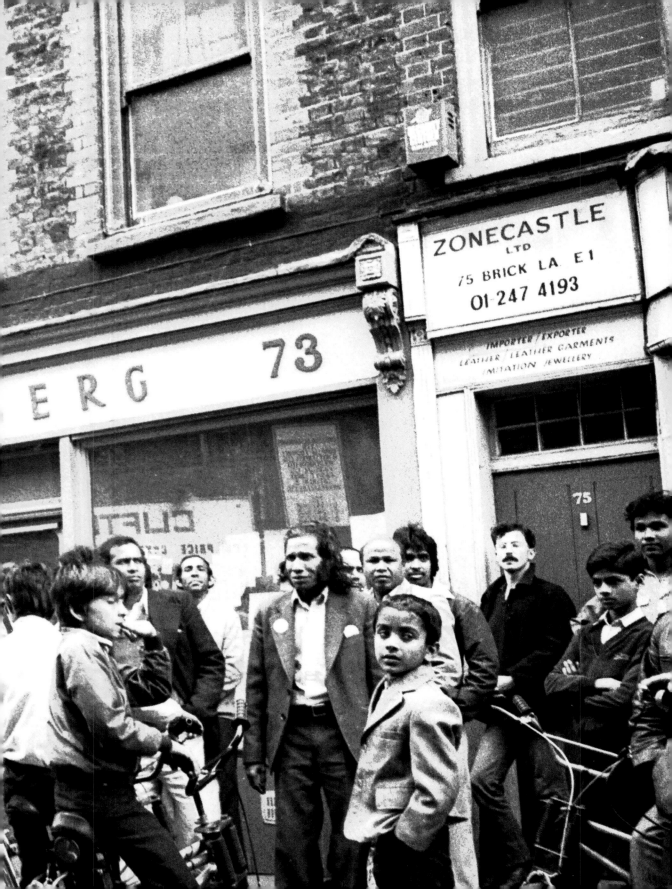

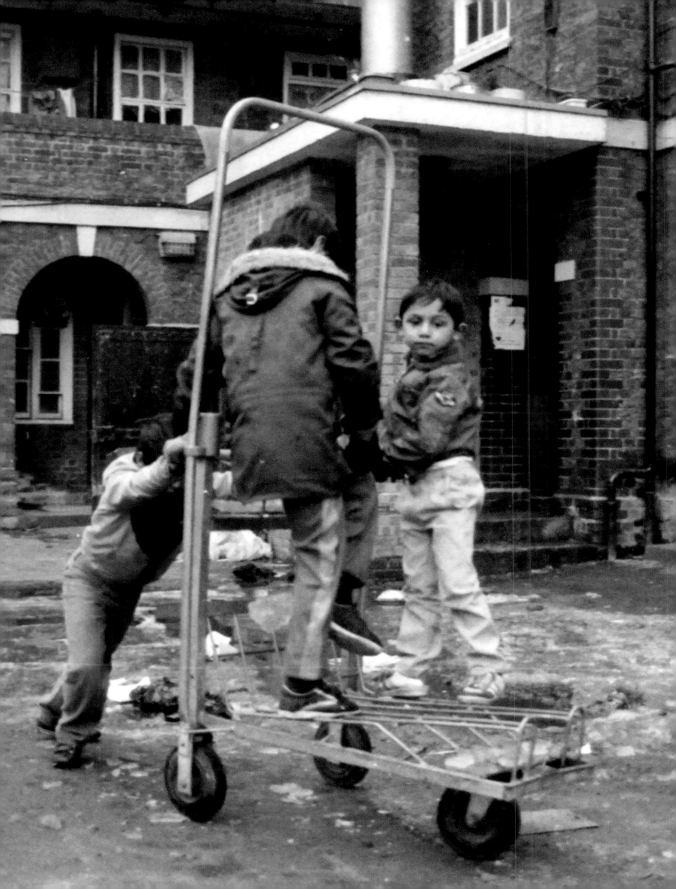

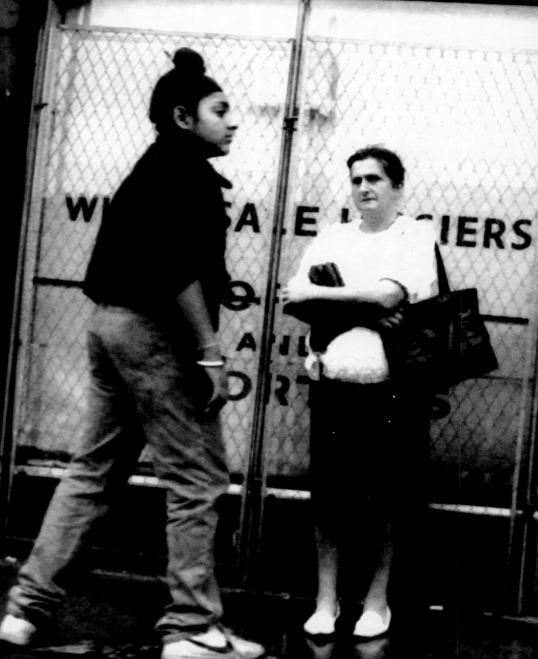

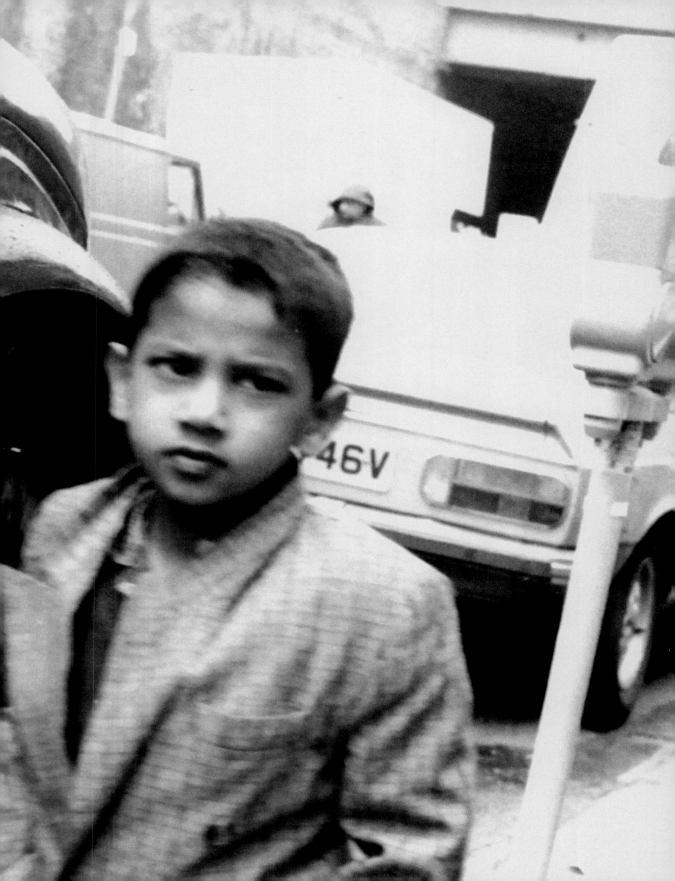

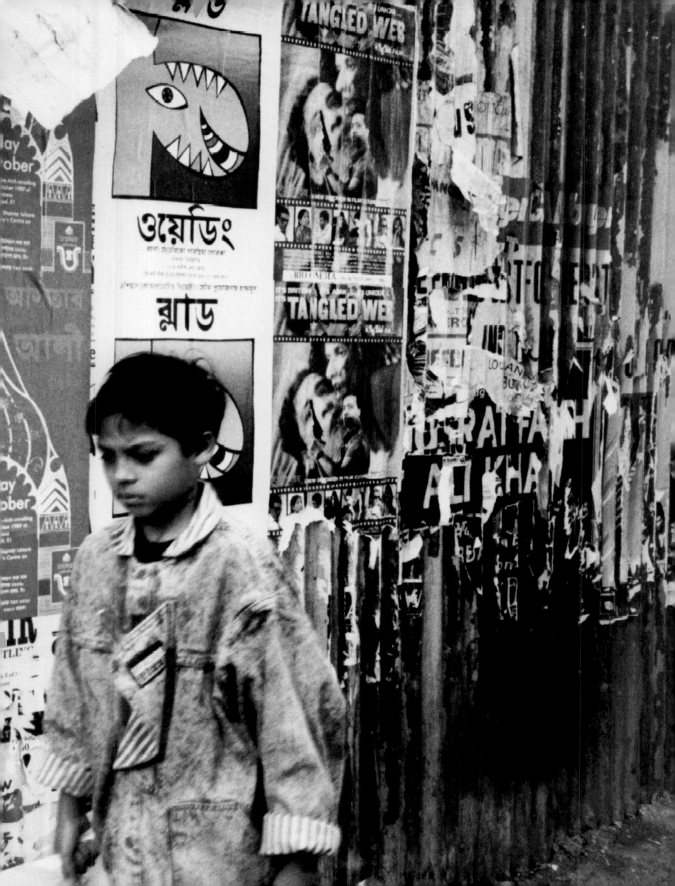

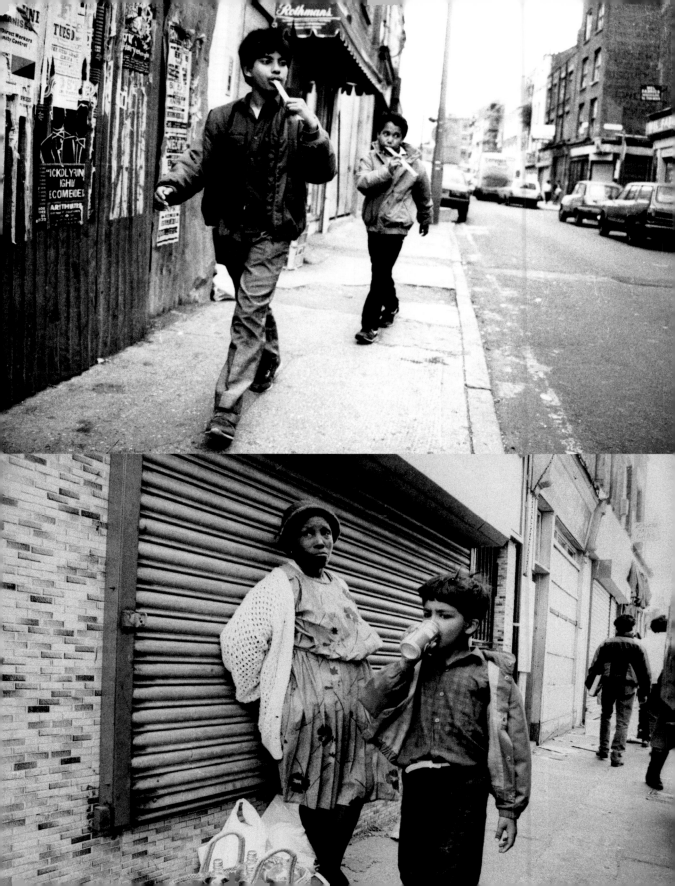

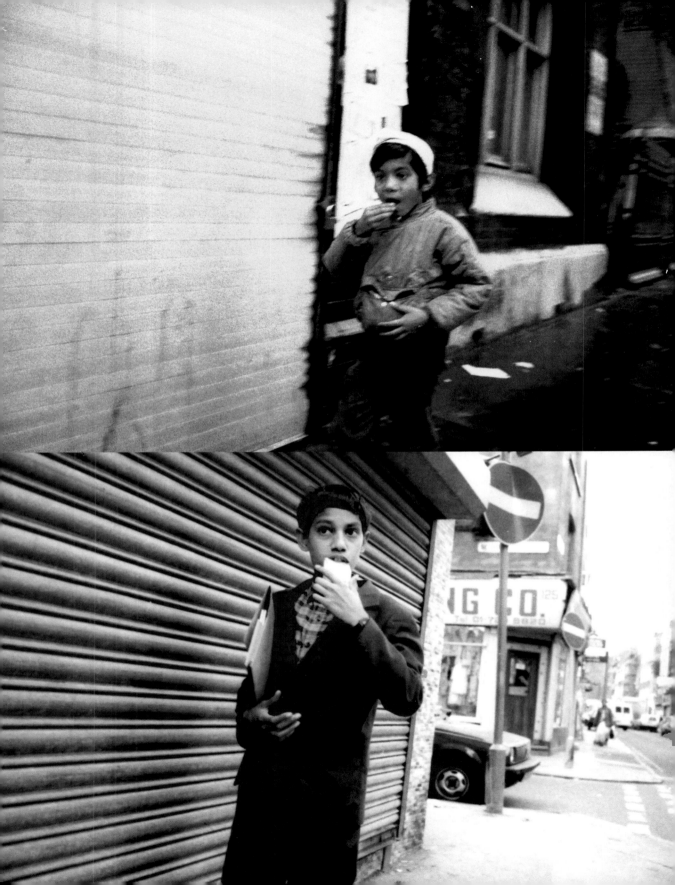

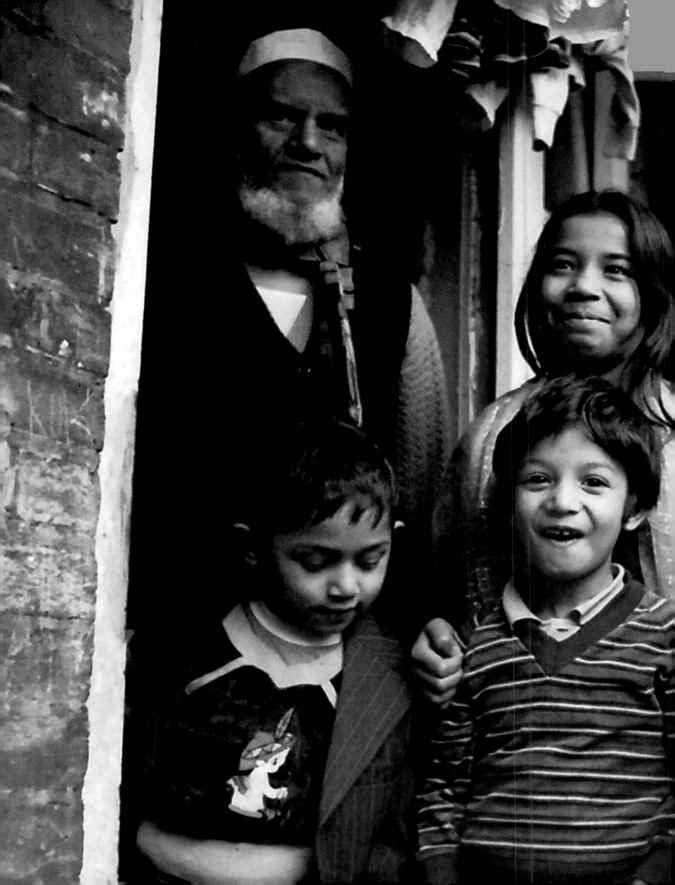

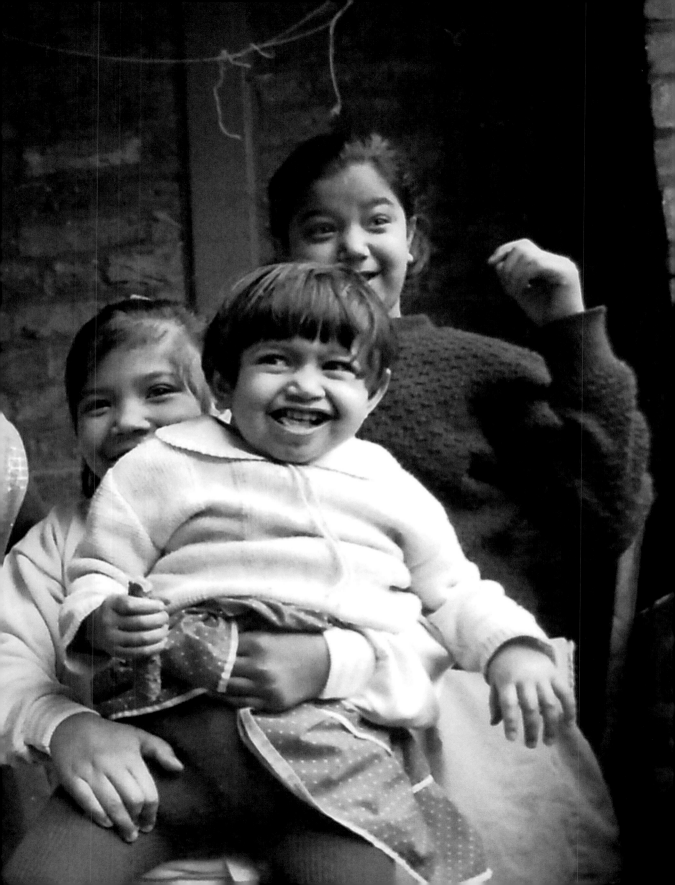

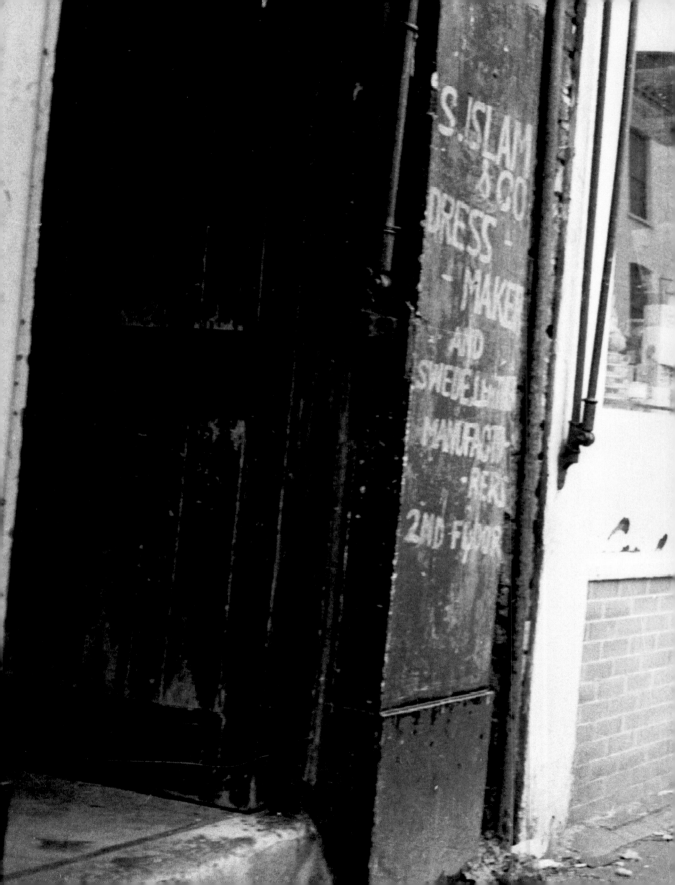

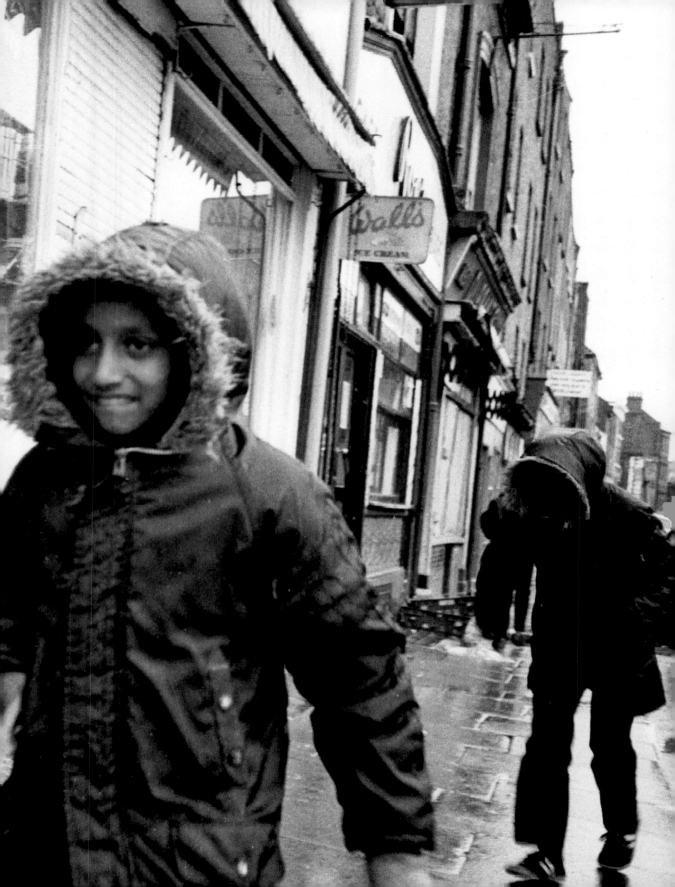

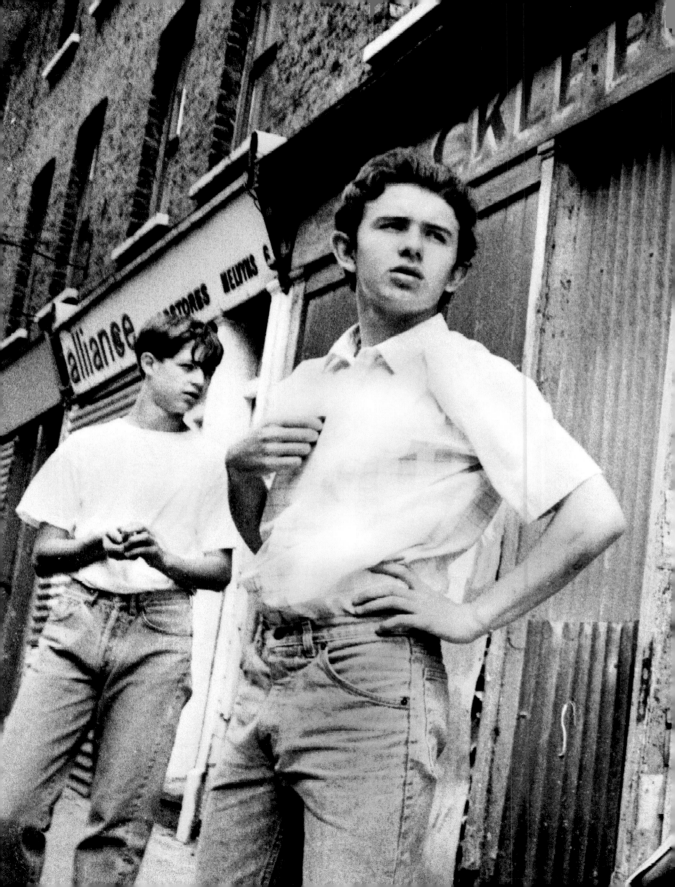

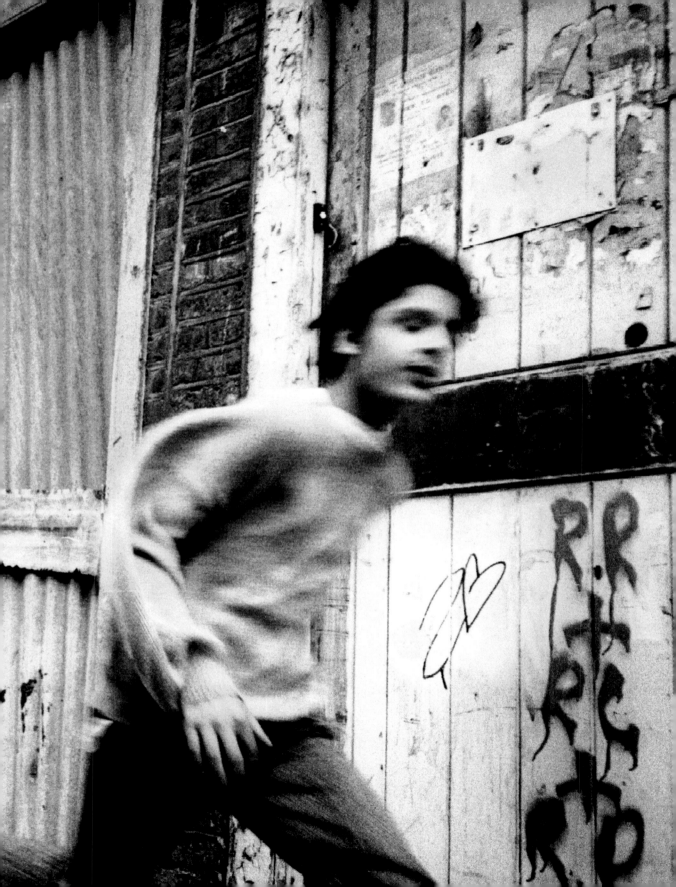

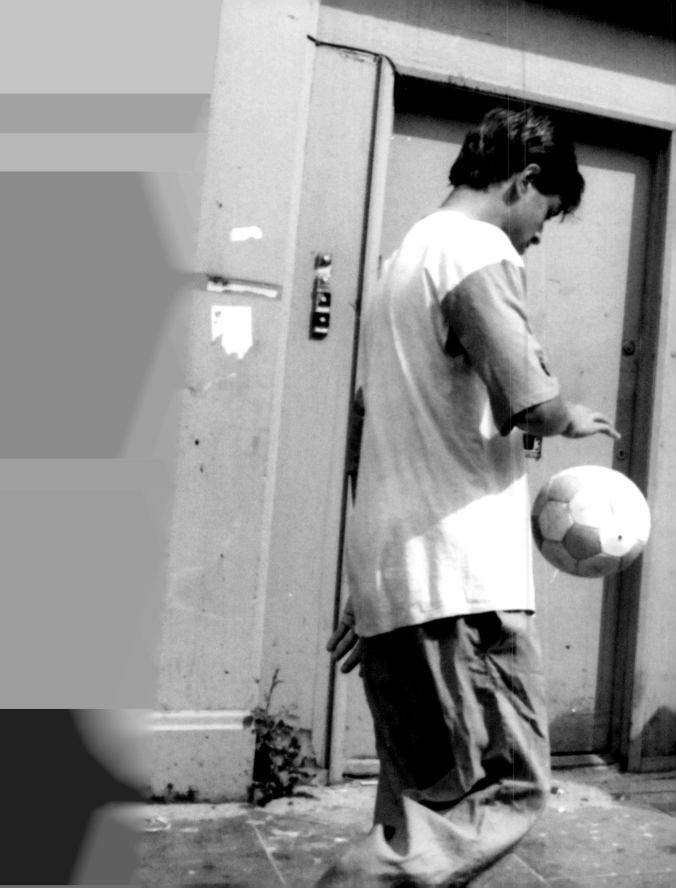

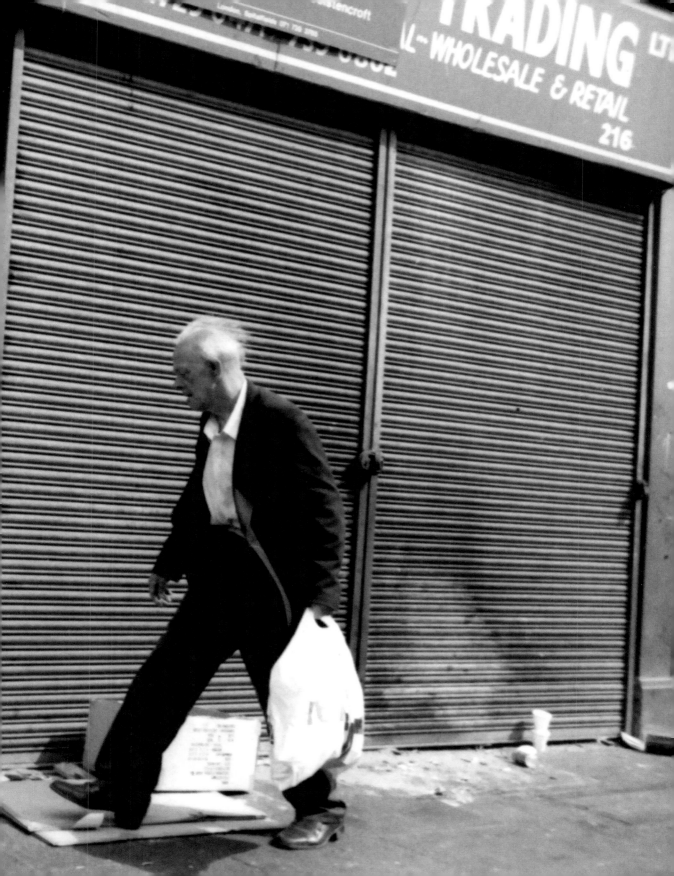

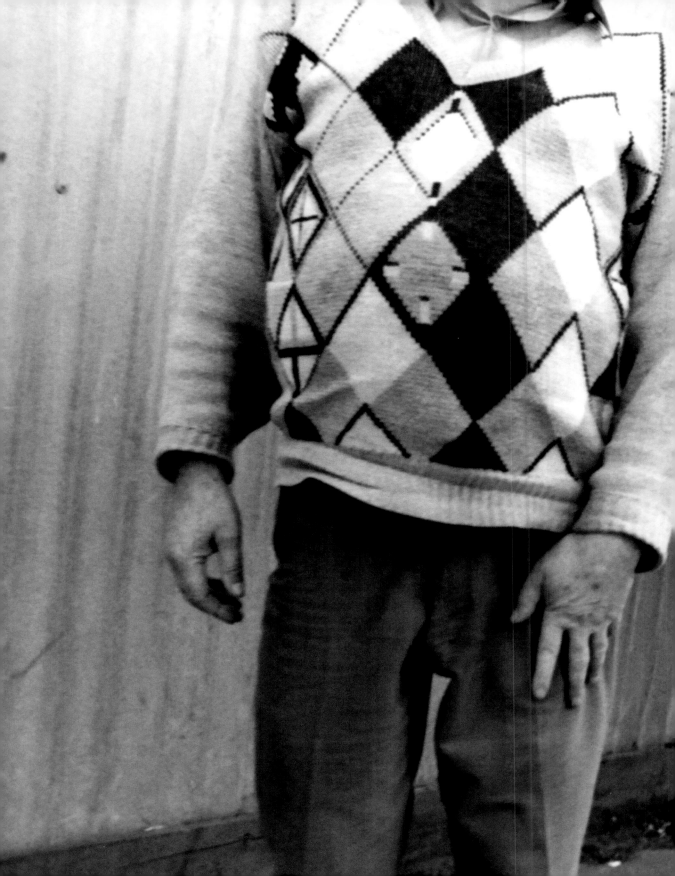

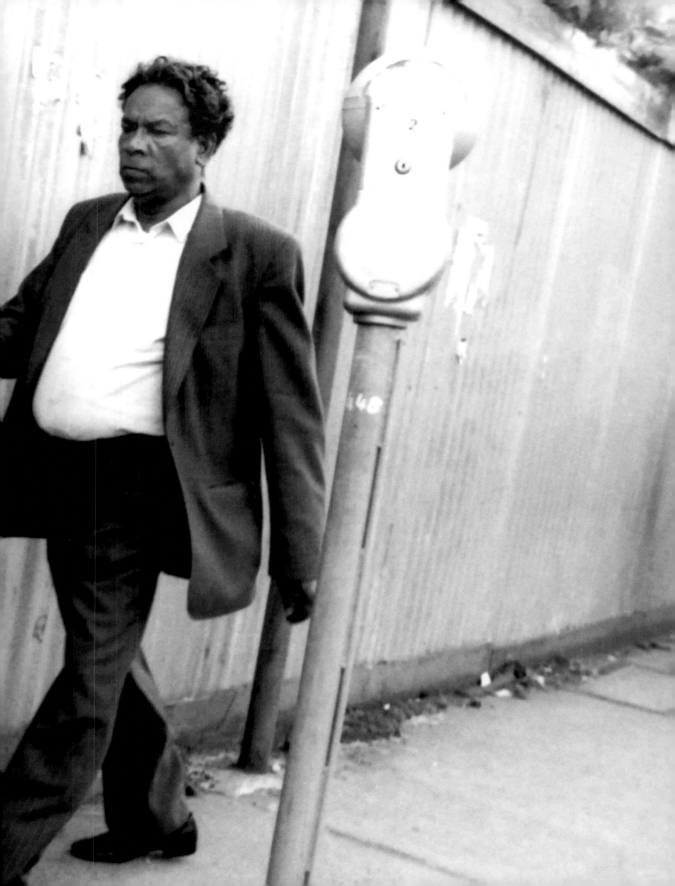

SE TUC/NUM

ALL OUT WITH THE MINERS

MARCH & RALLY
WEDNESDAY 27TH JUNE

ASSEMBLE TOWER HILL, EC3 1.00PM,
VIA FLEET ST. JUBILEE GDNS. 3.00PM.

DAY OF SOLIDARITY!

ALL OUT WITH THE MINERS

MARCH
WEDNESDAY 27TH
ASSEMBLE TOWER HILL, EC3 1
VIA FLEET ST. JUBILEE GDNS.

DAY OF SOLIDARITY!

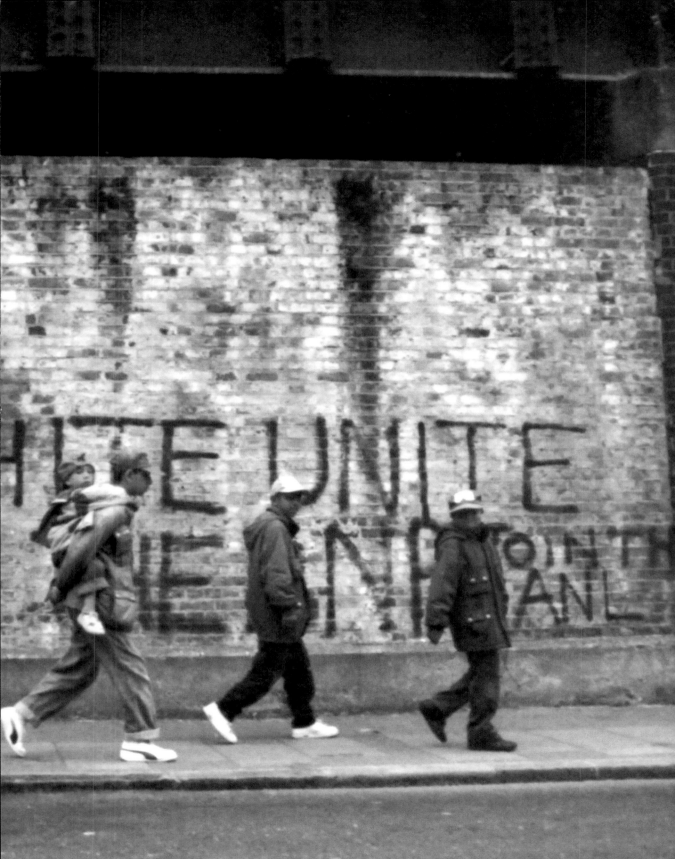

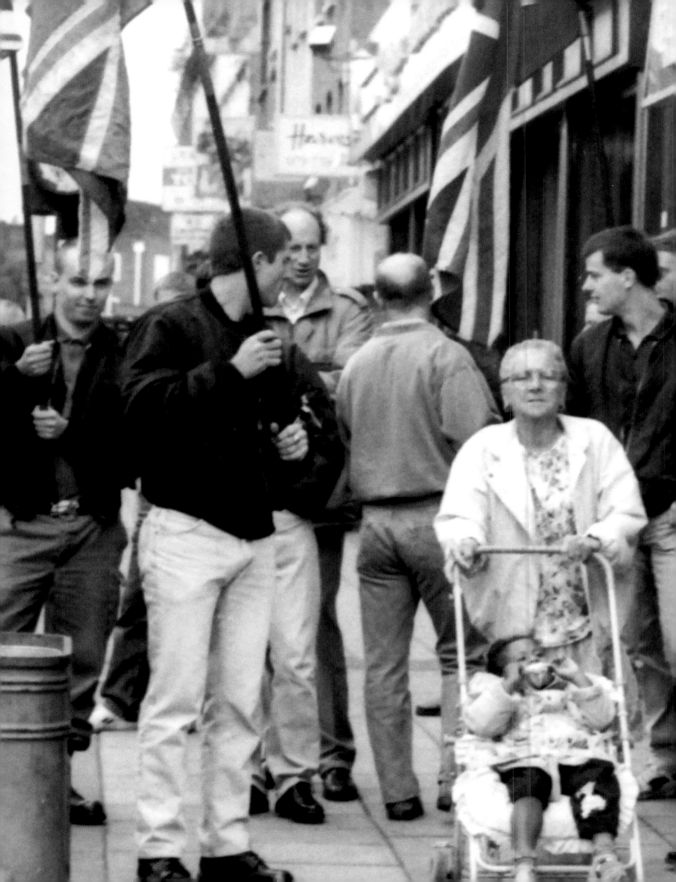

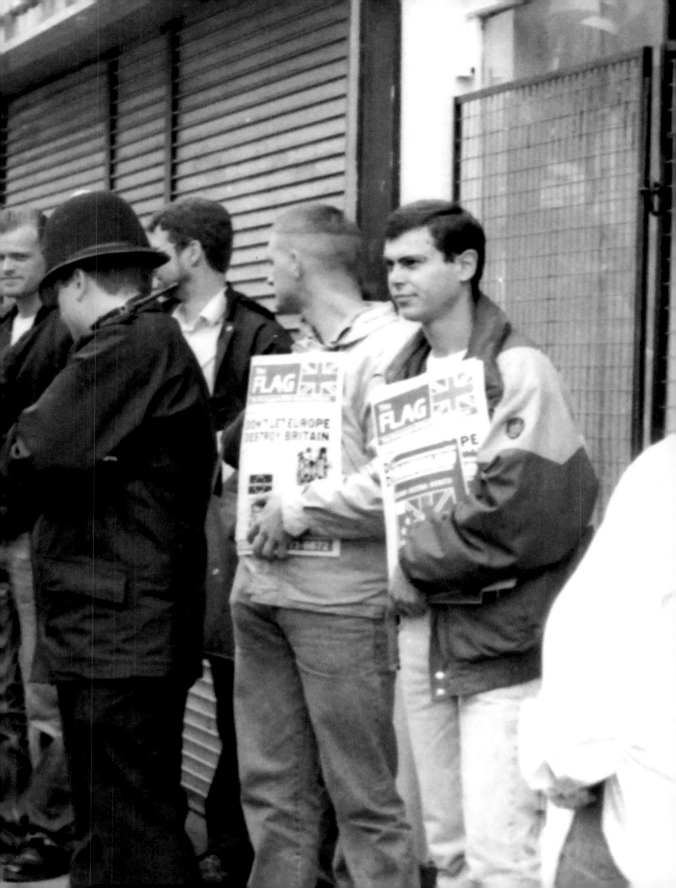

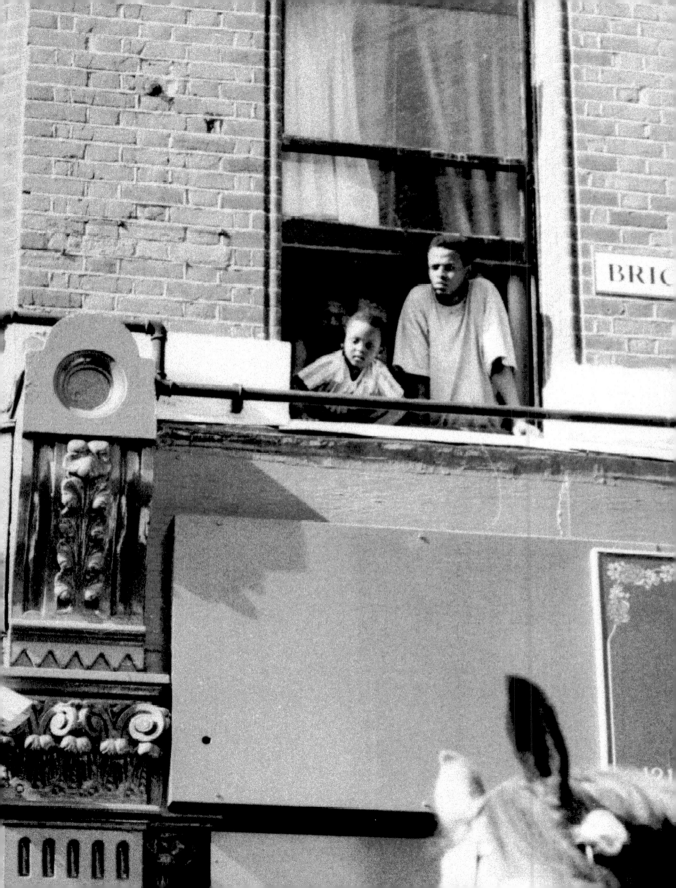

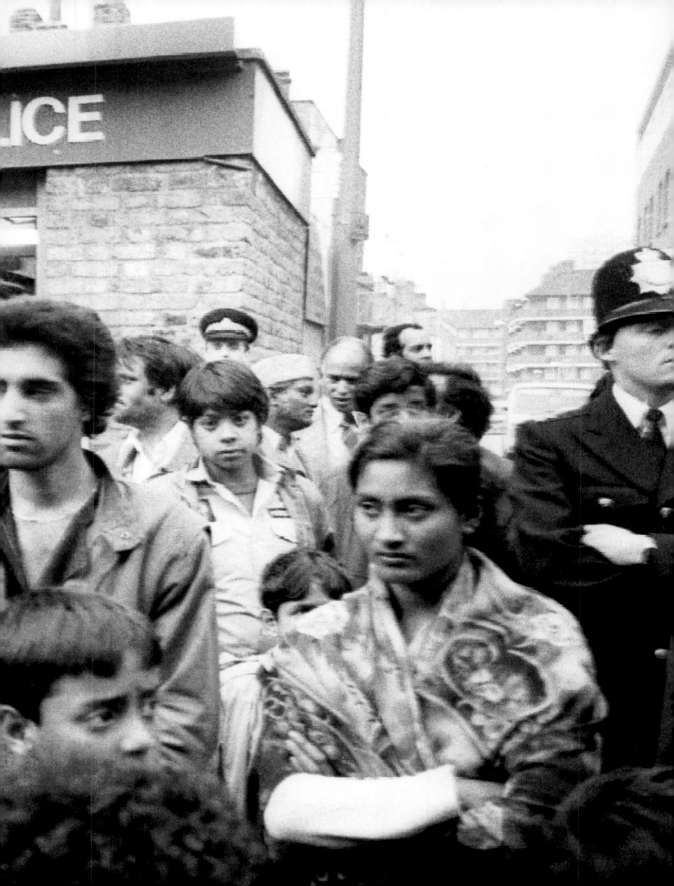

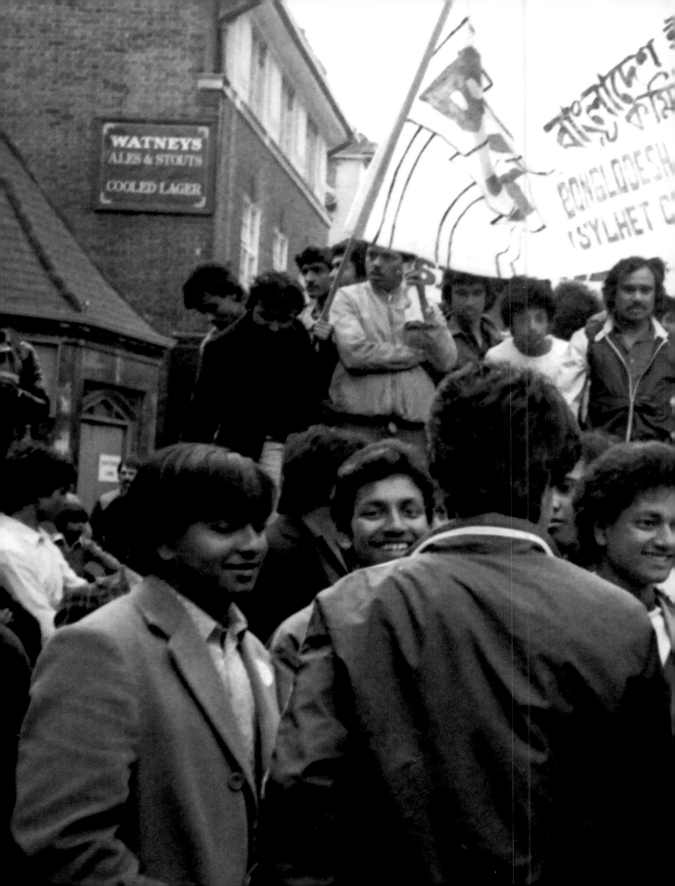

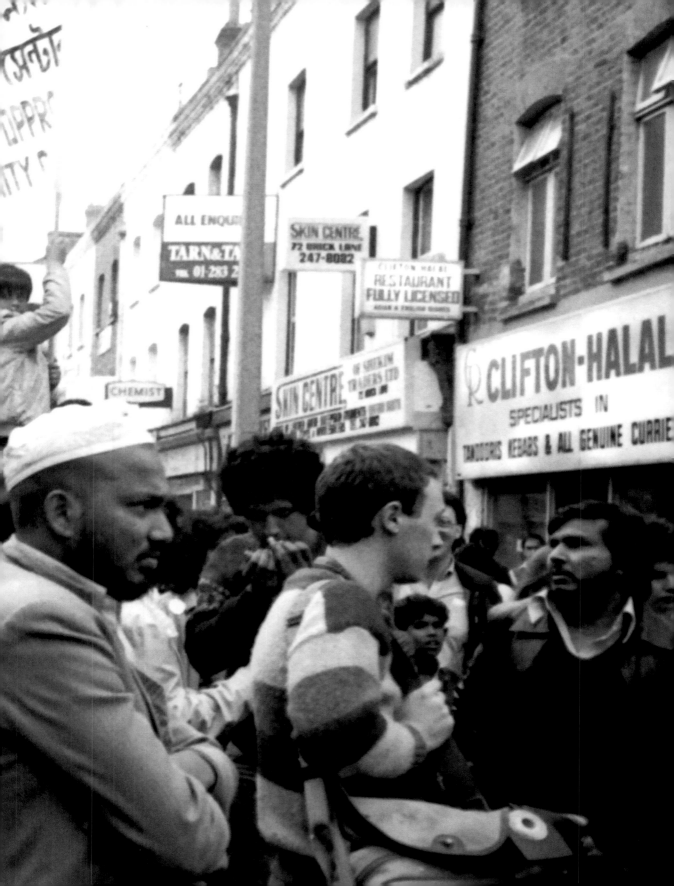

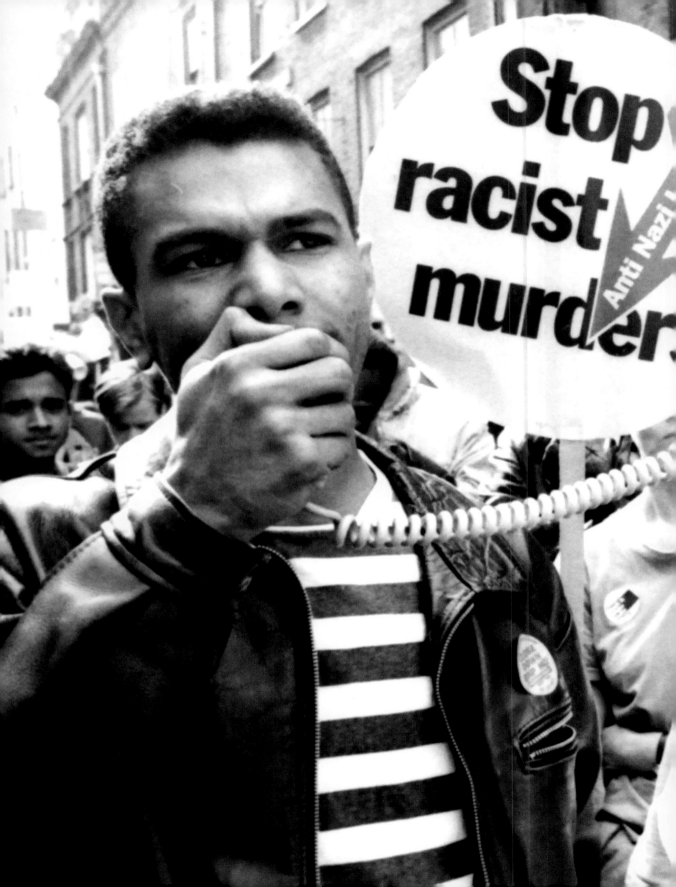

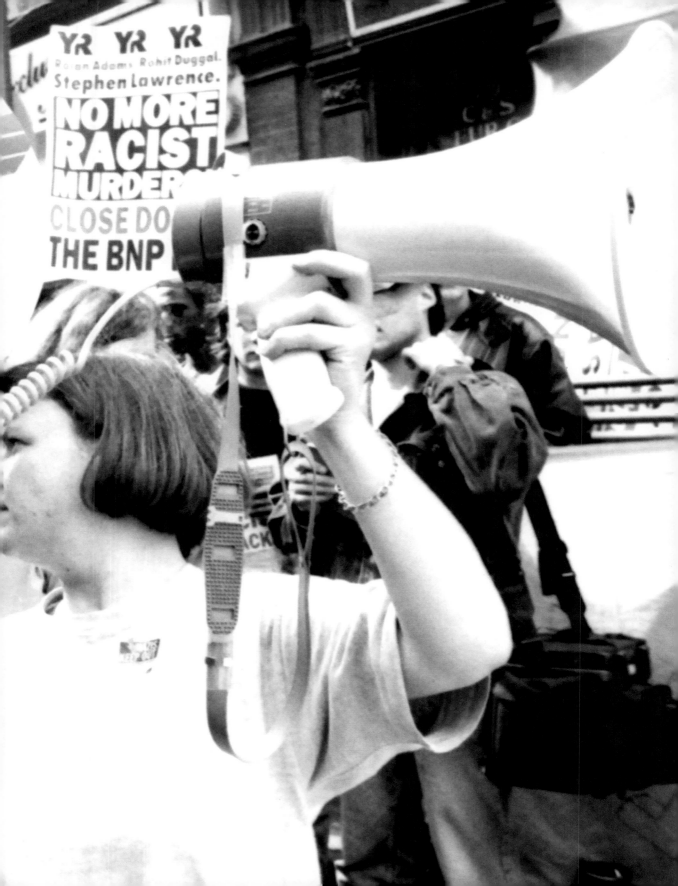

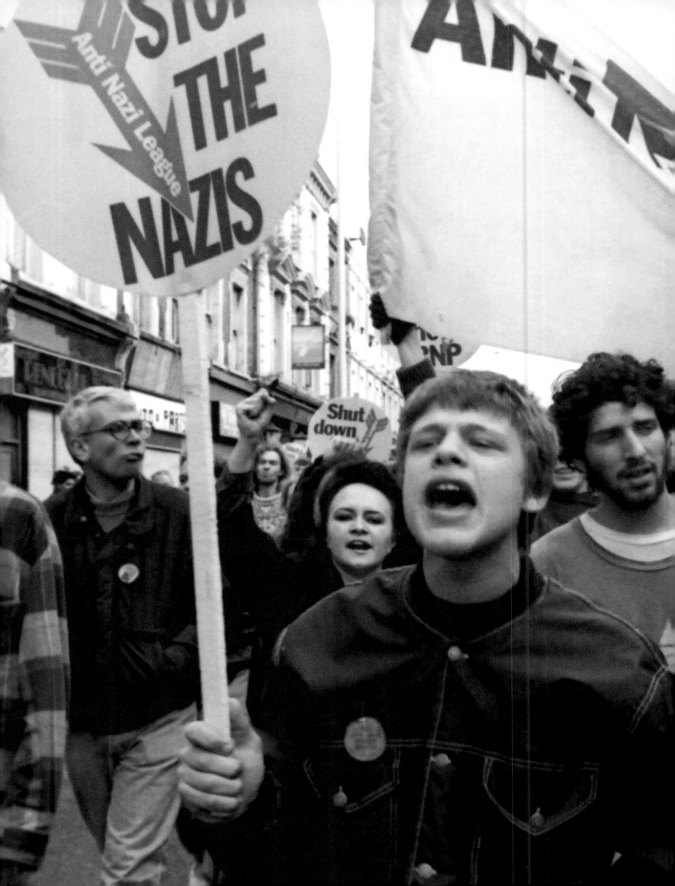

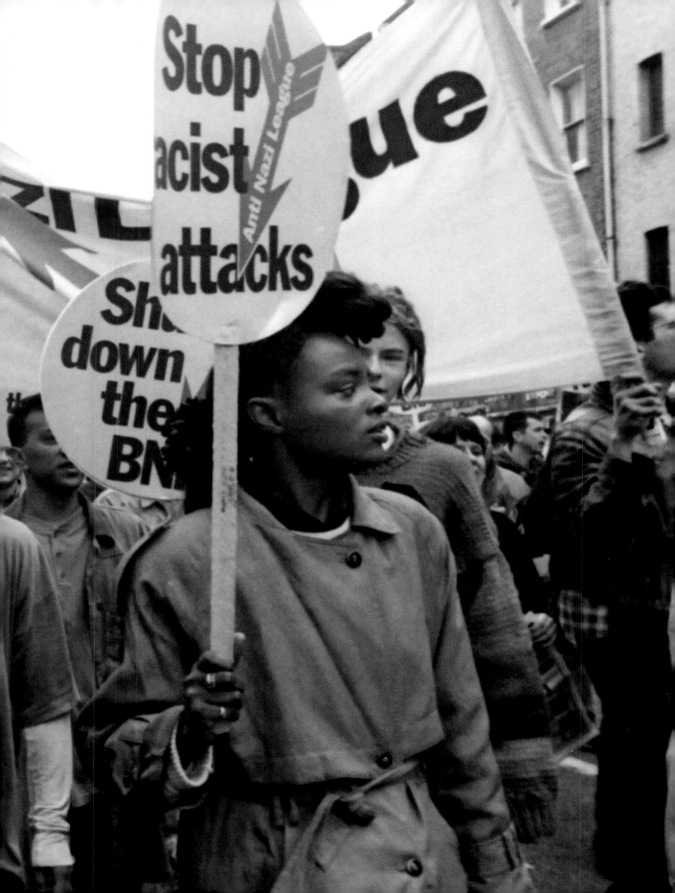

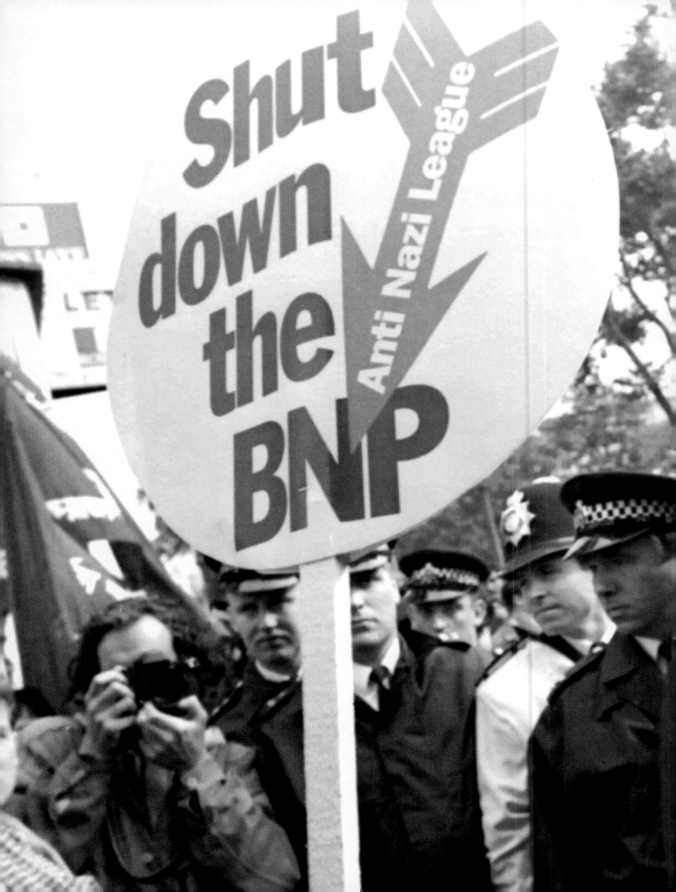

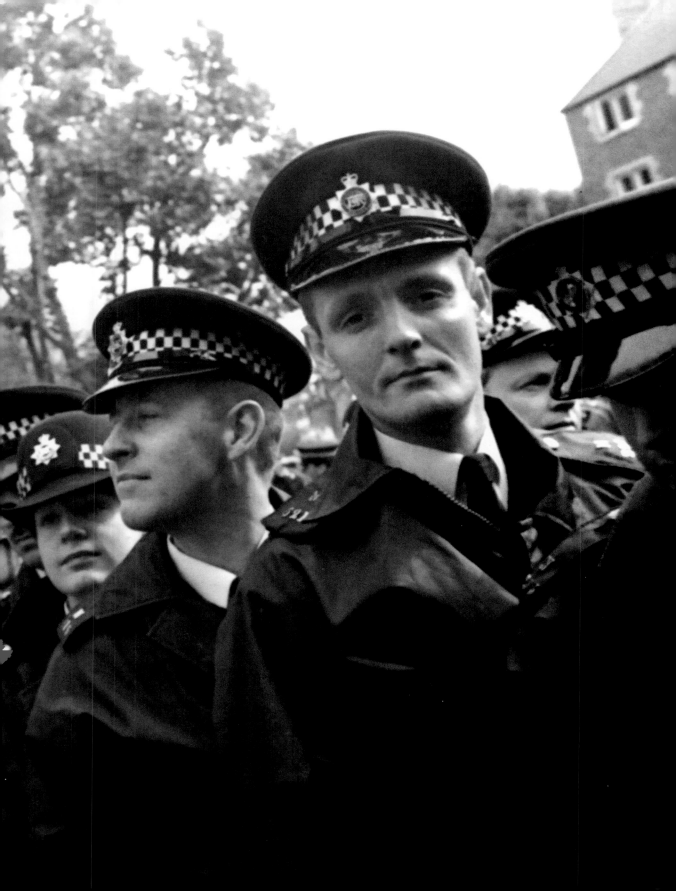

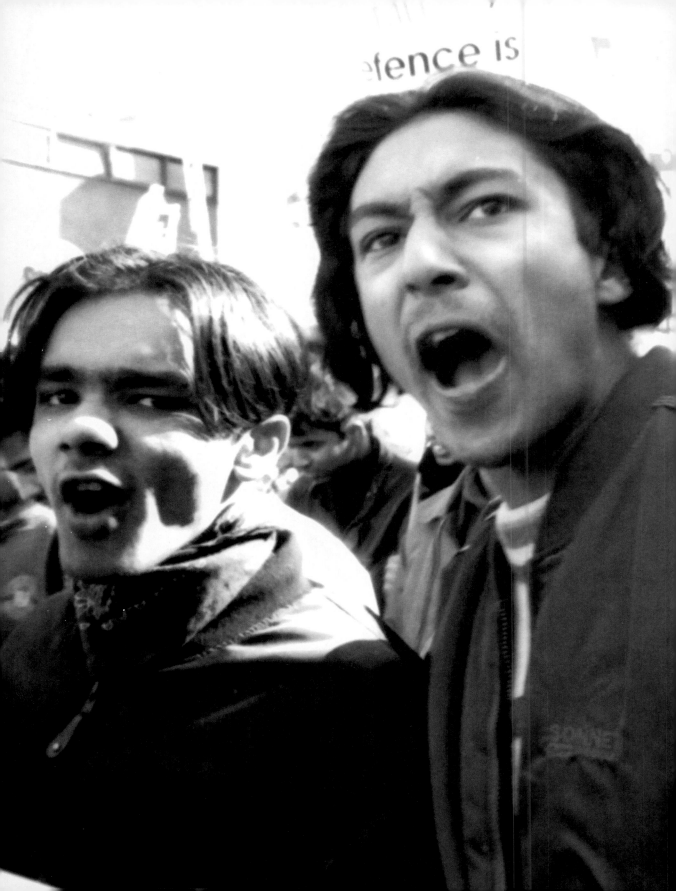

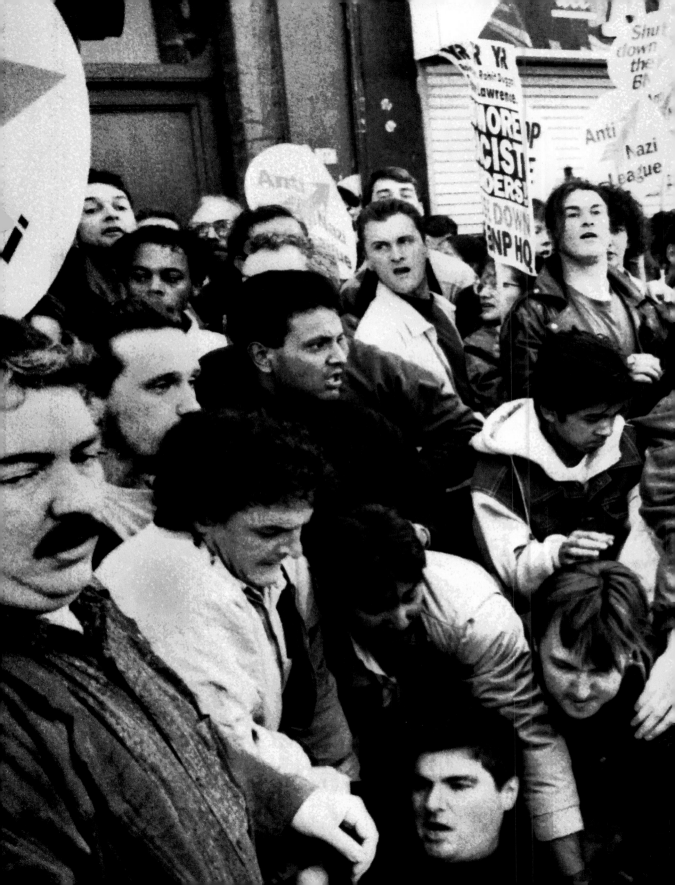

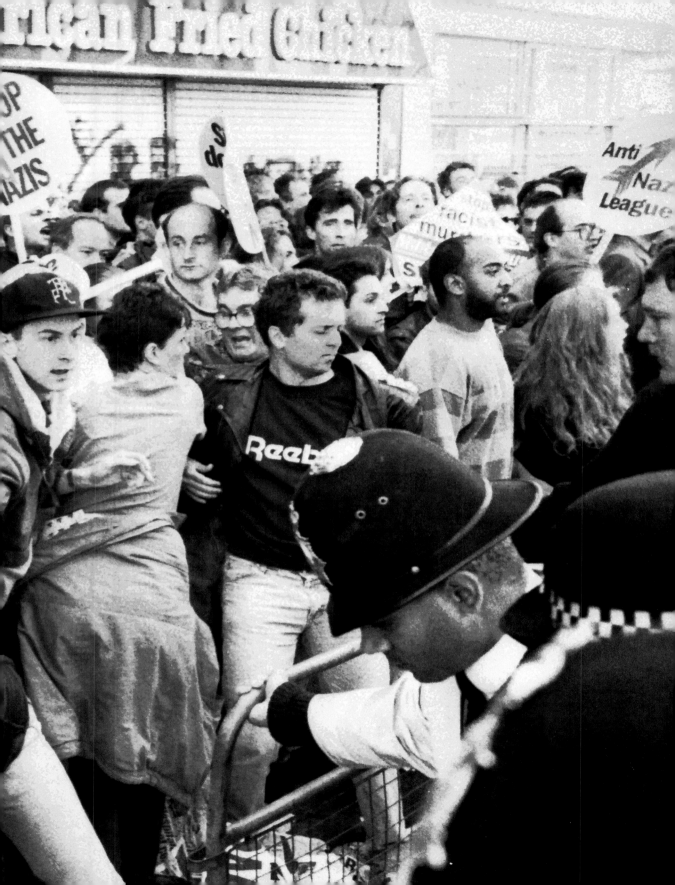

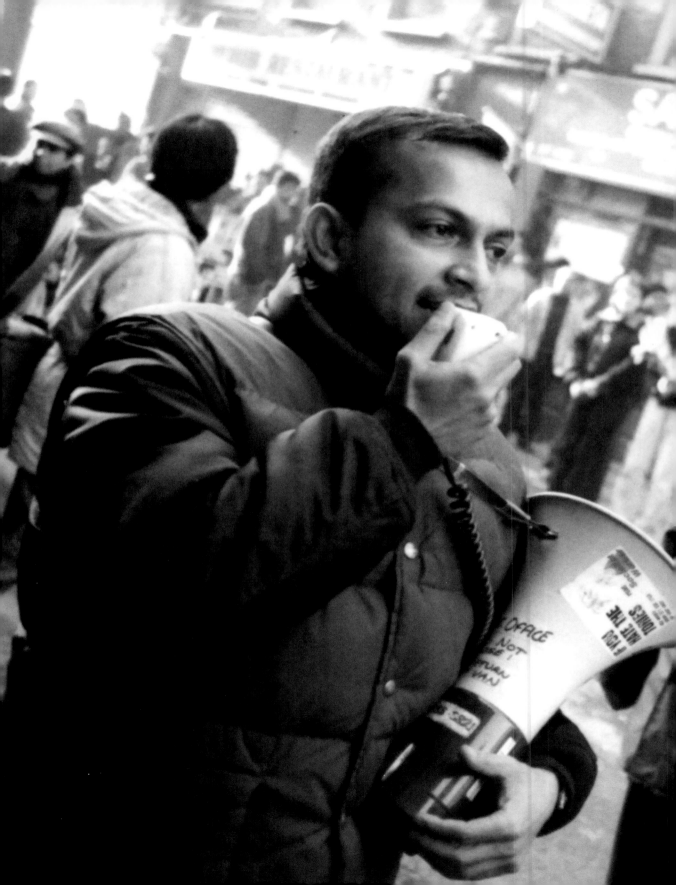

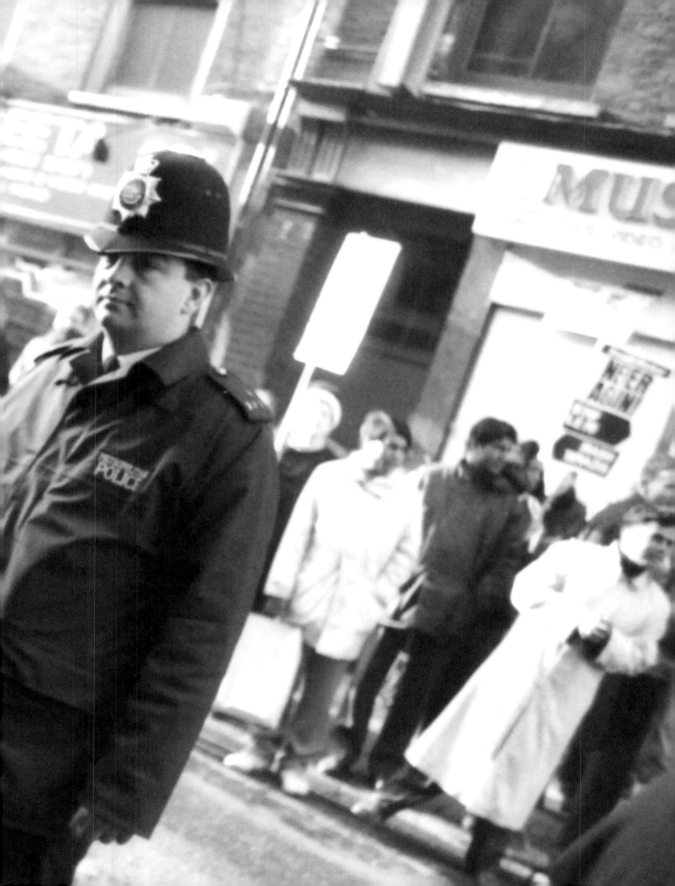

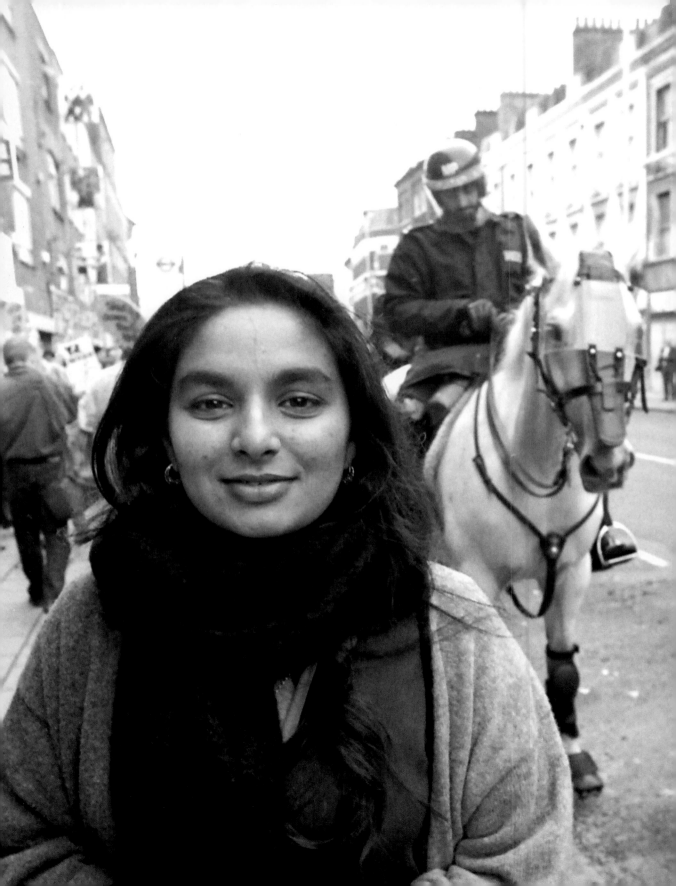

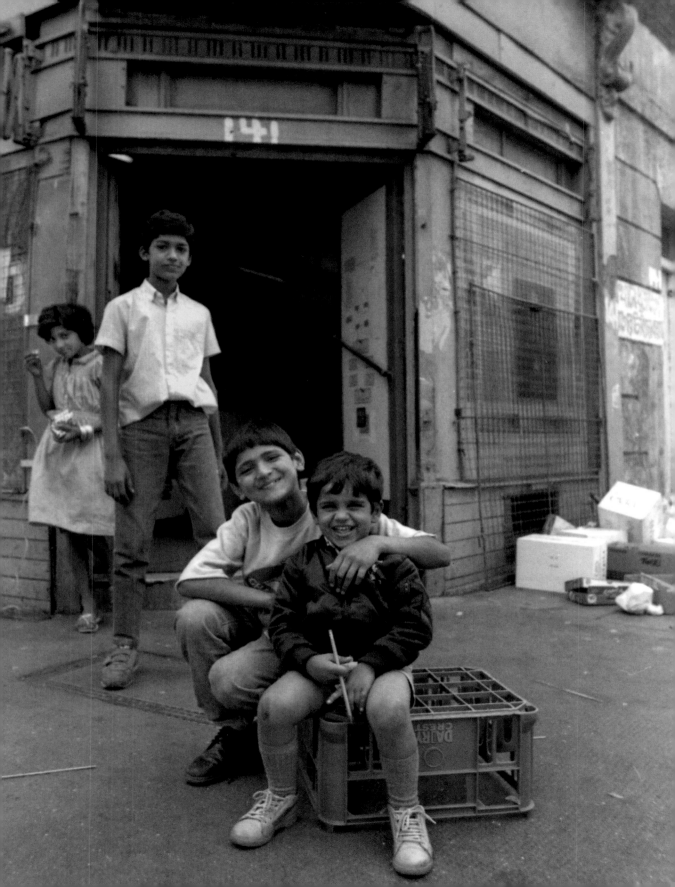

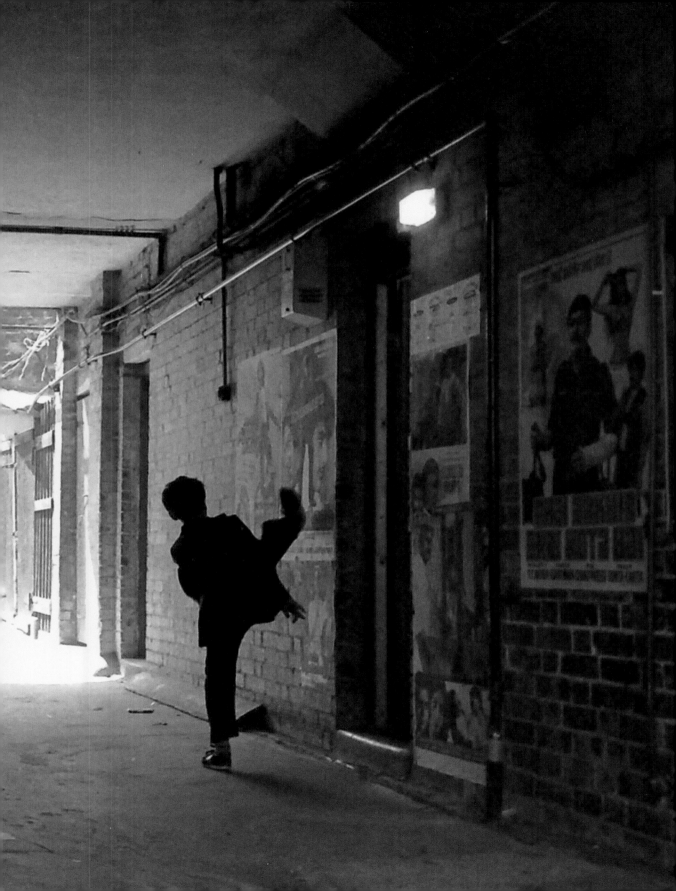

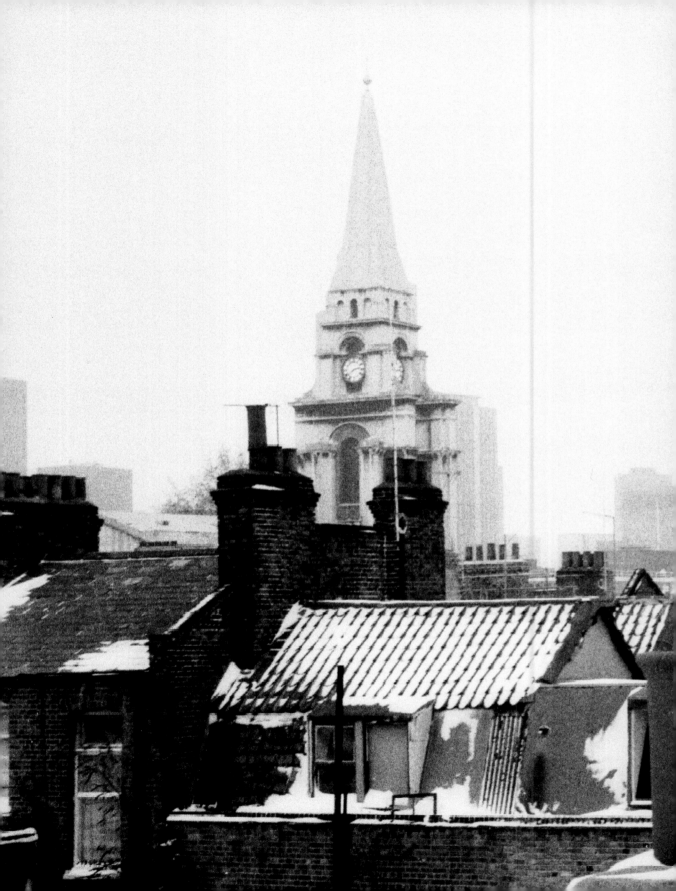

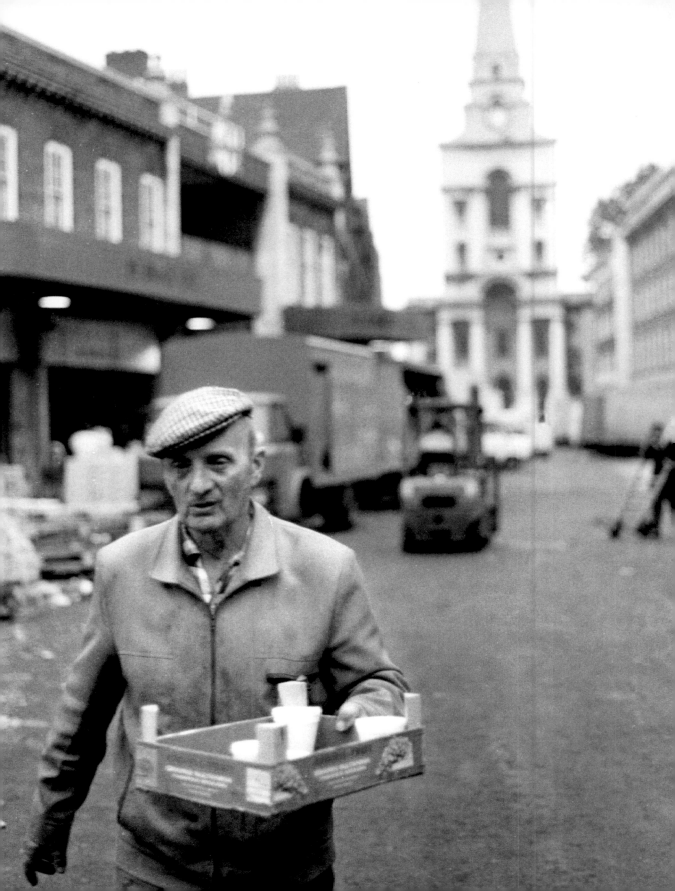

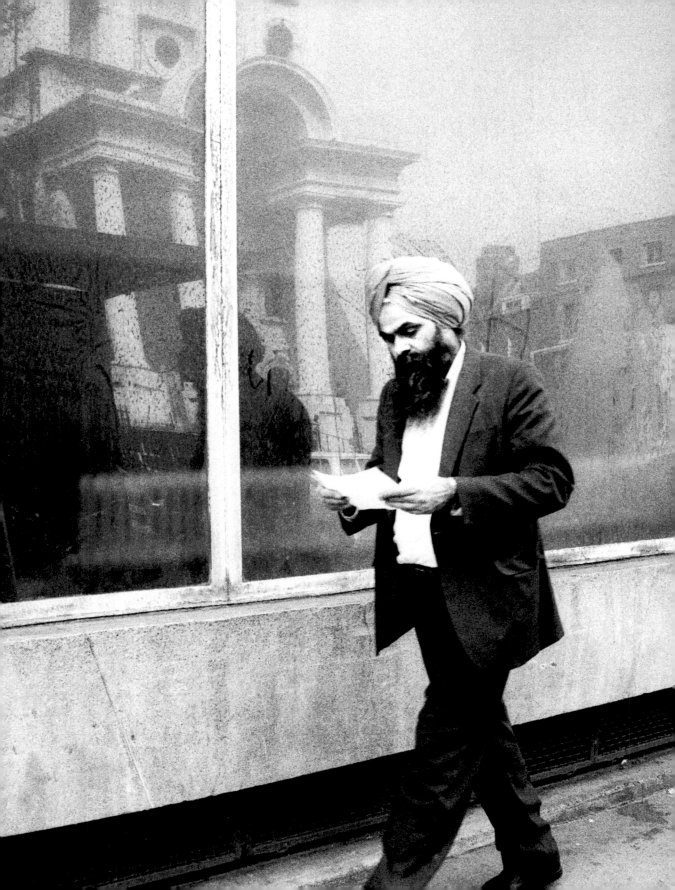

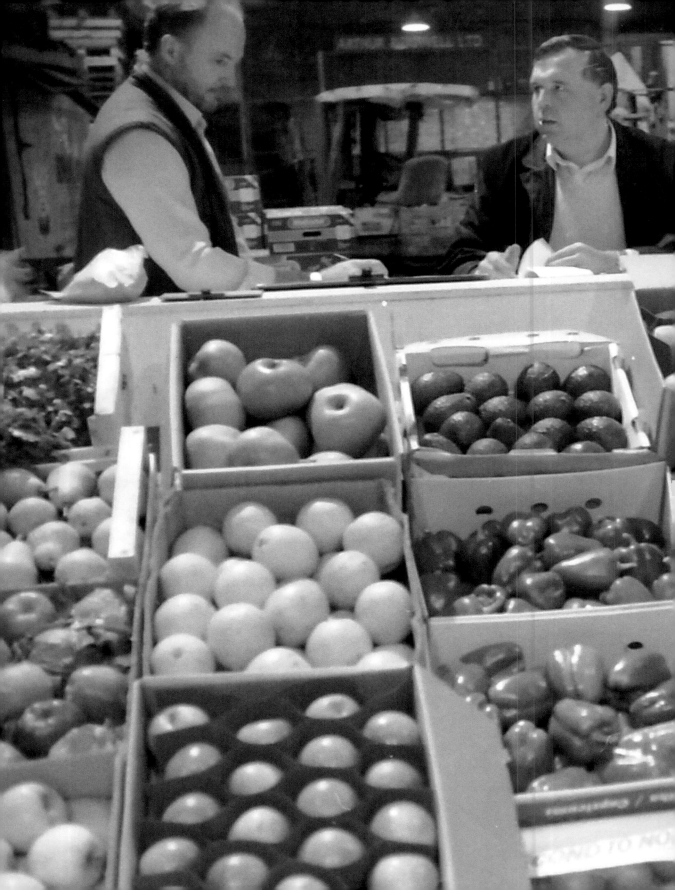

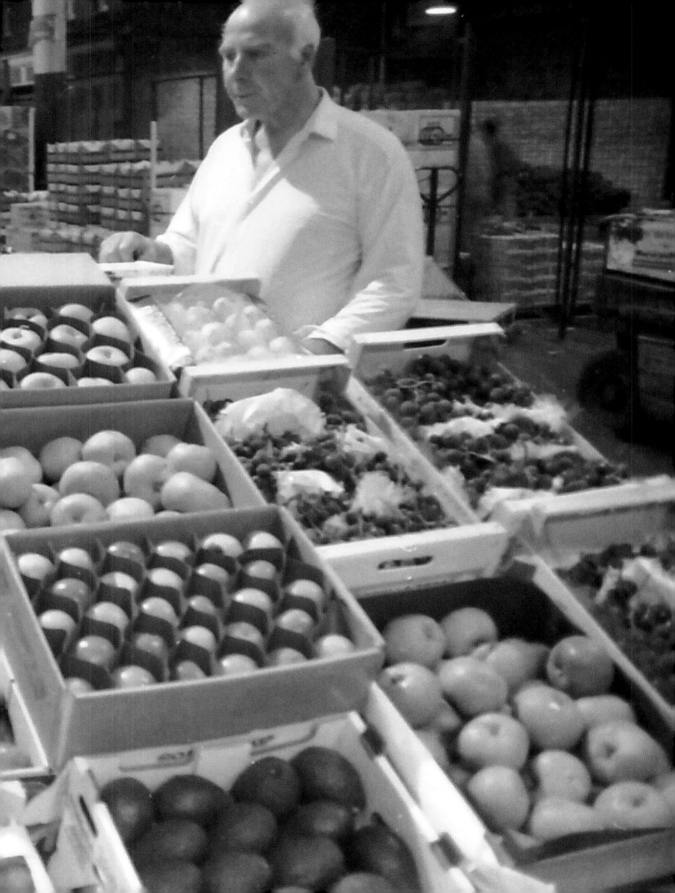

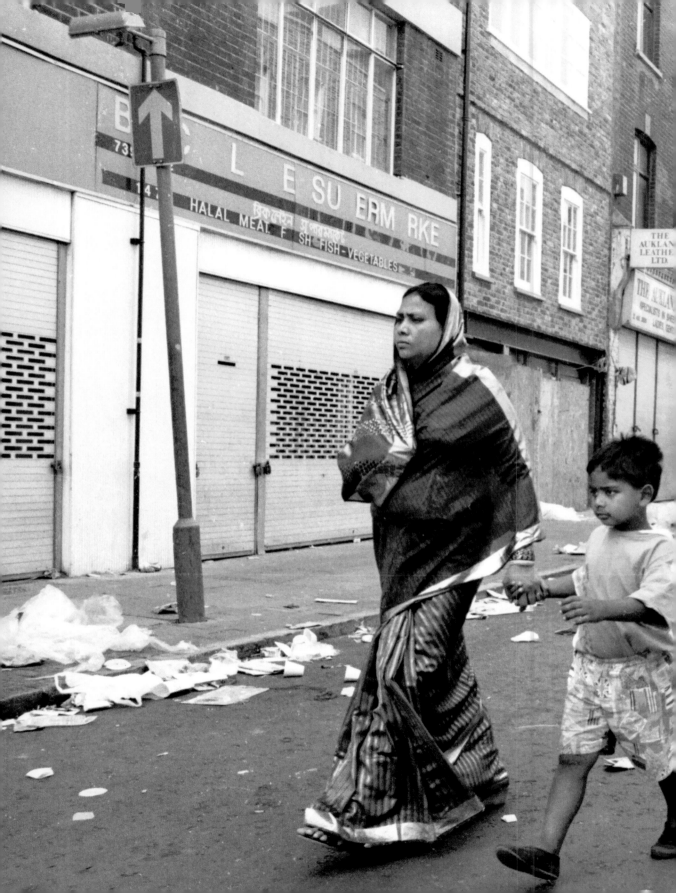

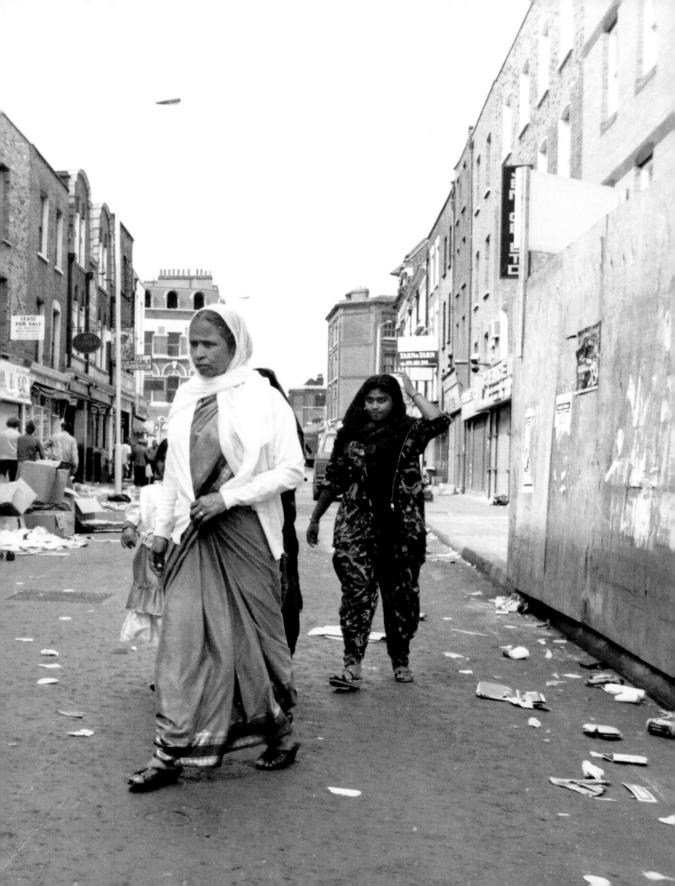

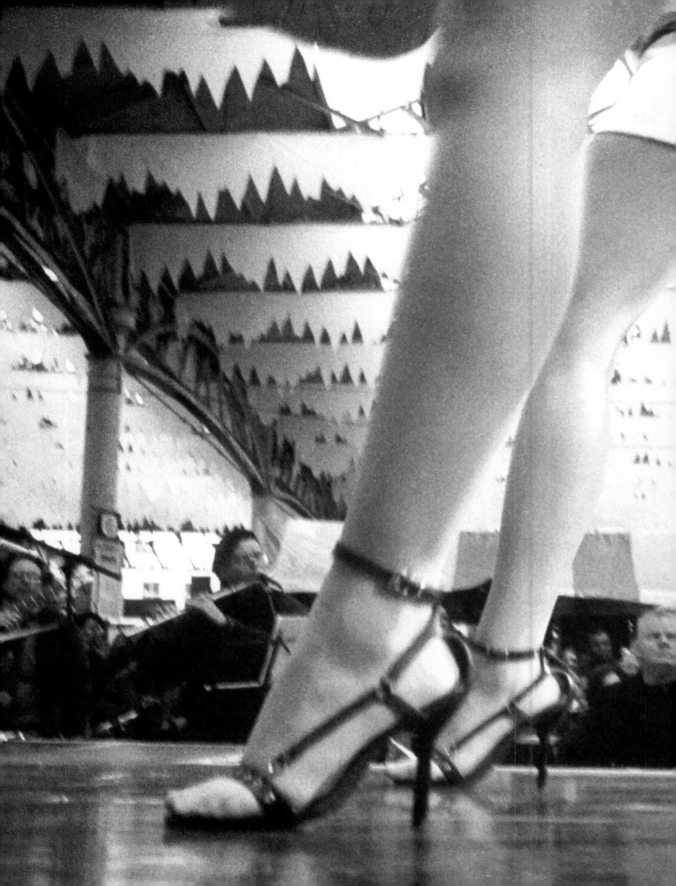

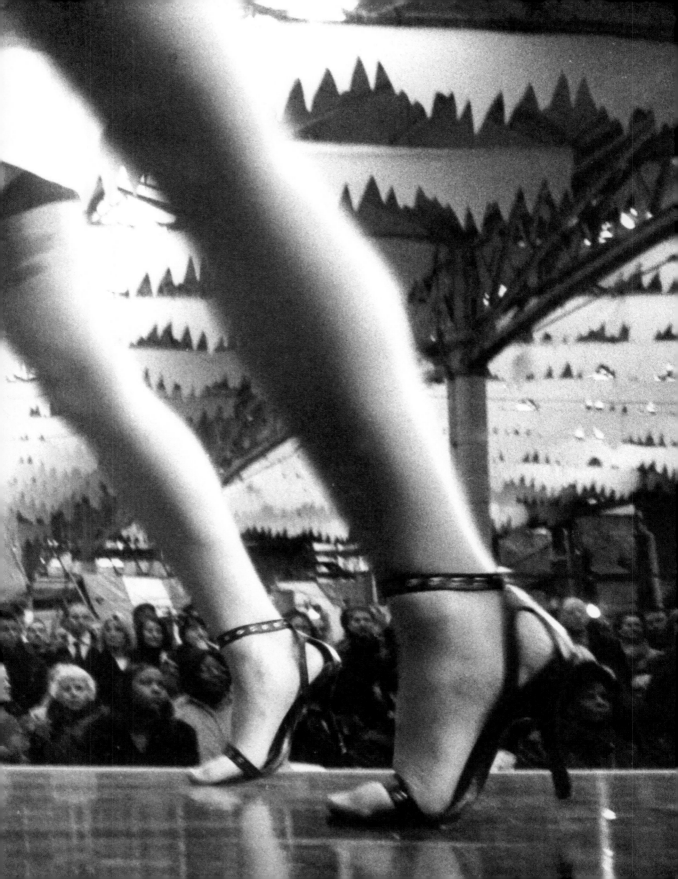

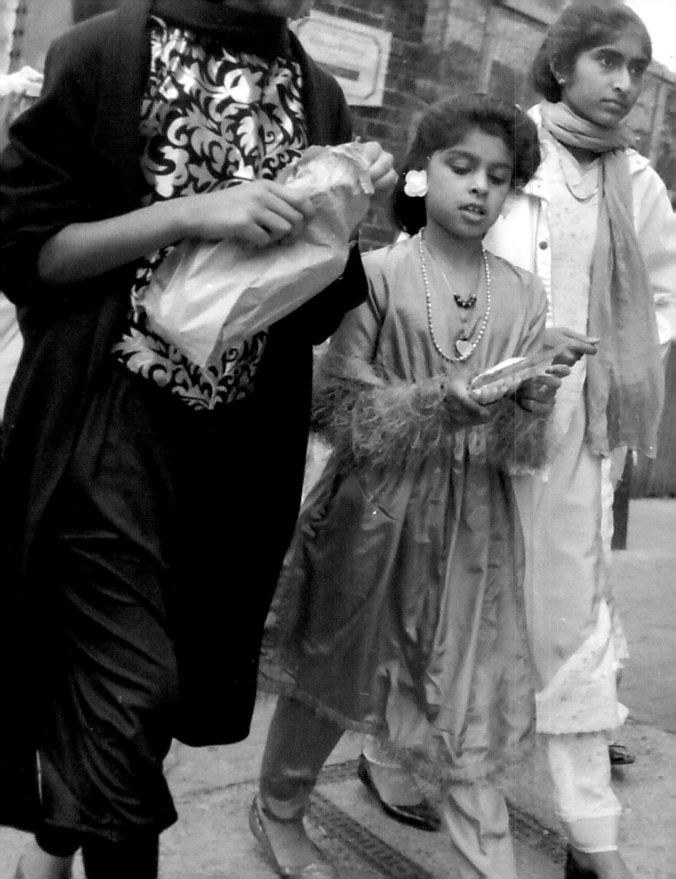

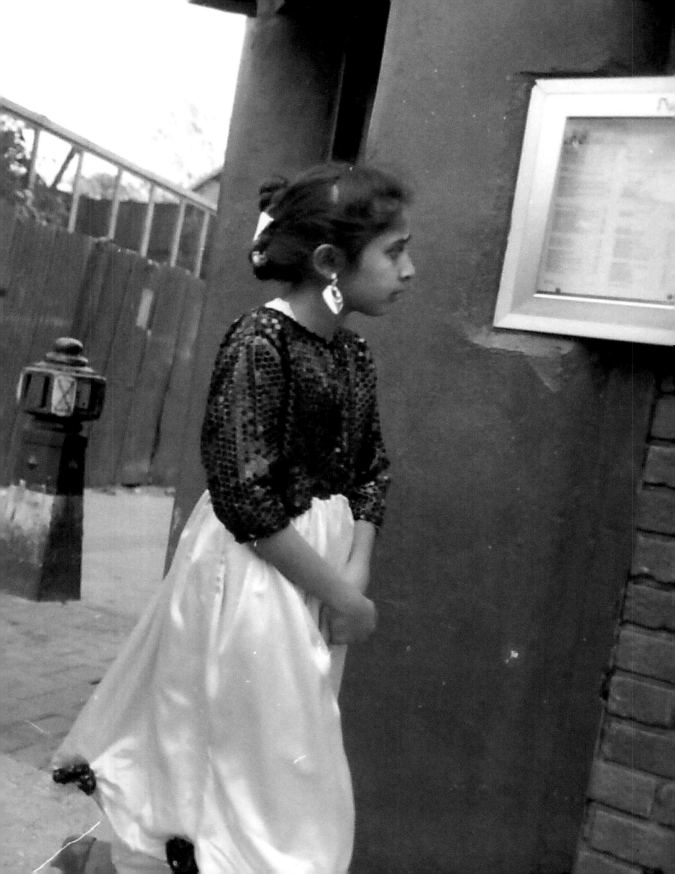

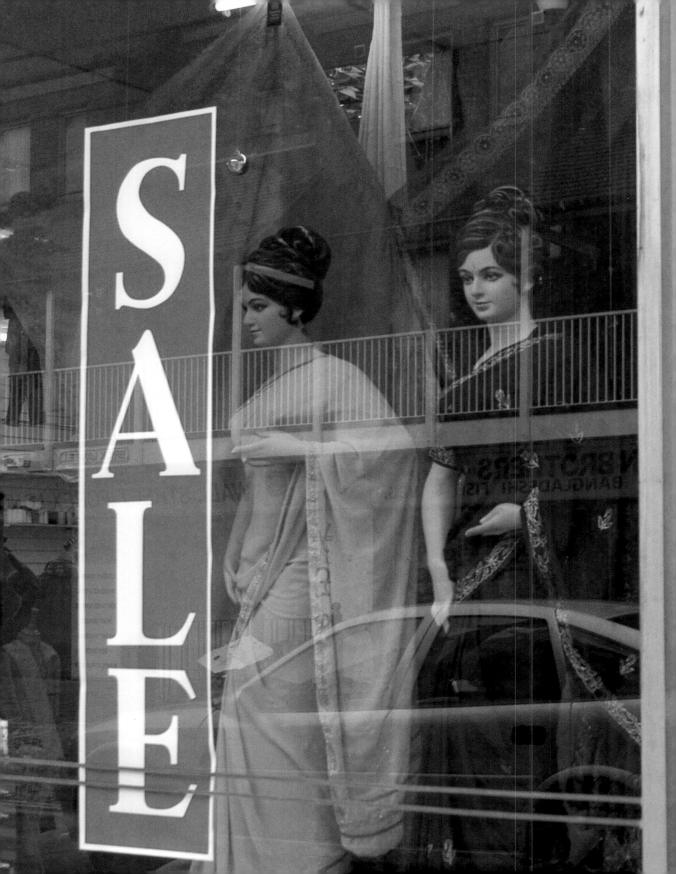

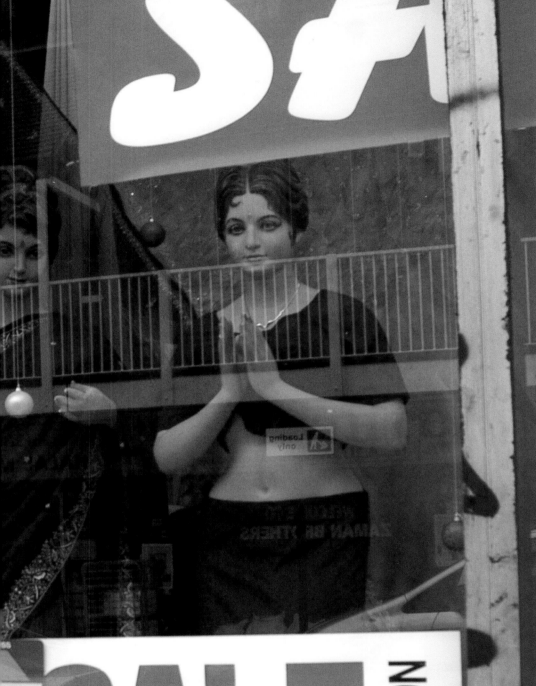

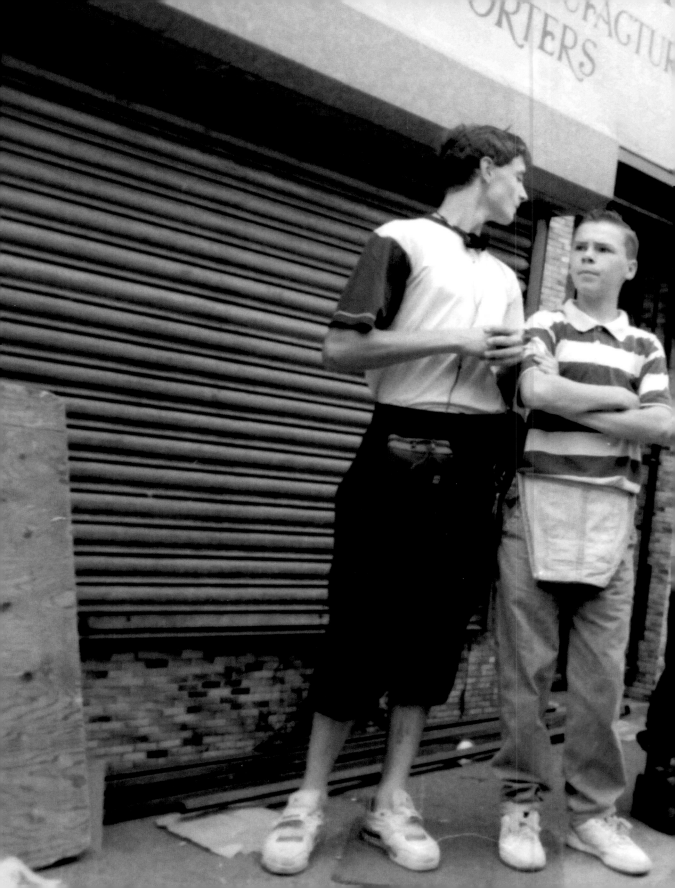

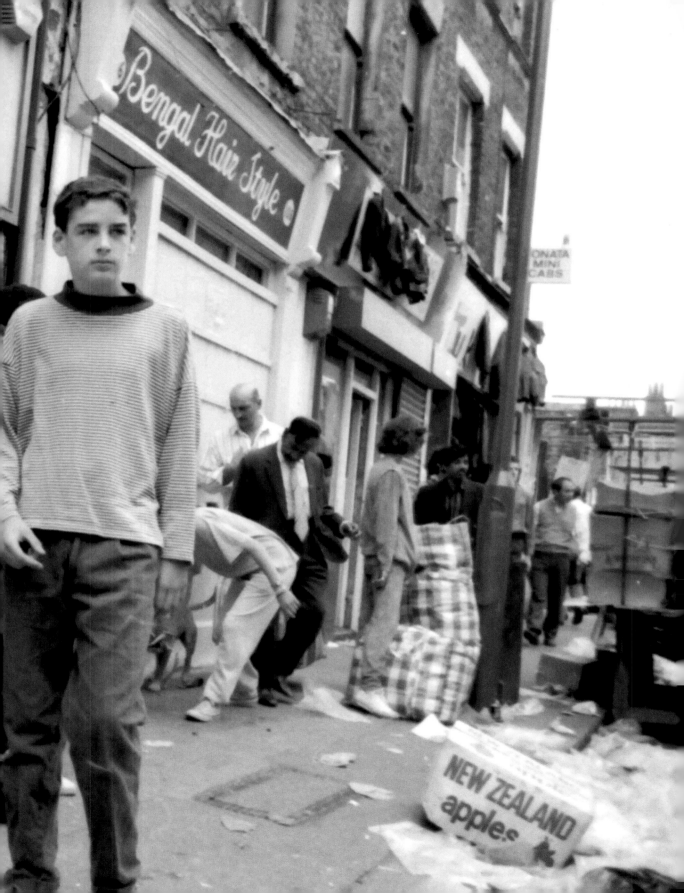

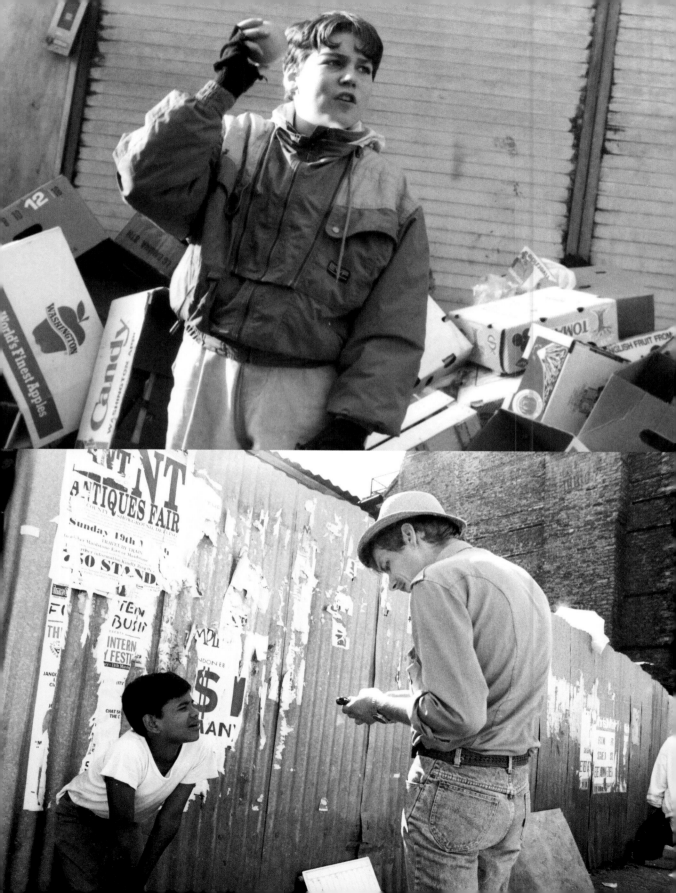

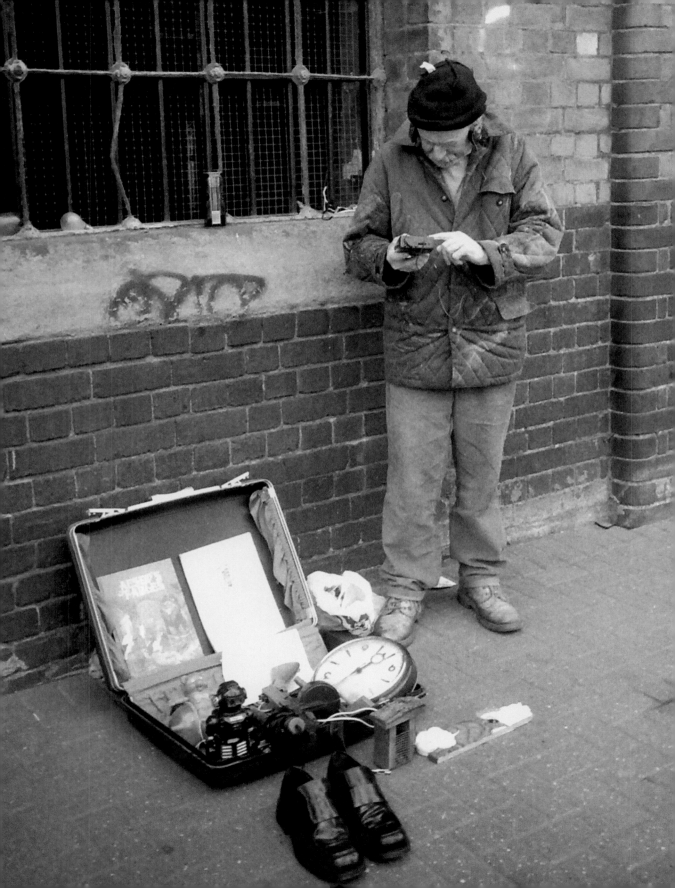

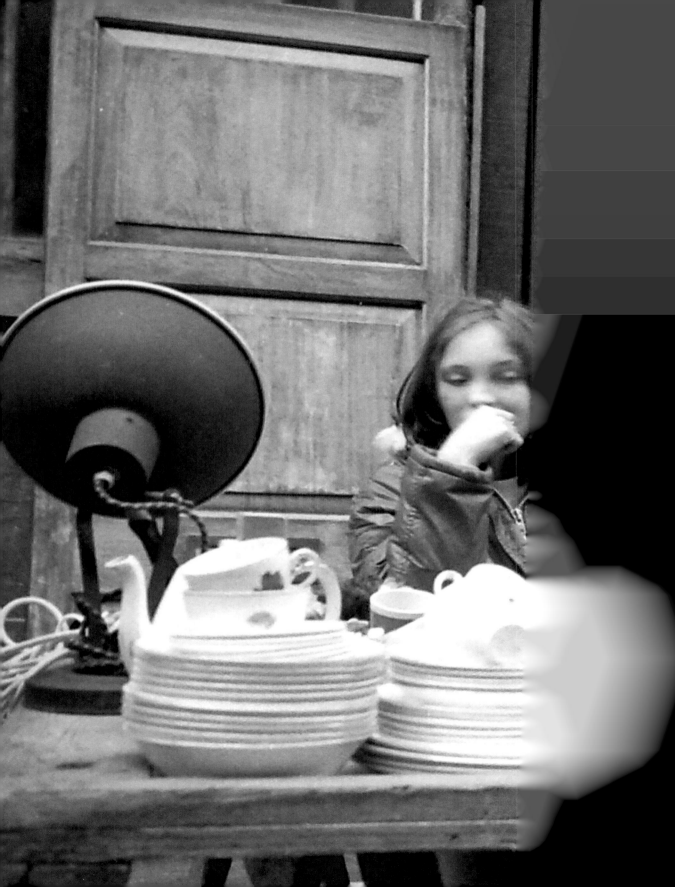

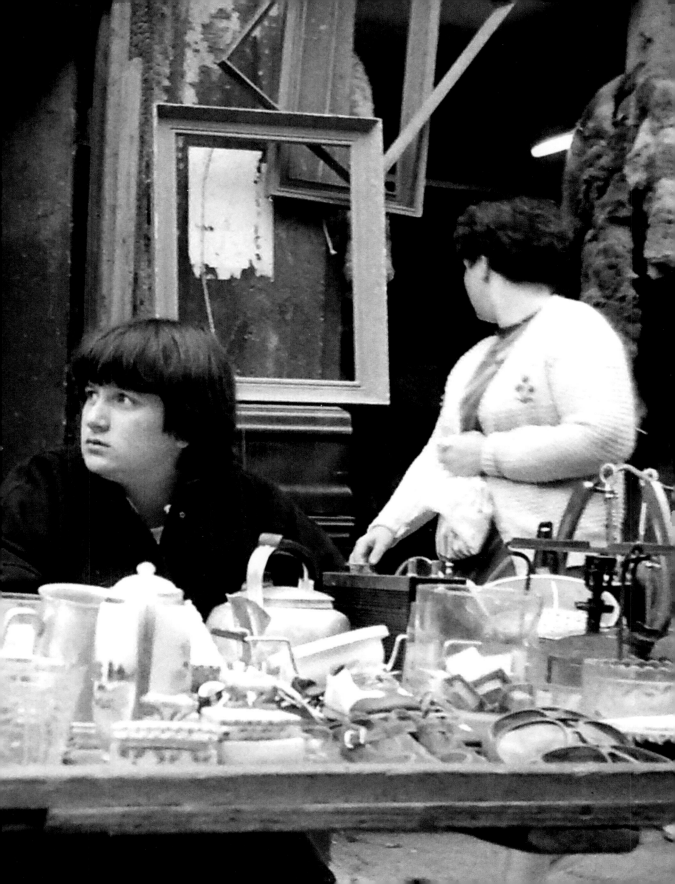

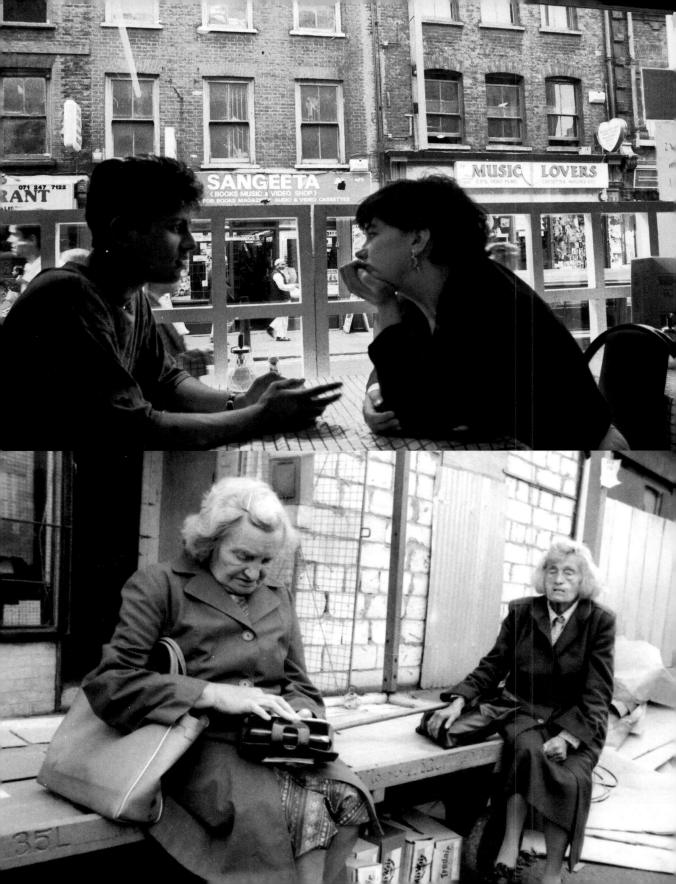

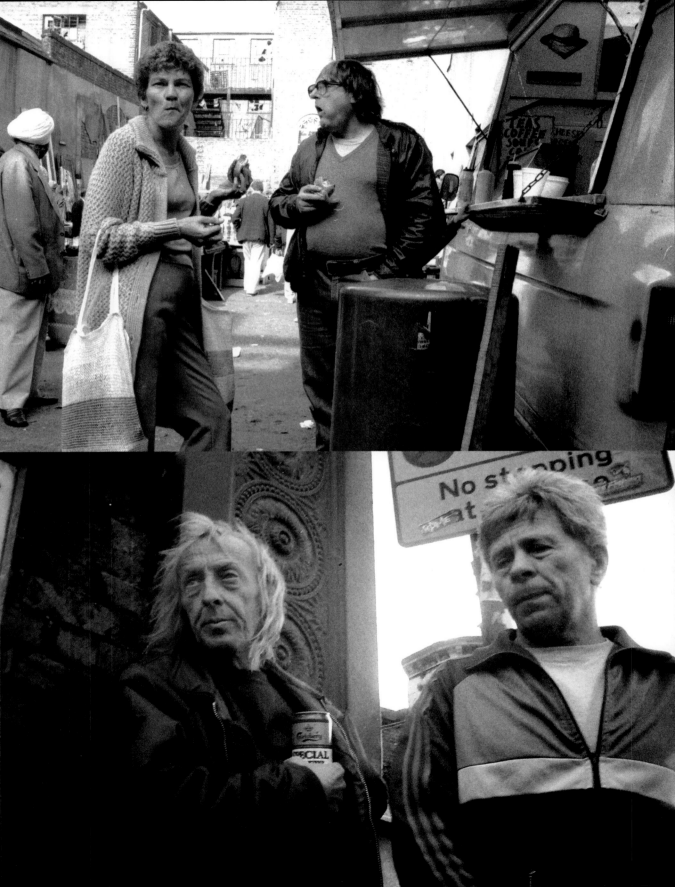

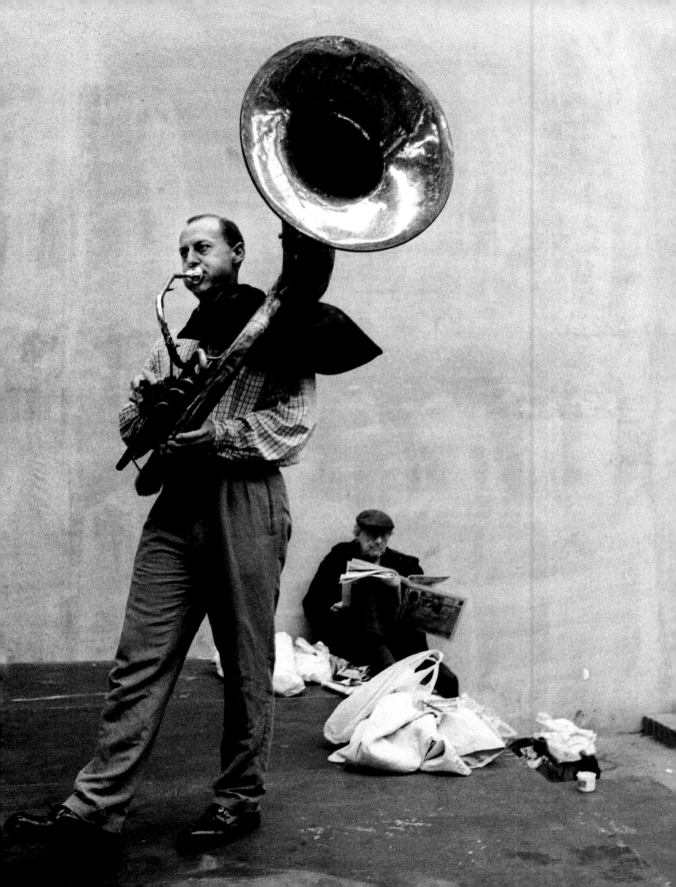

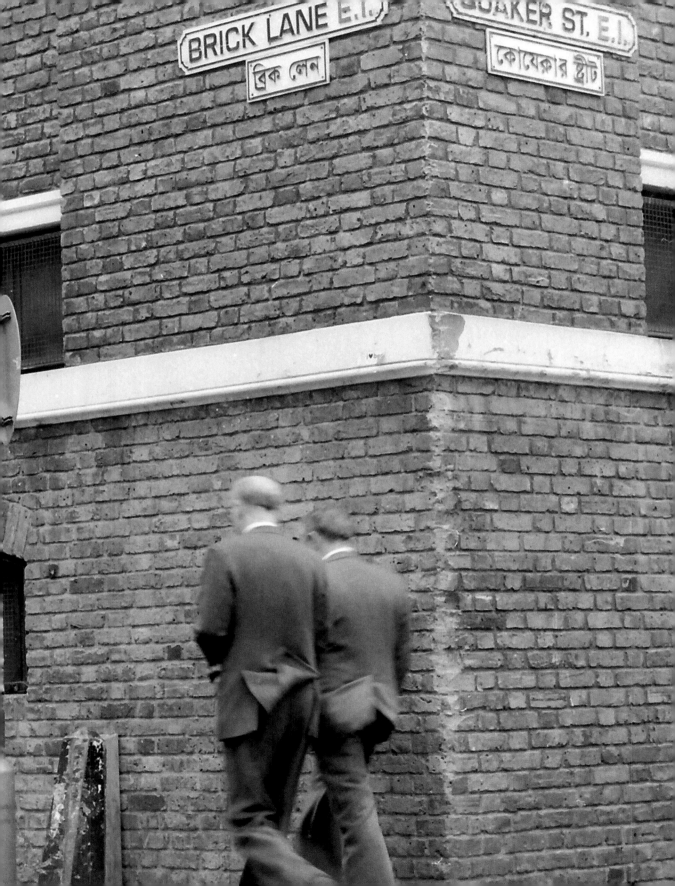

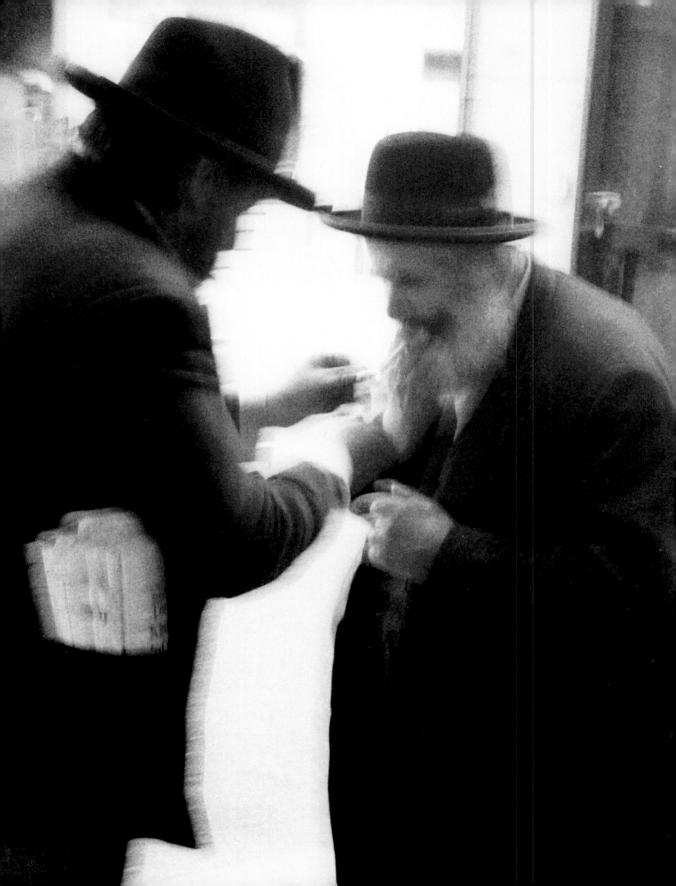

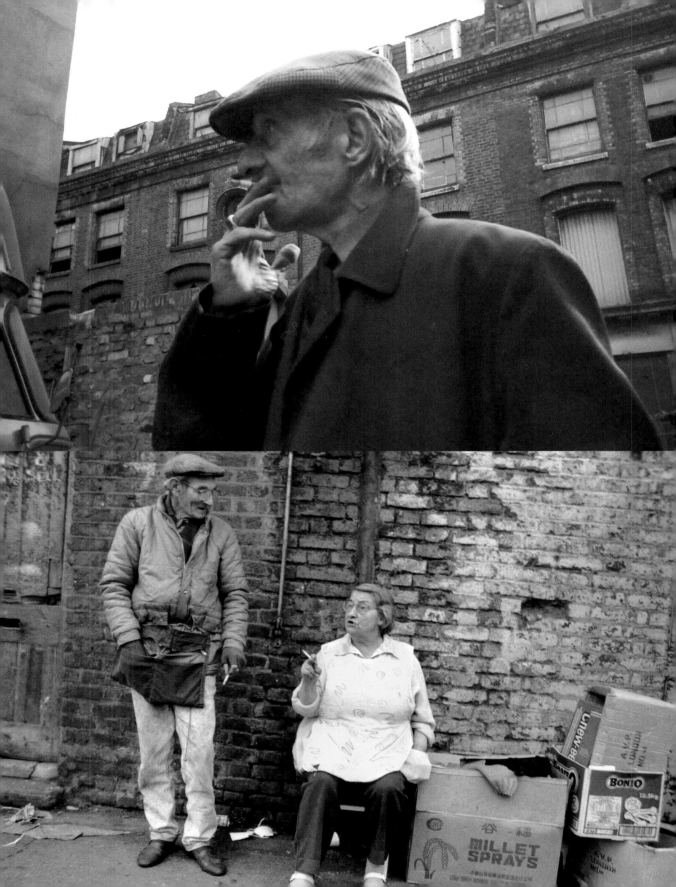

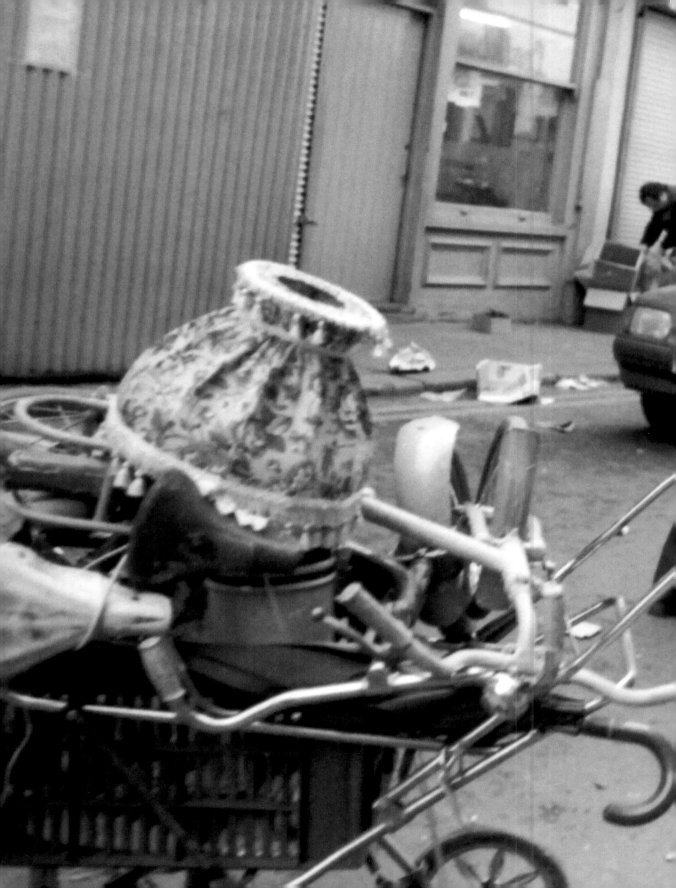

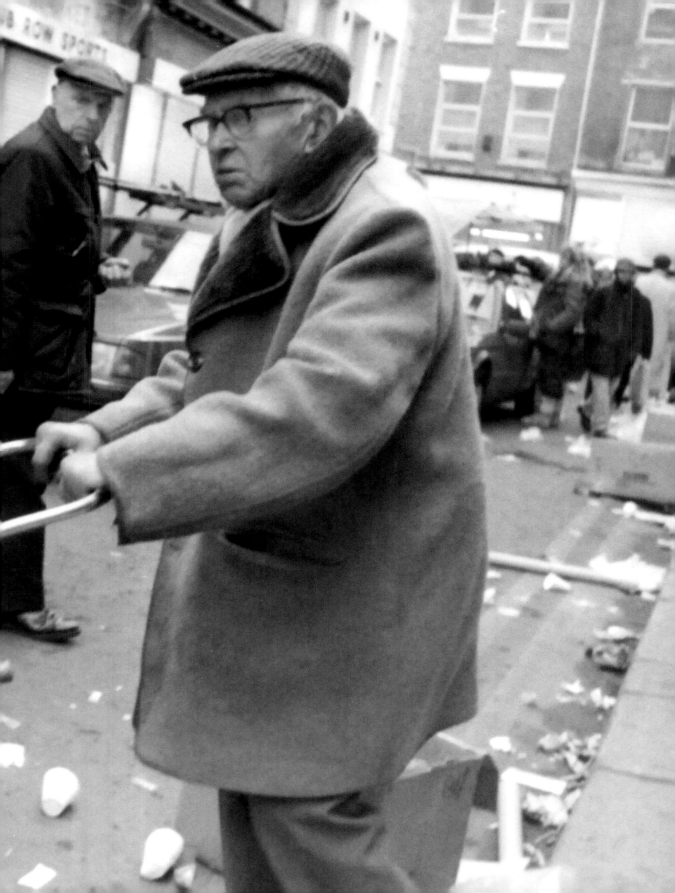

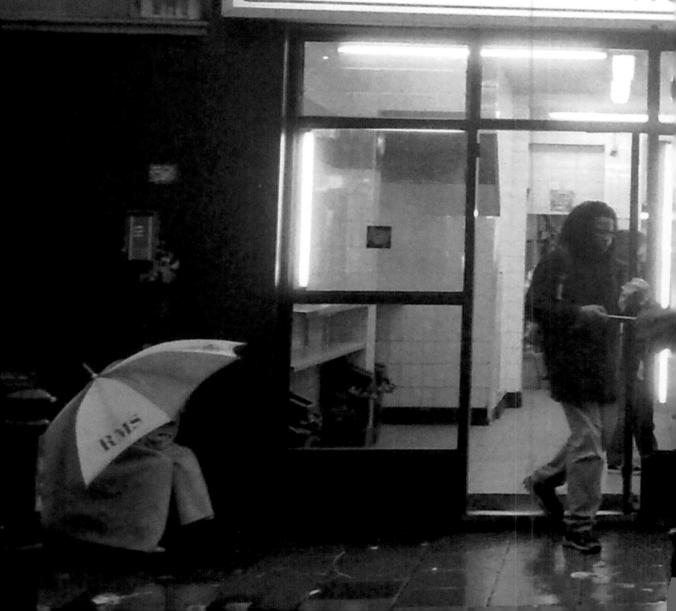

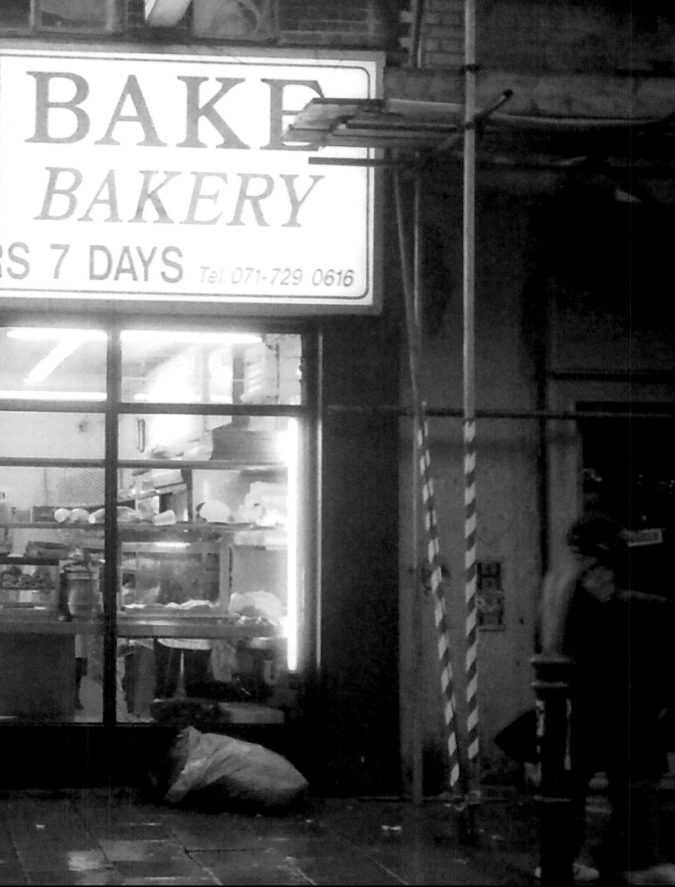

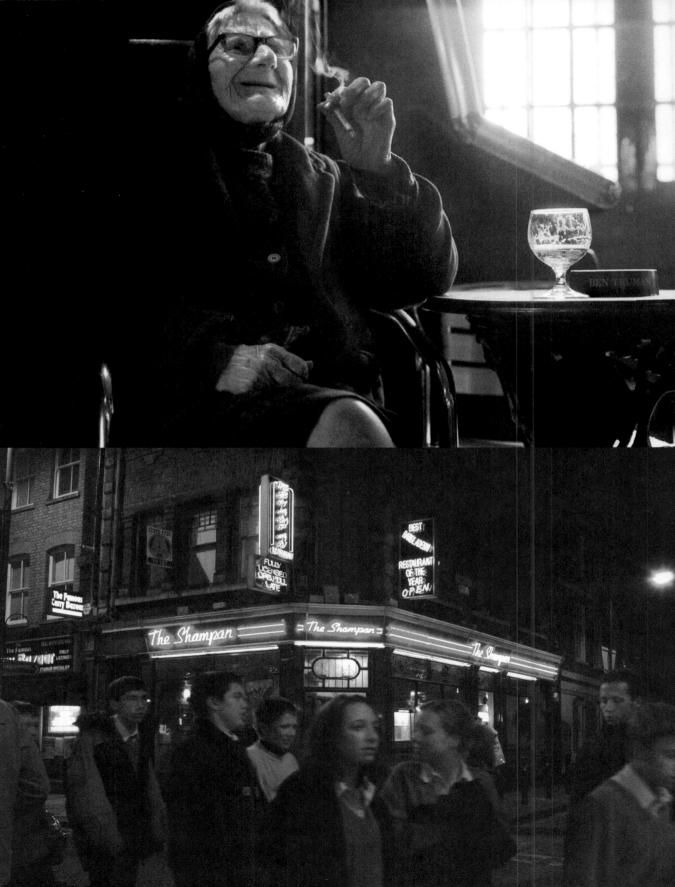

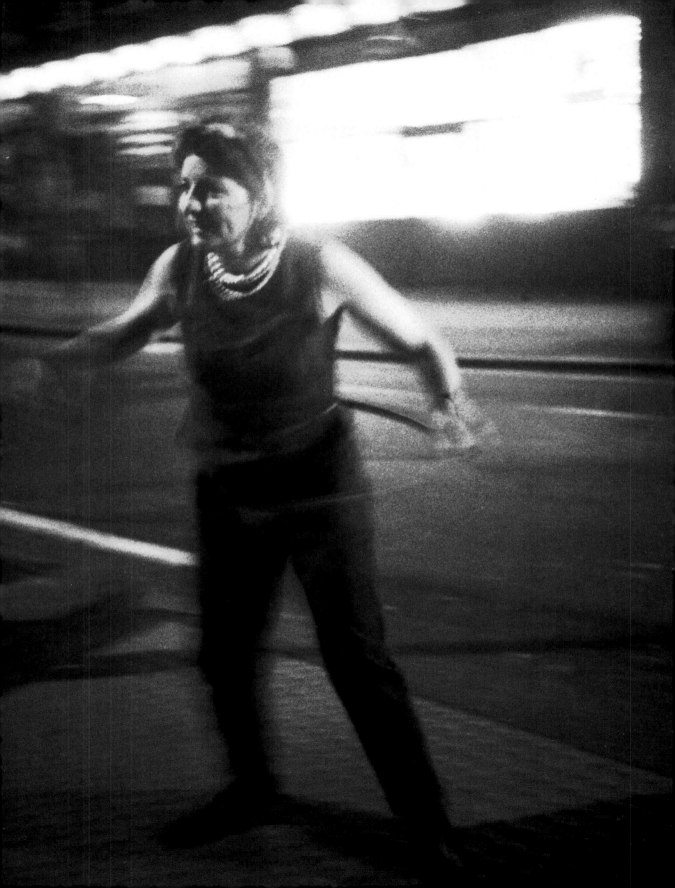

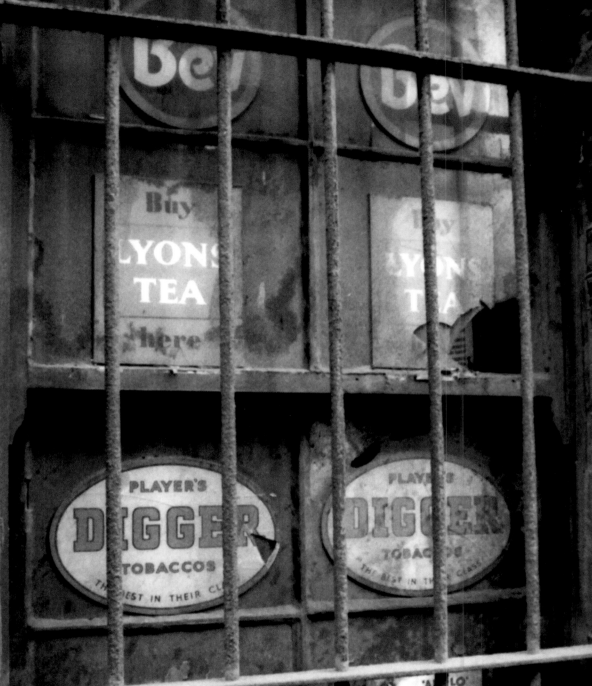

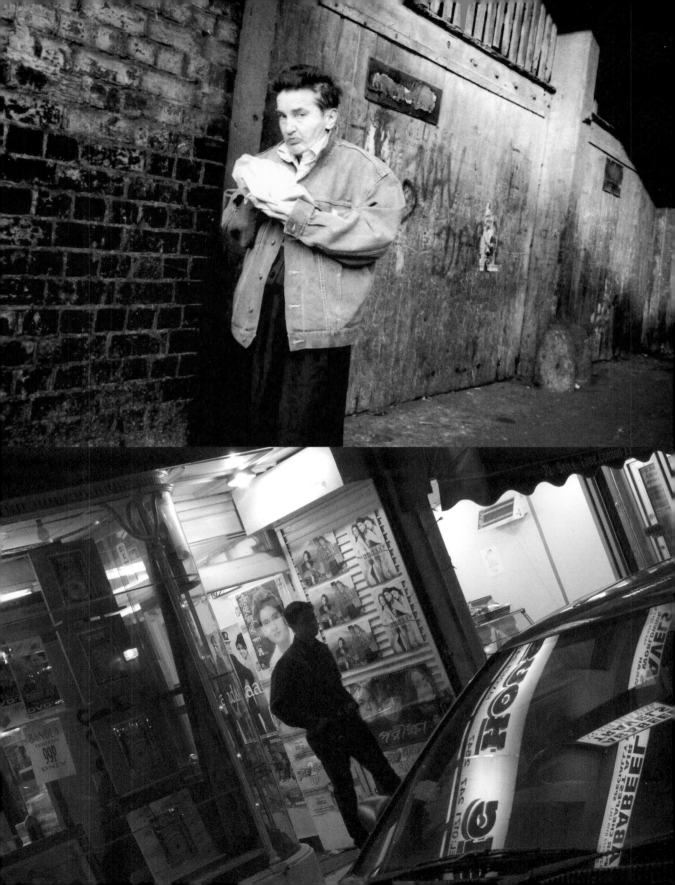

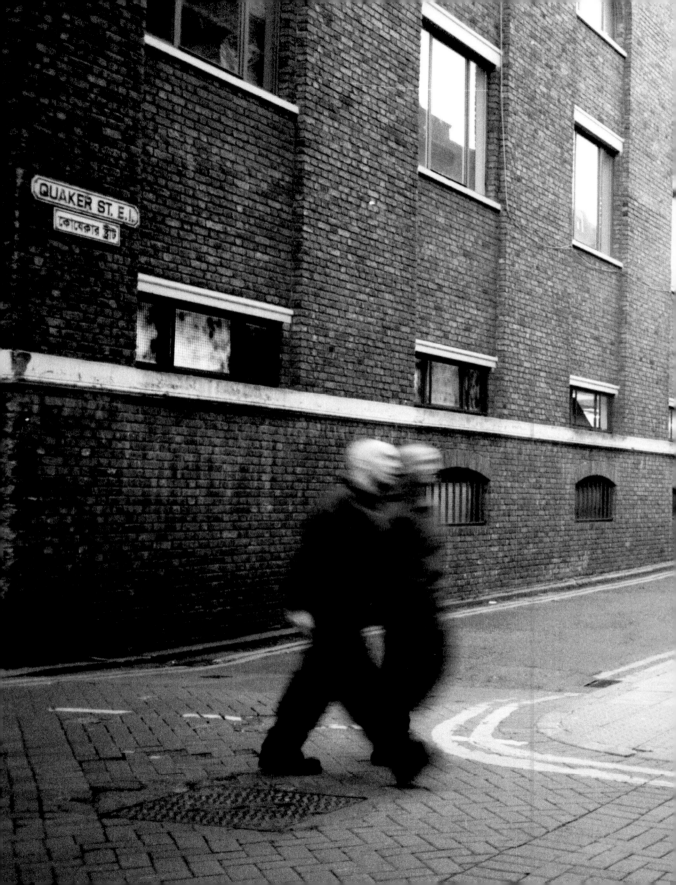

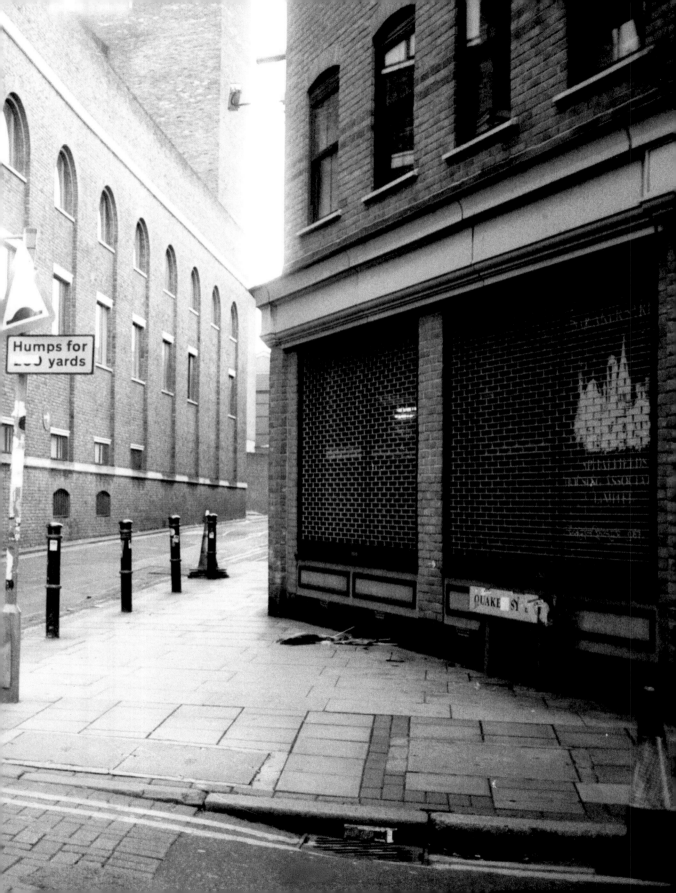

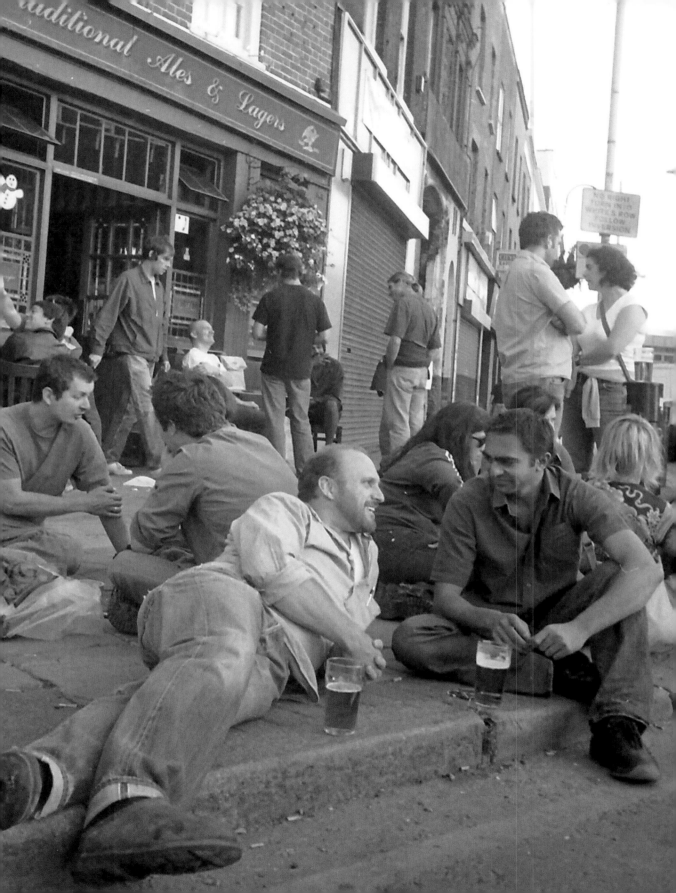

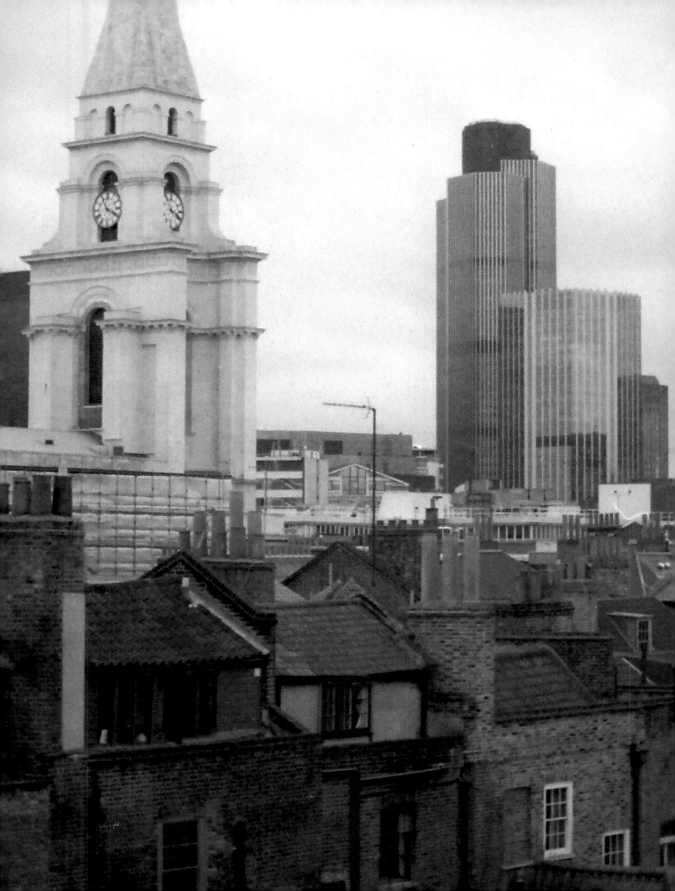

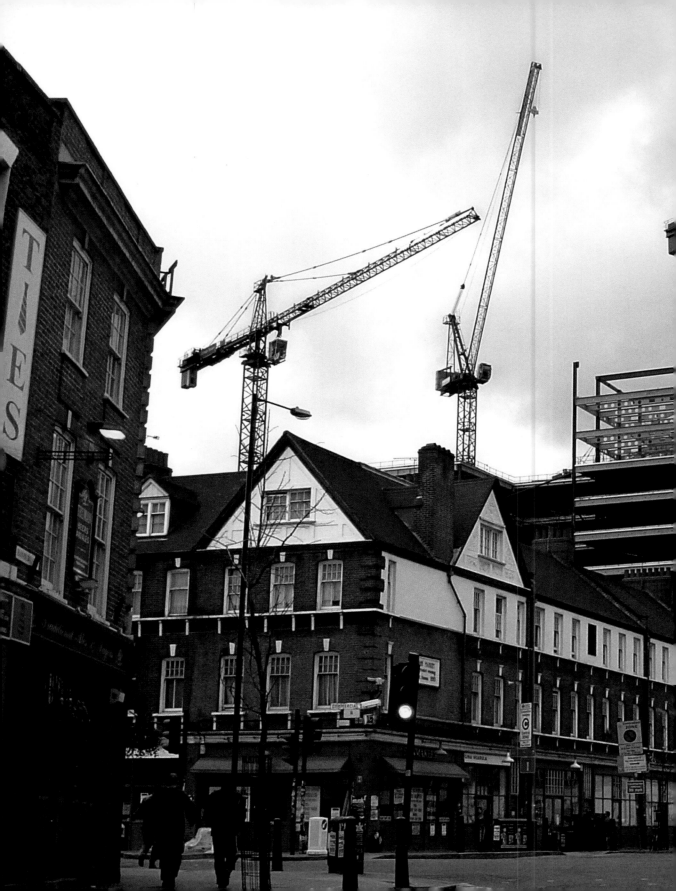

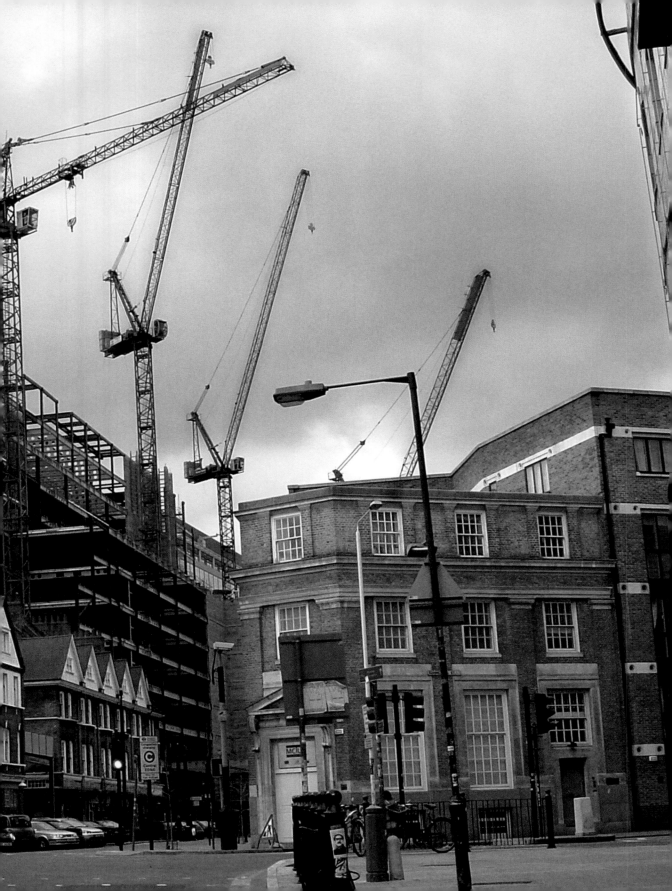

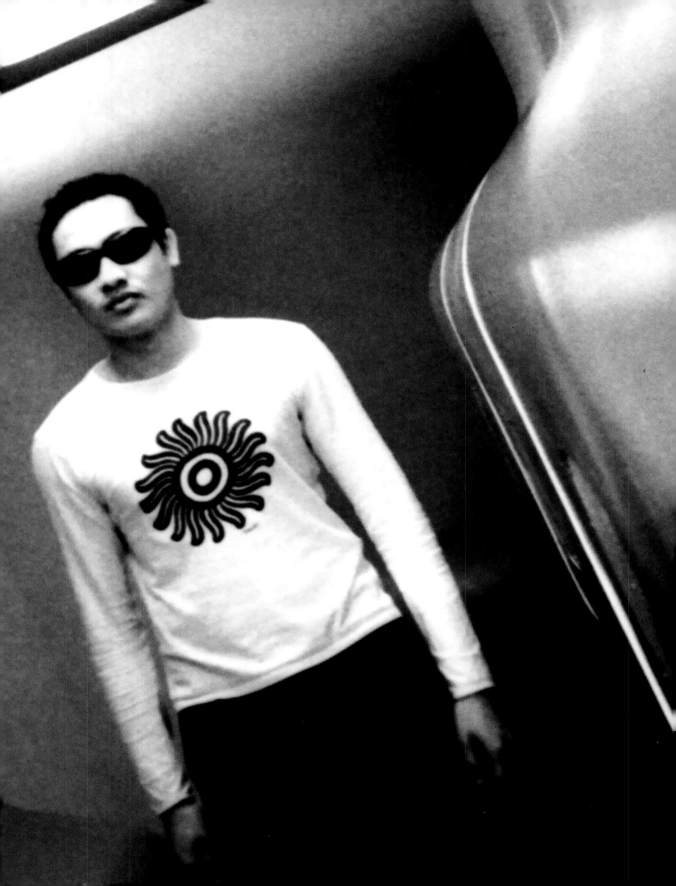

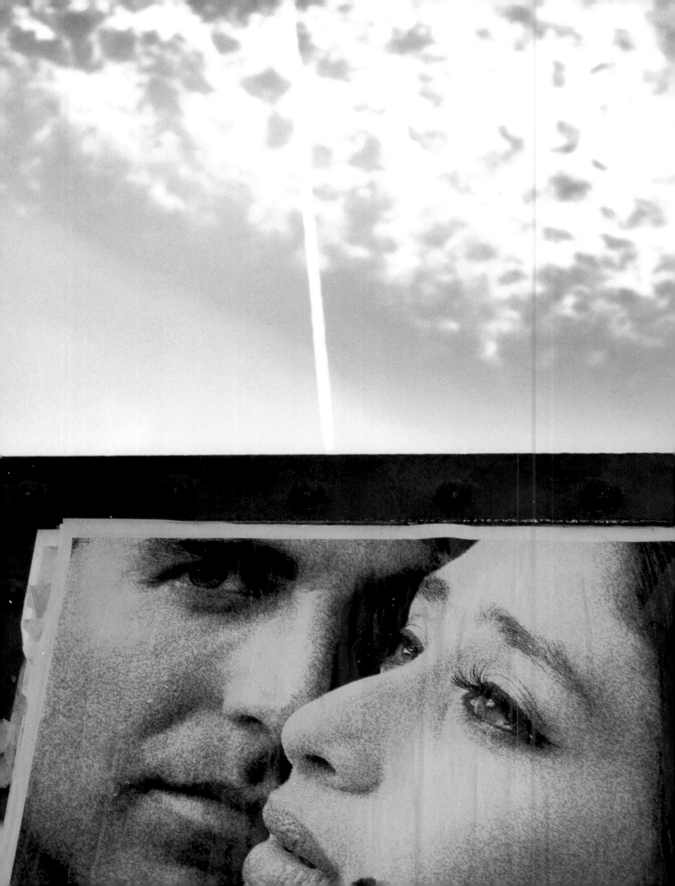

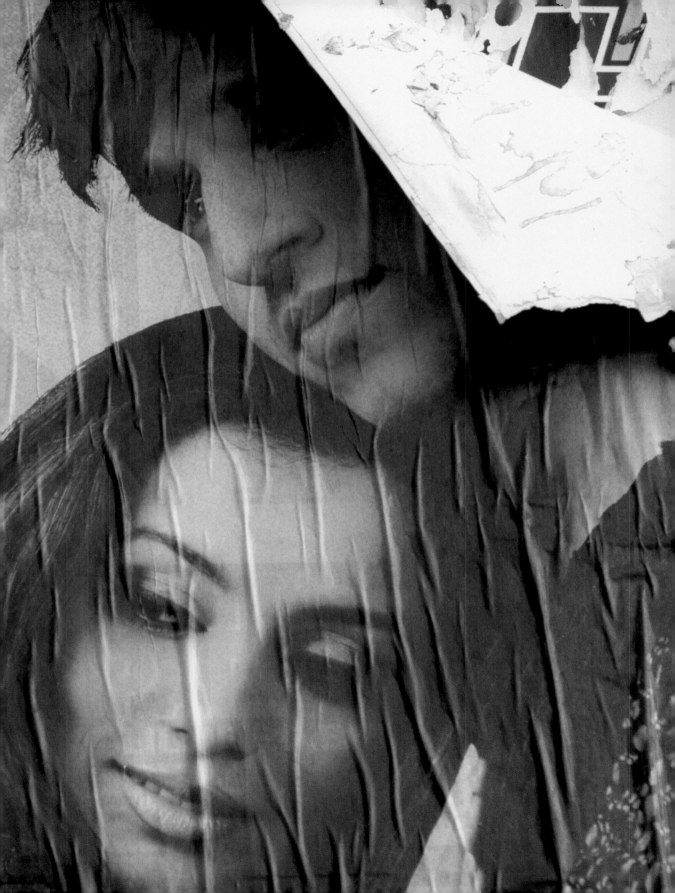

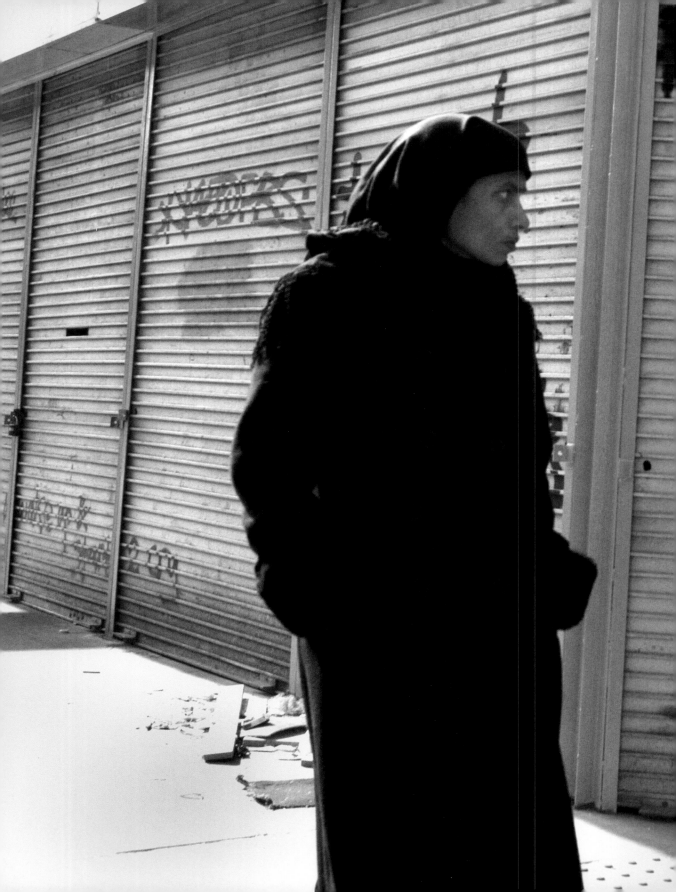

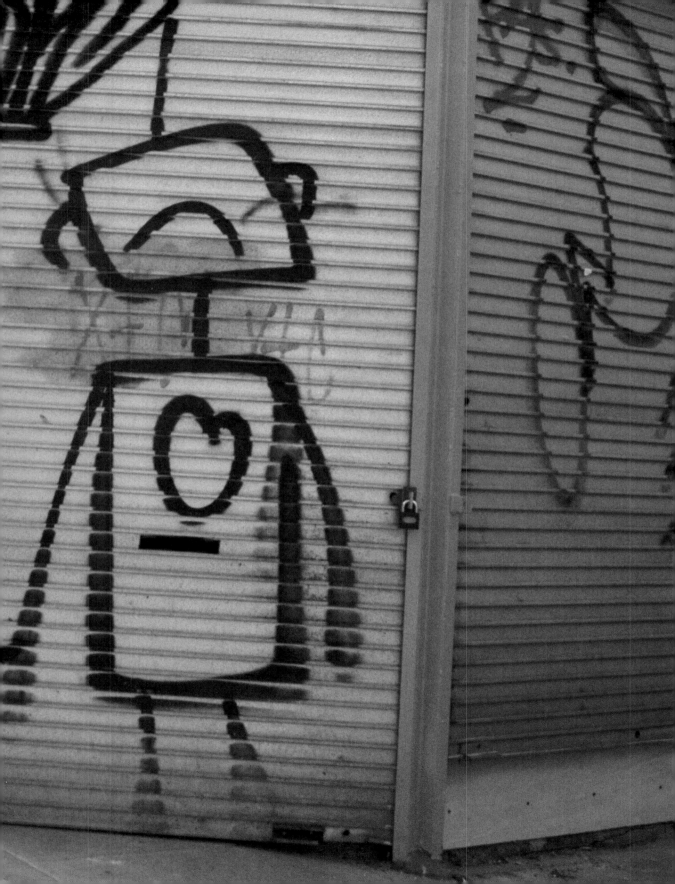

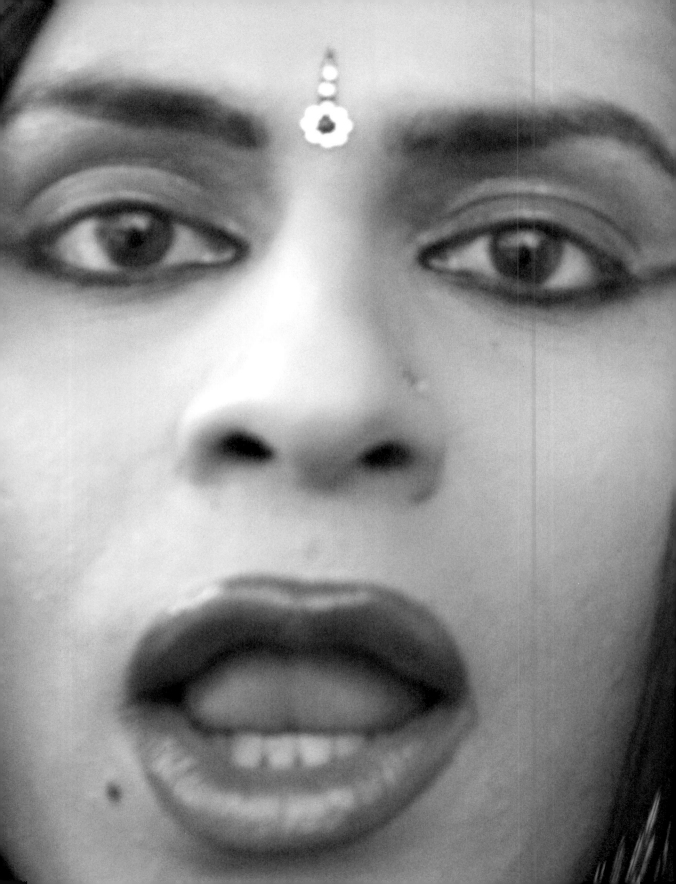

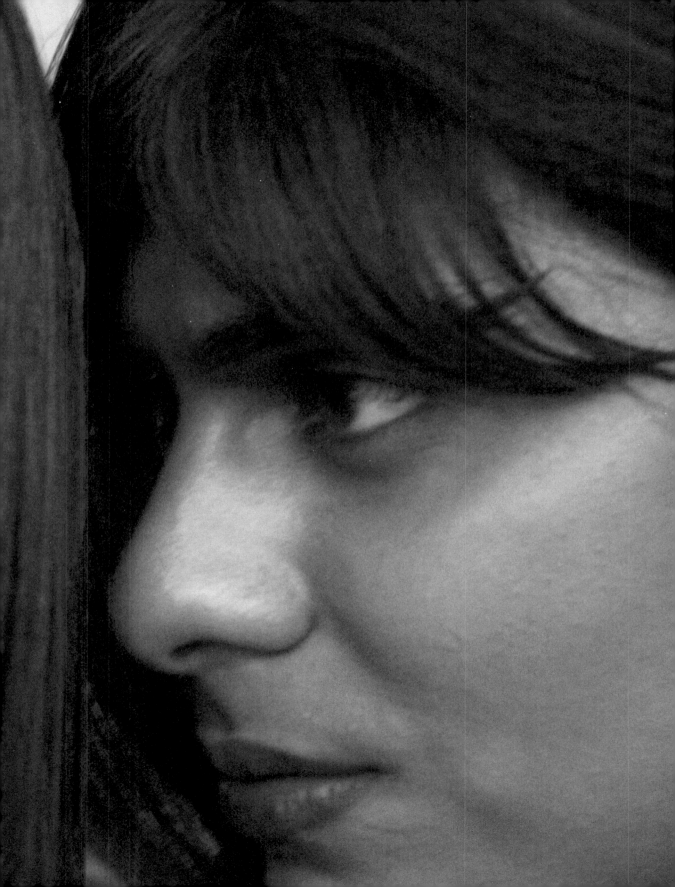

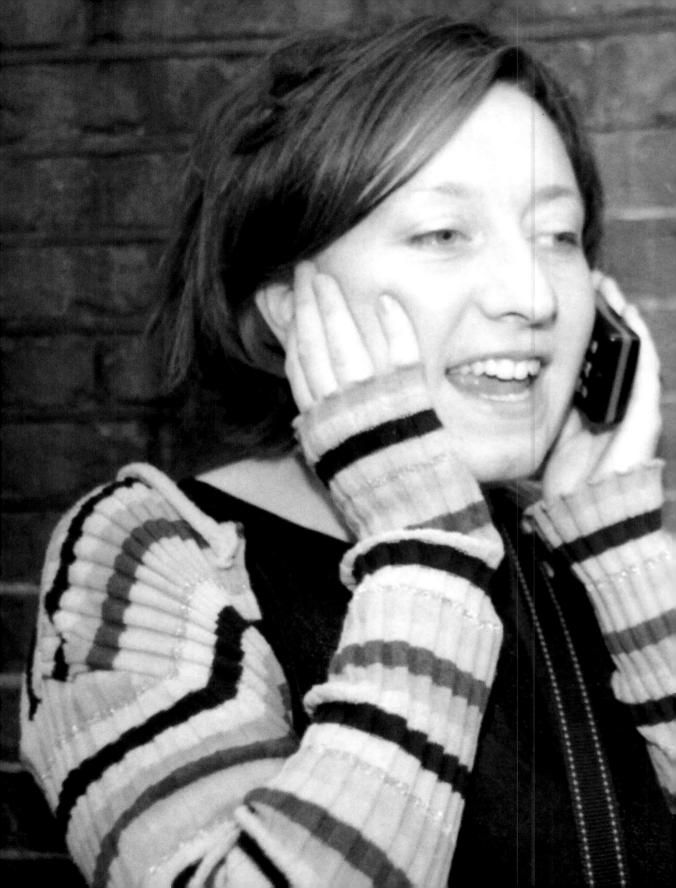

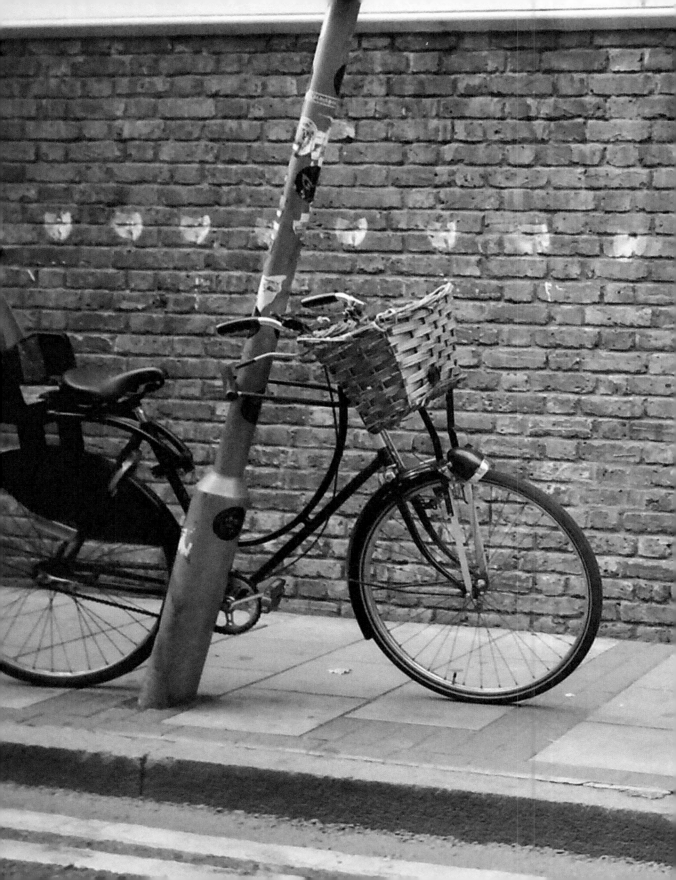

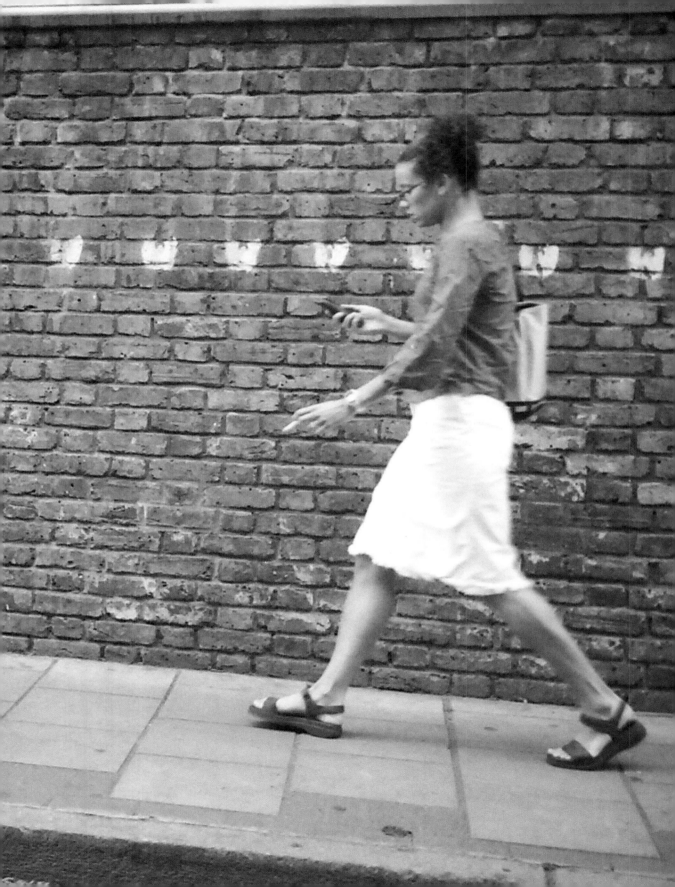

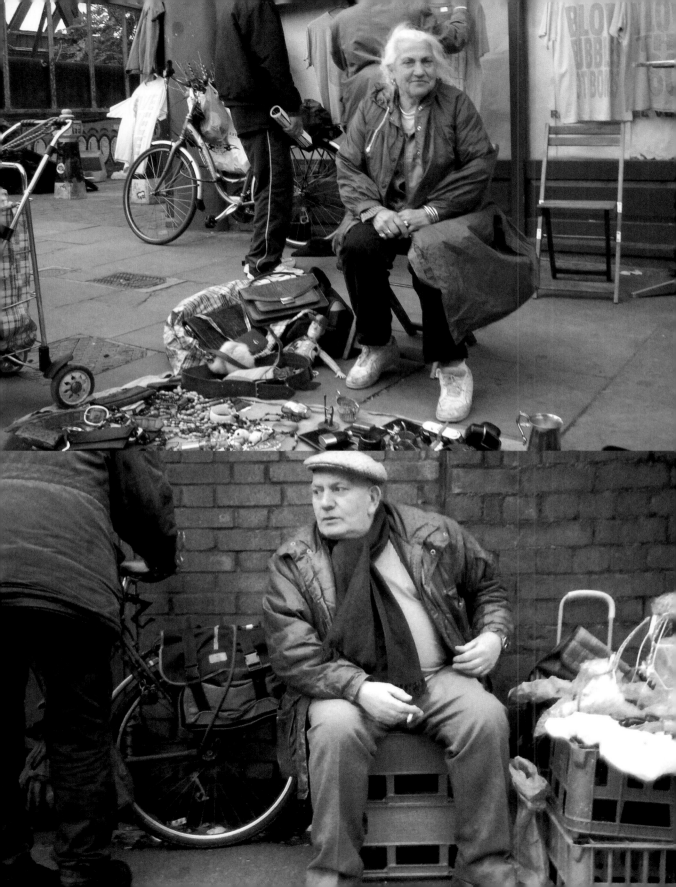

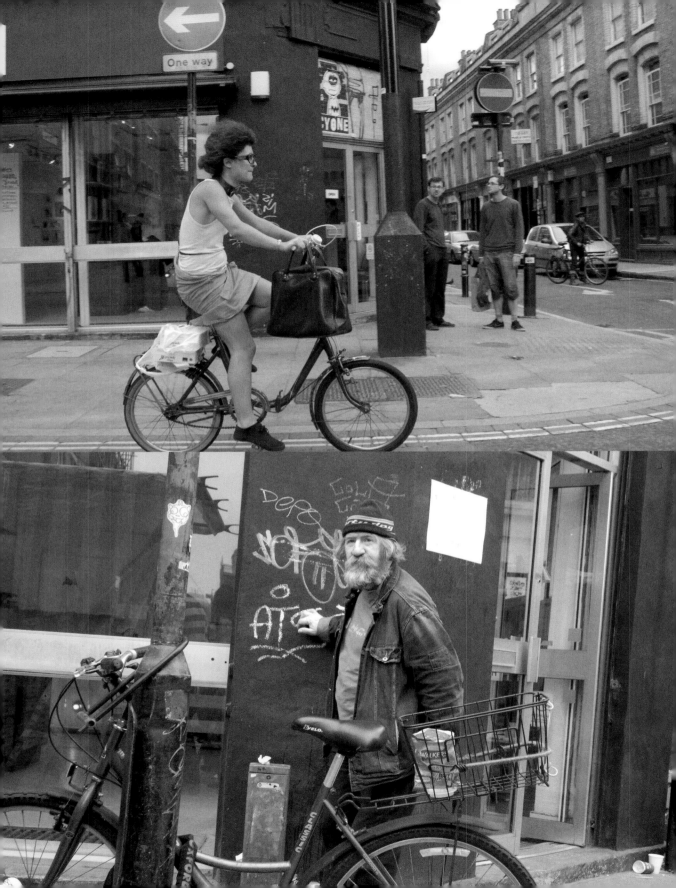

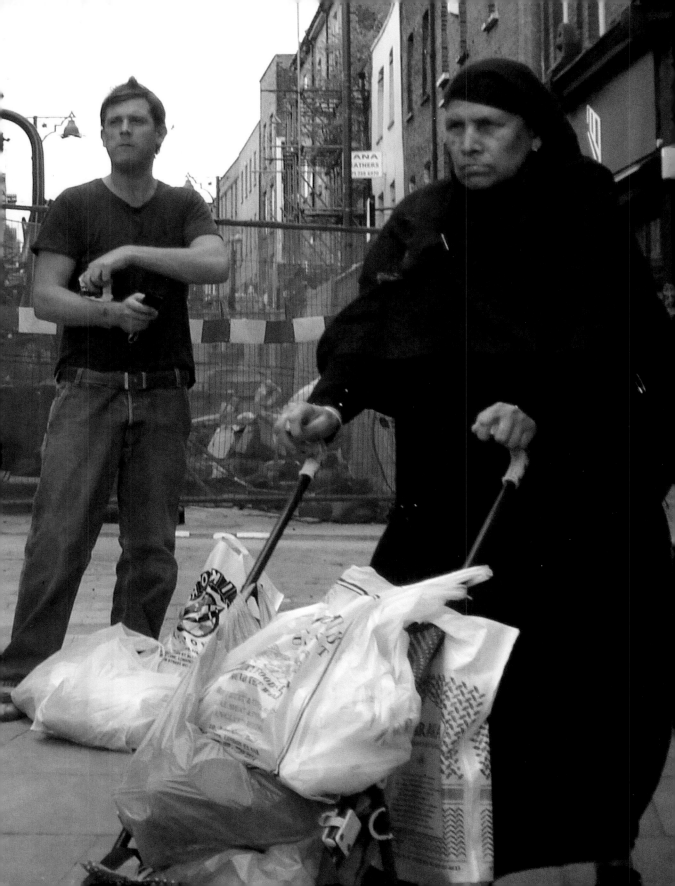

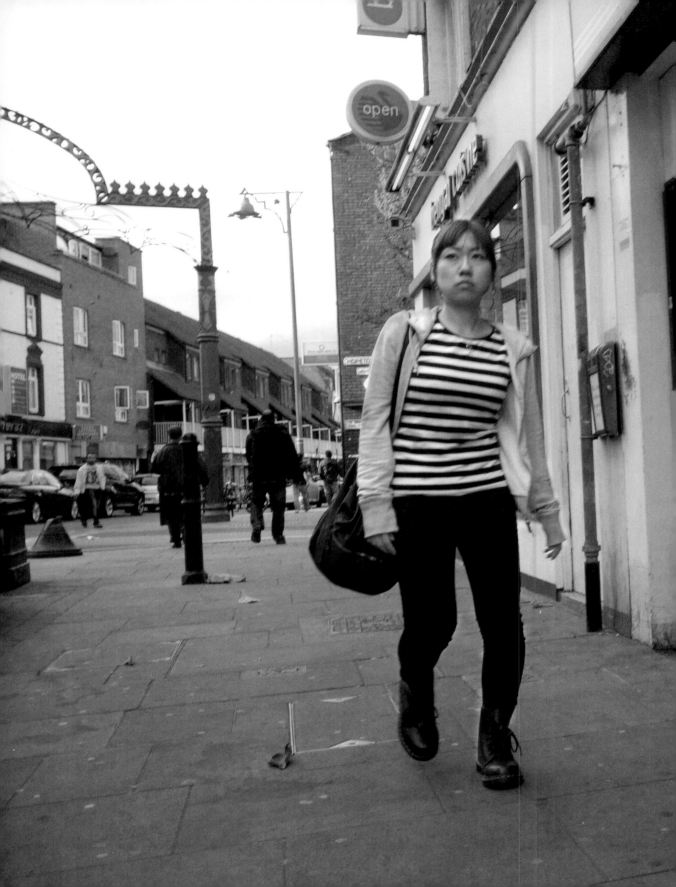

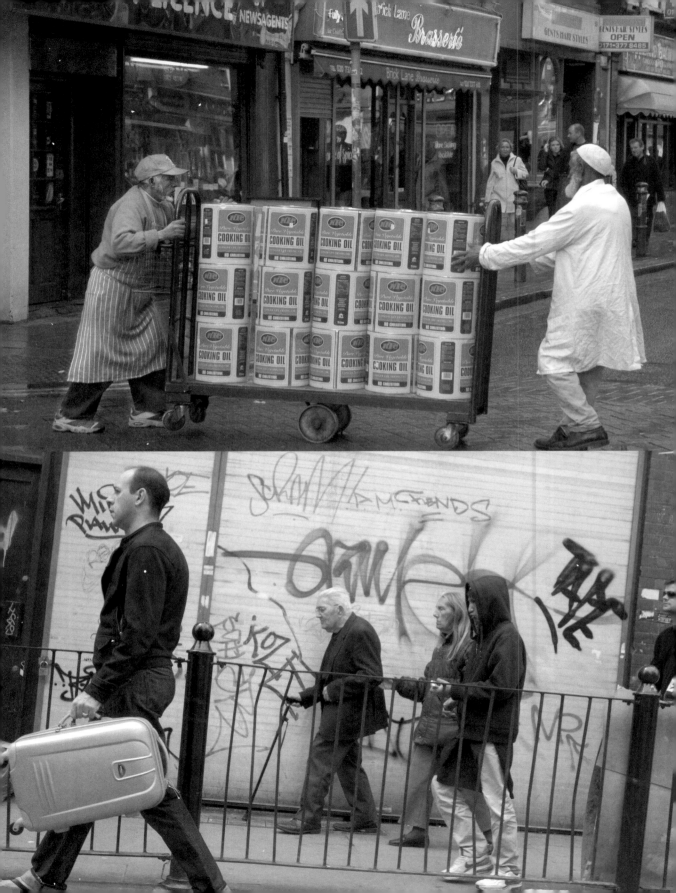

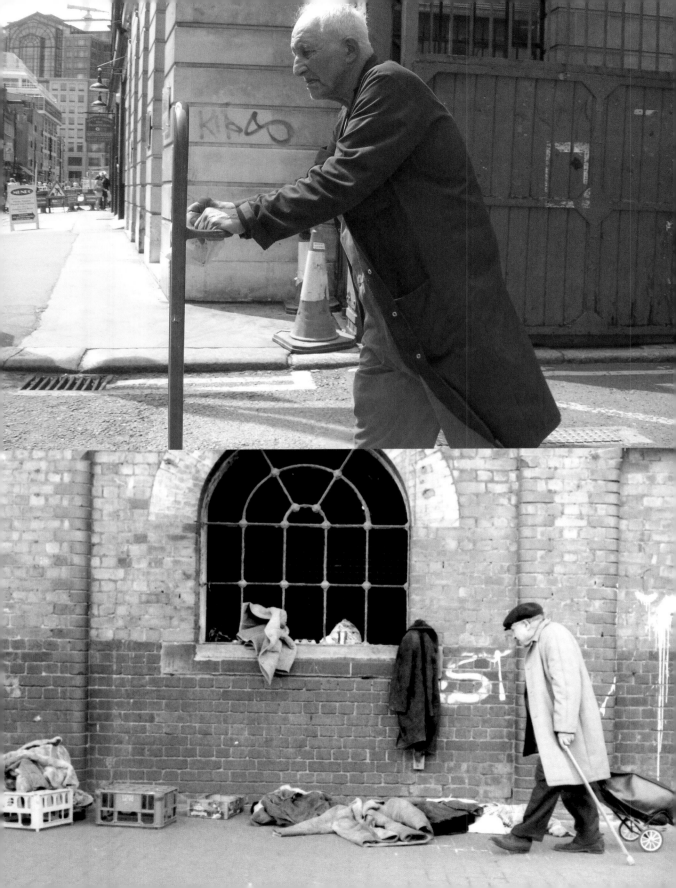

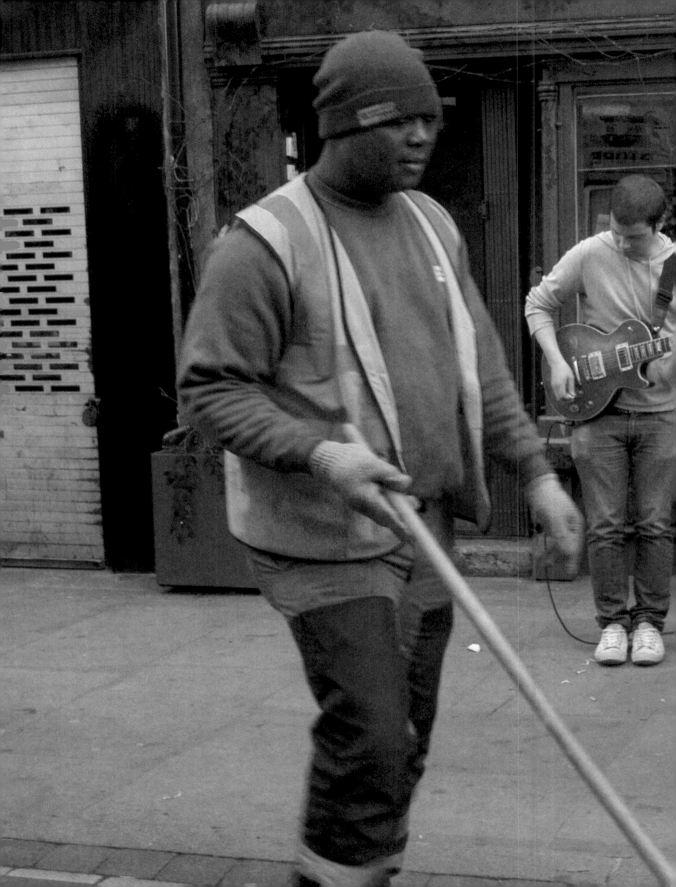

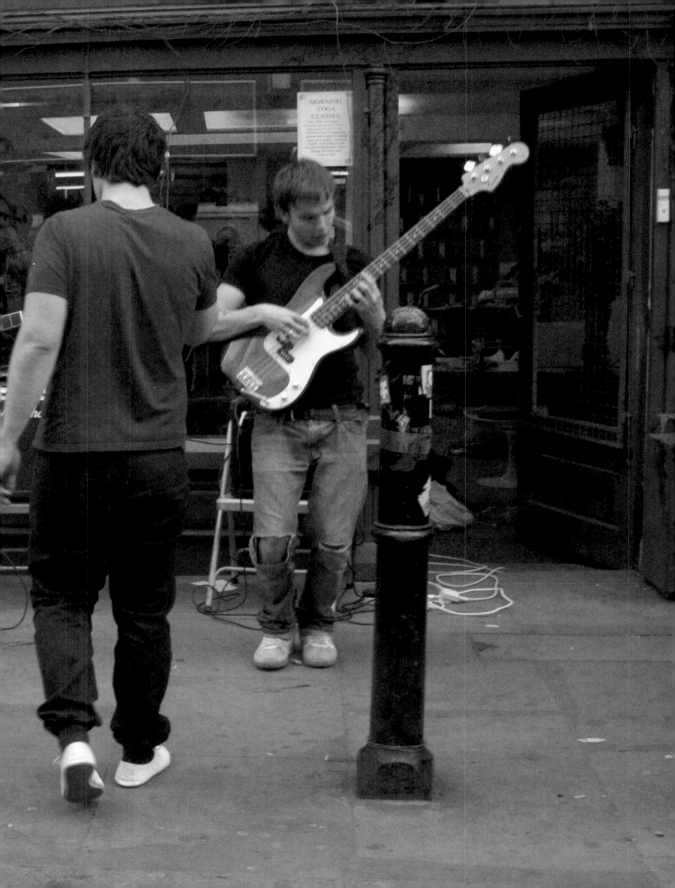

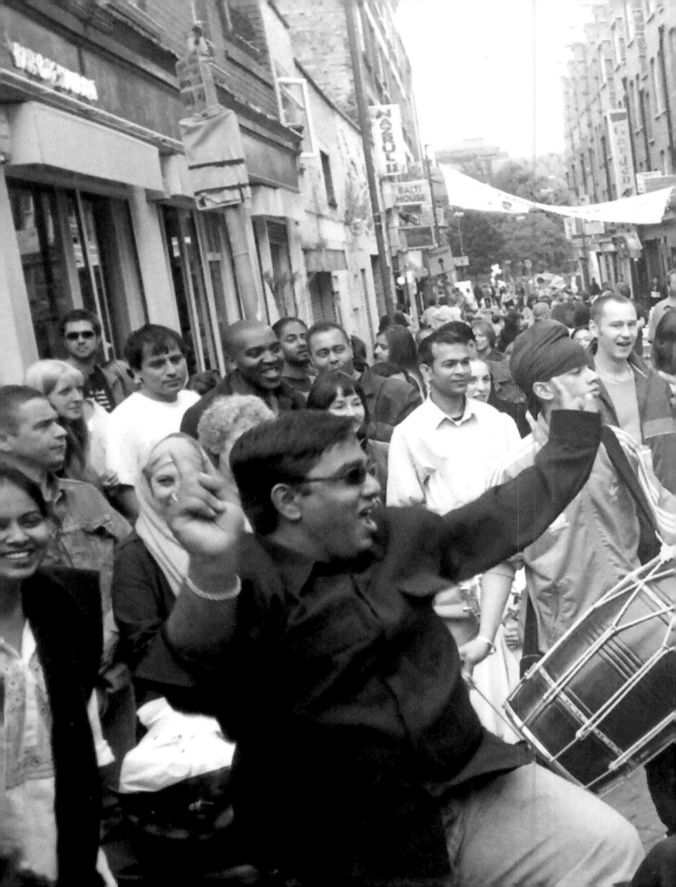

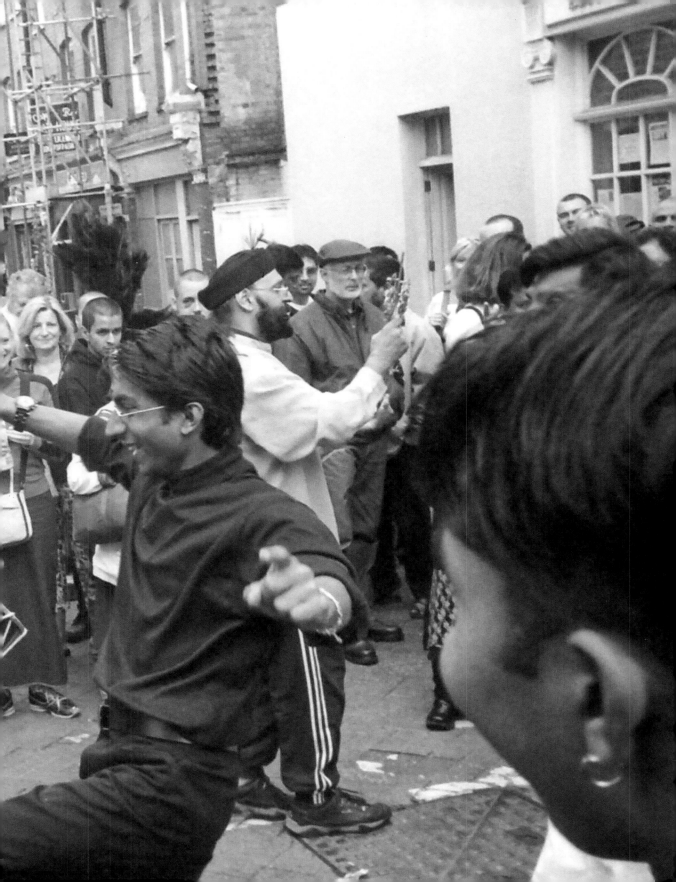

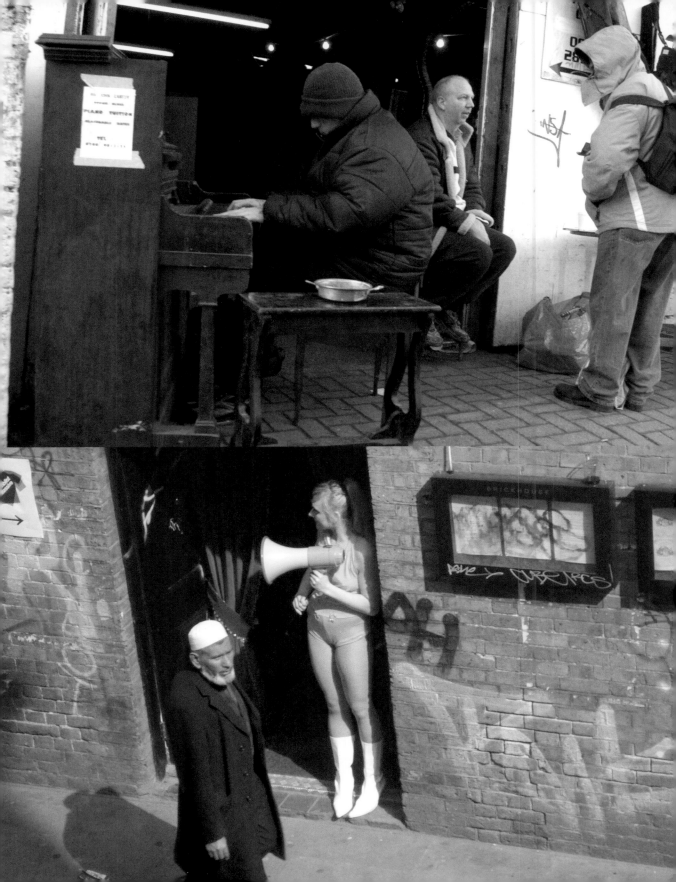

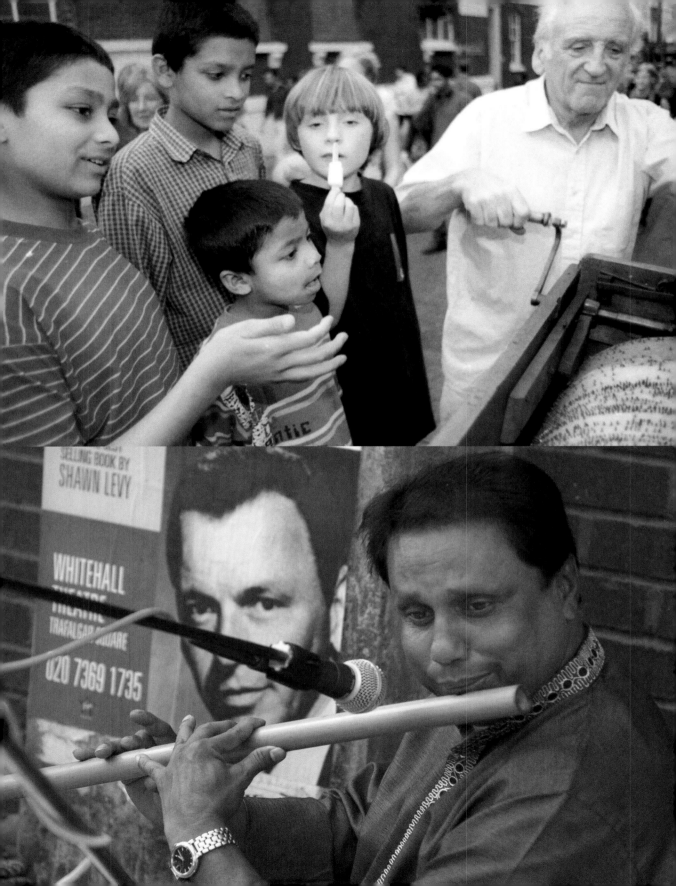

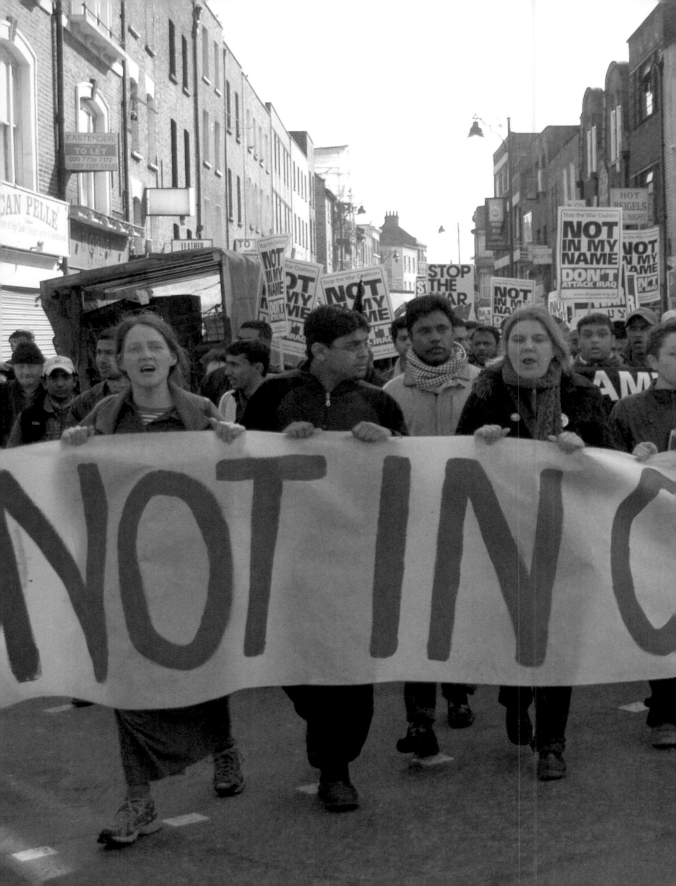

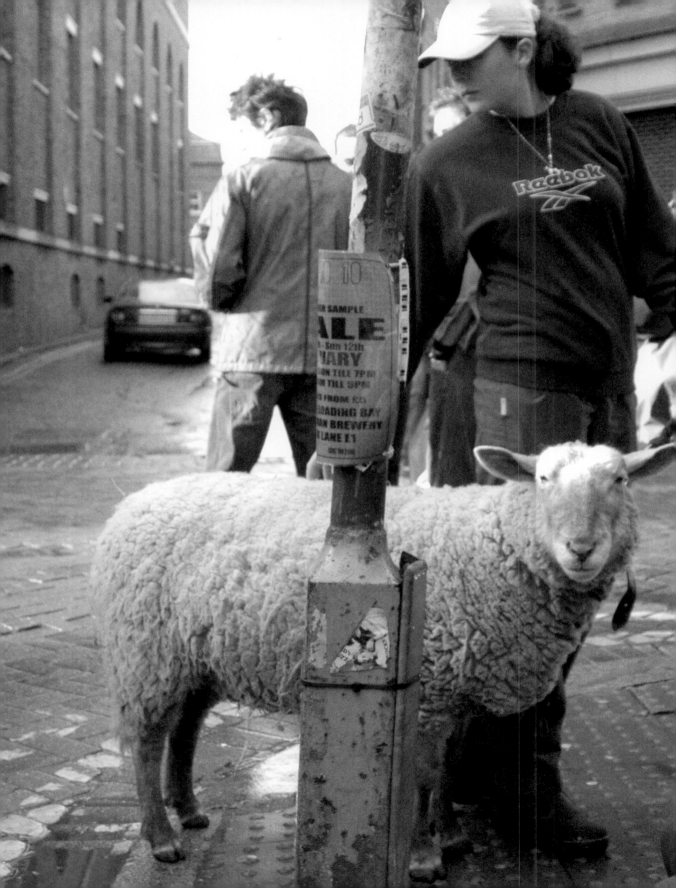

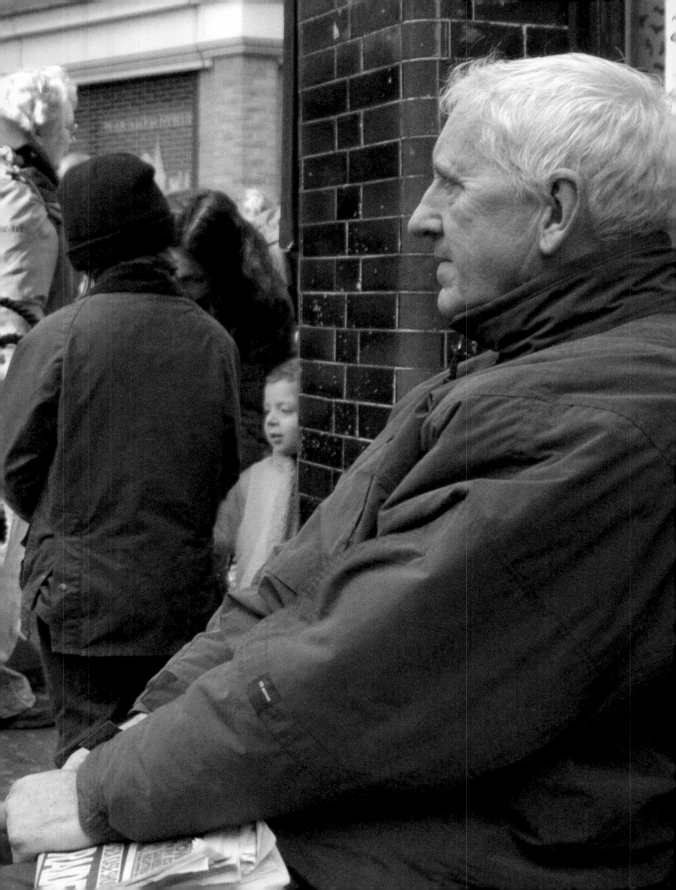

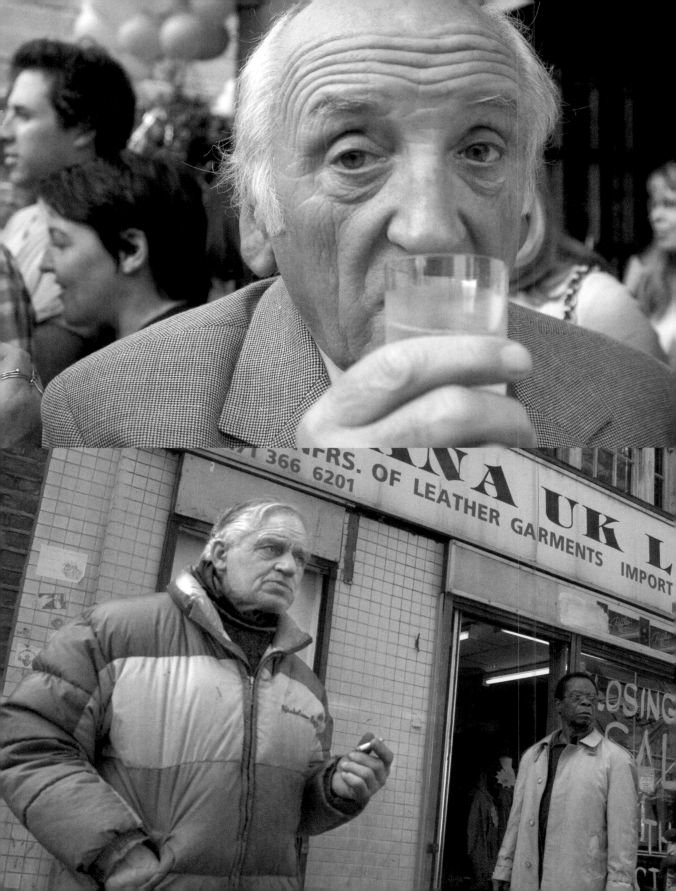

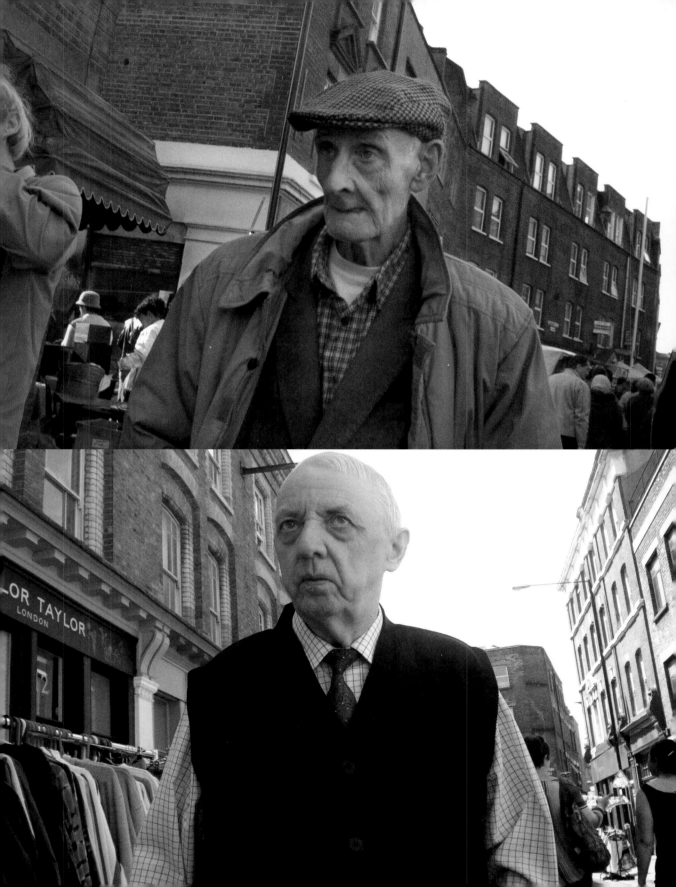

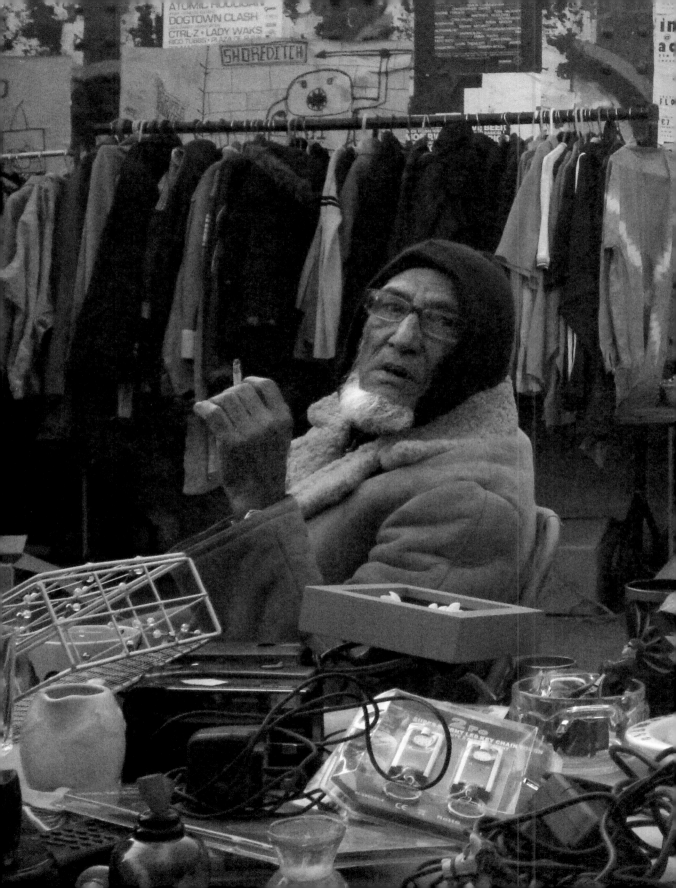

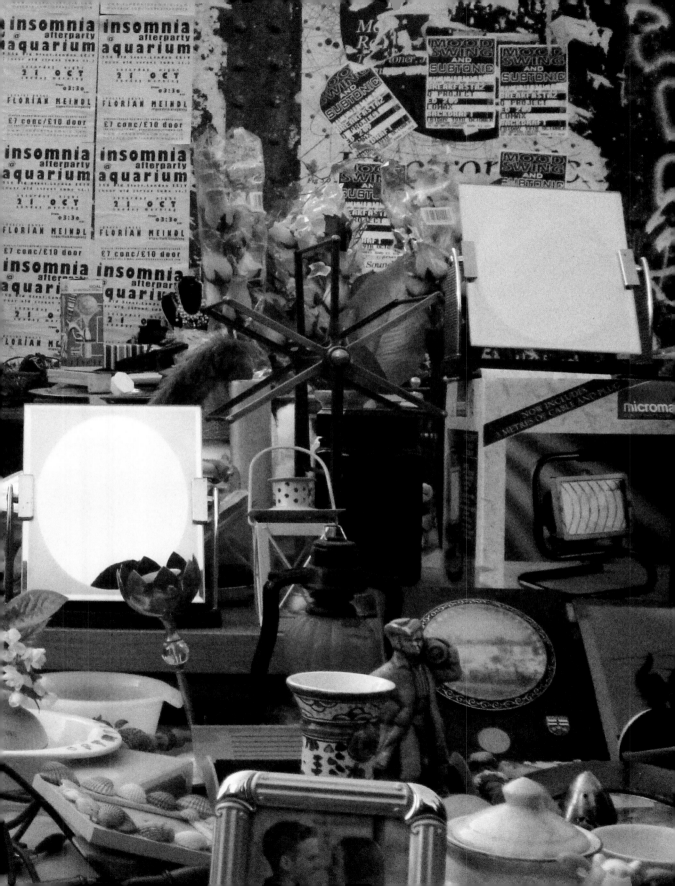

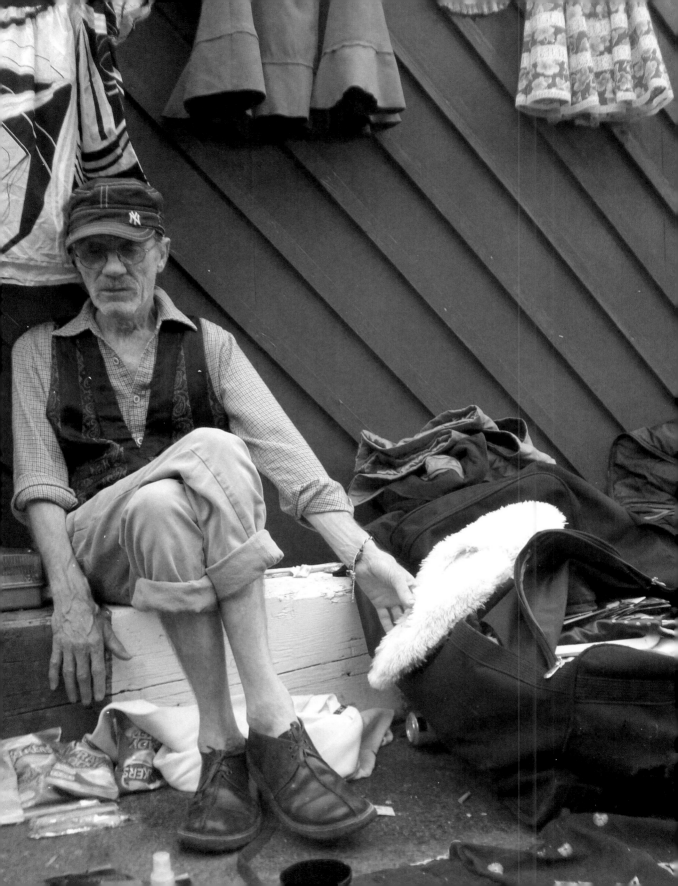

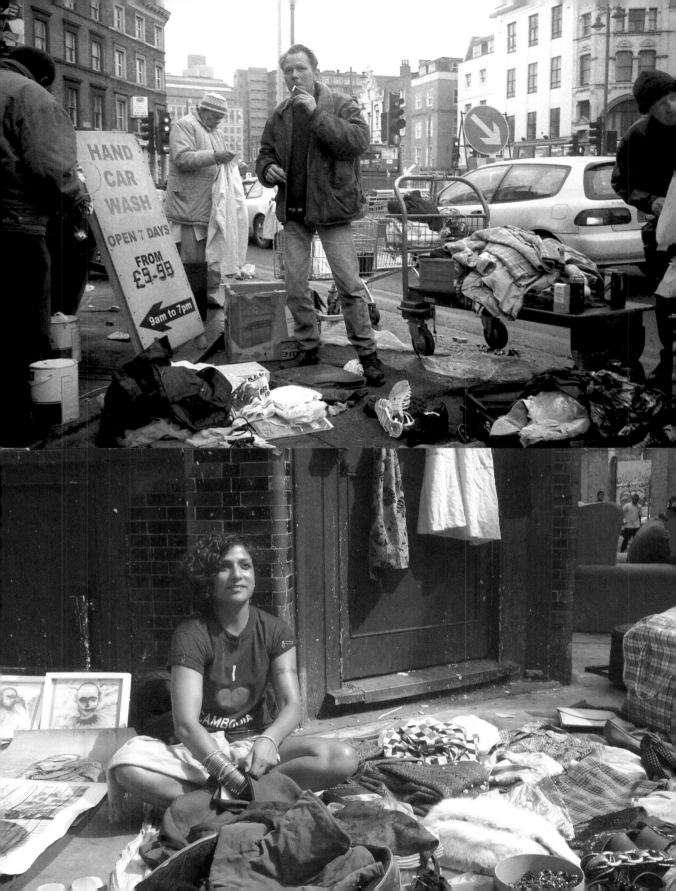

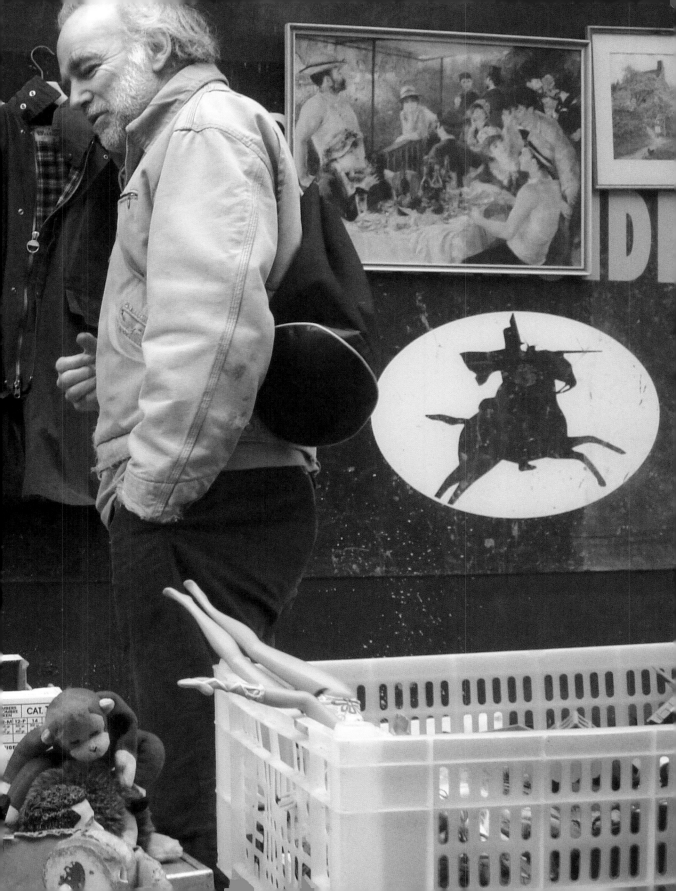

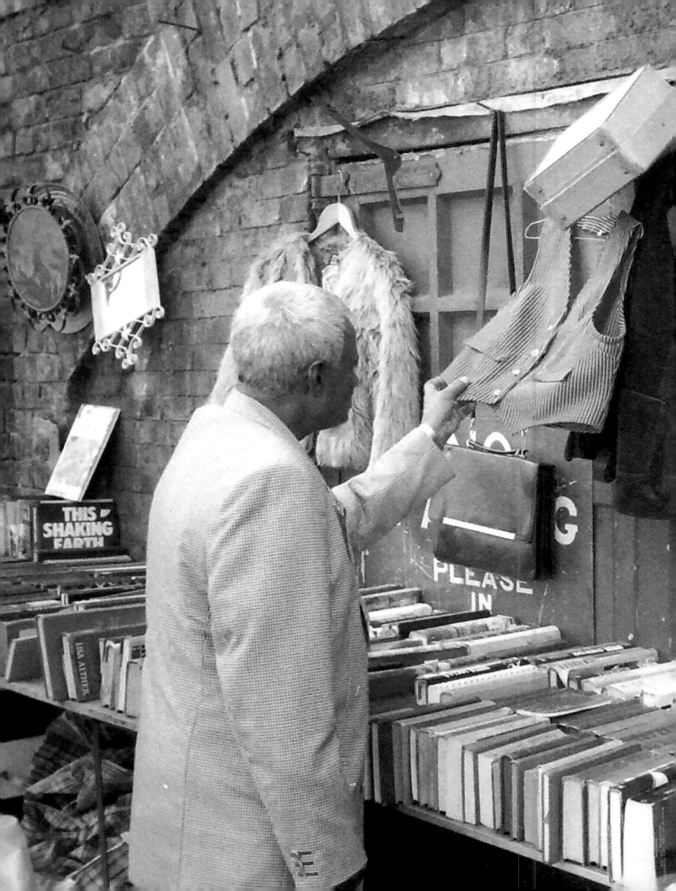

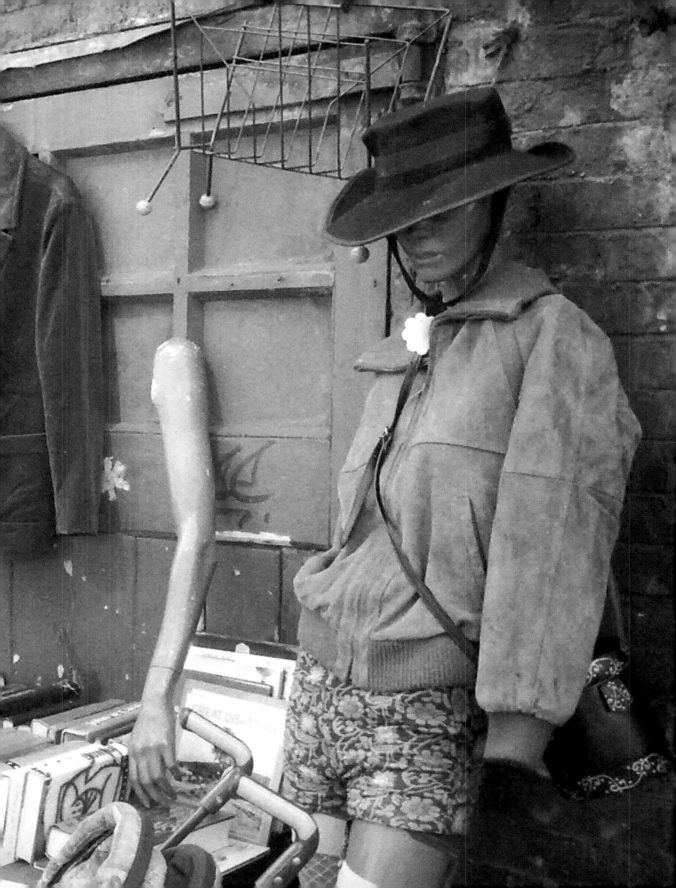

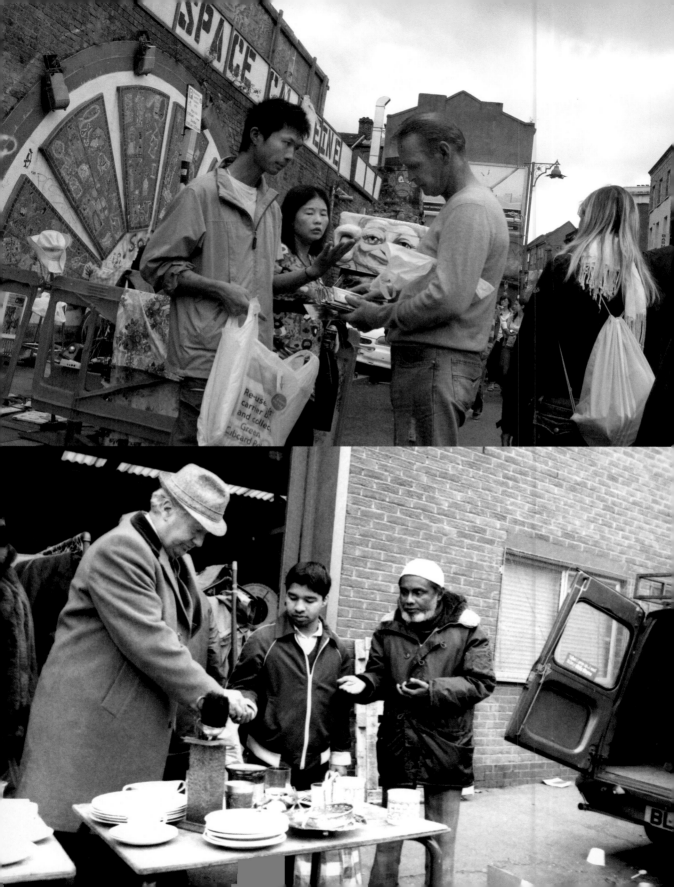

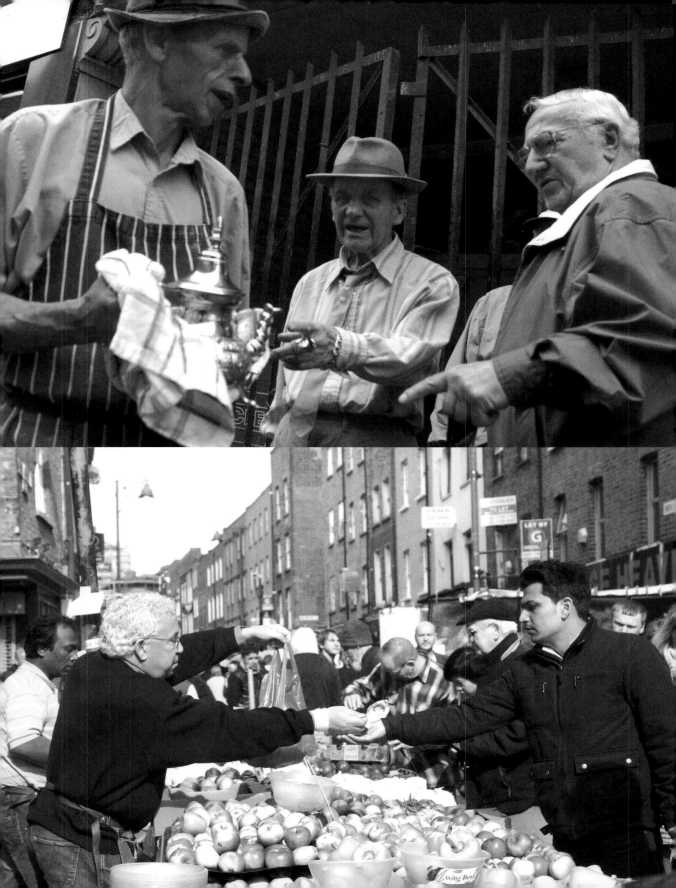

BURGER BAR
TEAS COFFEE COLD DRINKS

HOT DOG £1.50
HAMBURGER £1.50
¼ POUNDER £1.50
CHEESEBURGER £2.00
EGG BURGER £2.00
BACON Roll £1.50
TEA 50p
COFFEE 60p
HOT CHOCOLATE 80p

NEWS
FLASH

FROM SATURDAY
7 JUNE 2008

THIS BRICK LANE
MARKET WILL BE
OPENING 10AM
TO 3PM EVERY
SATURDAY

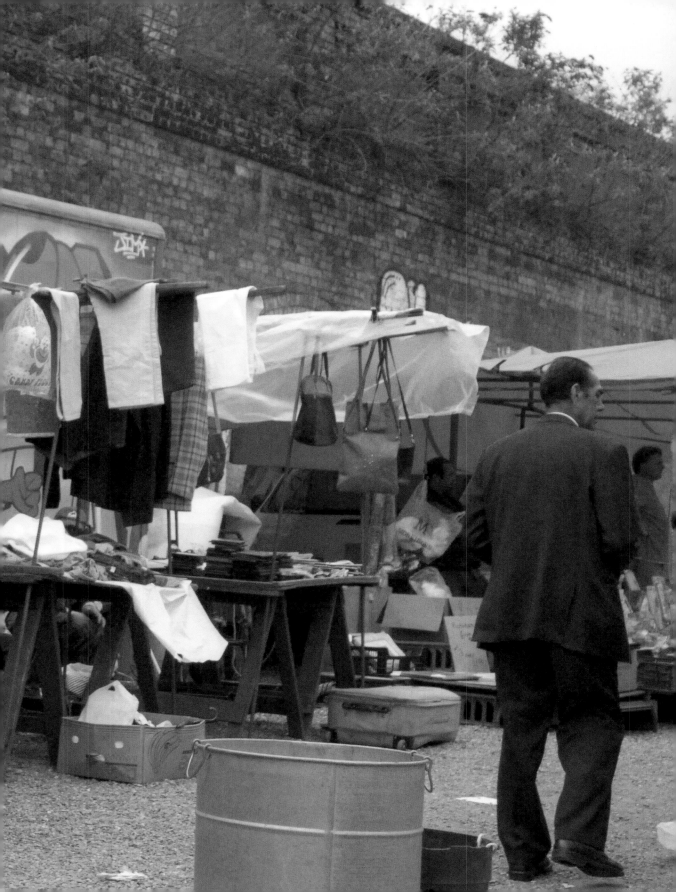

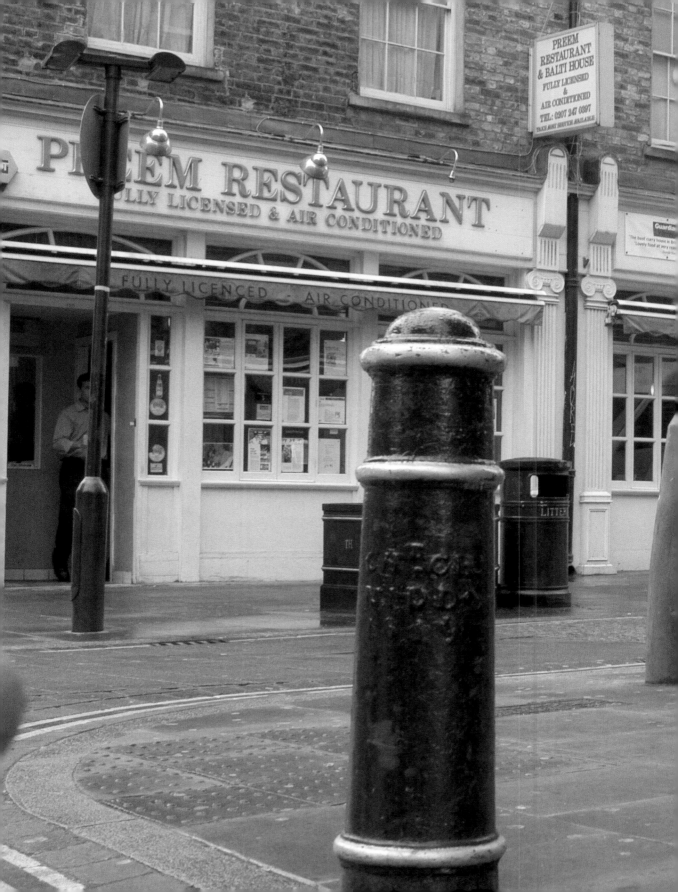

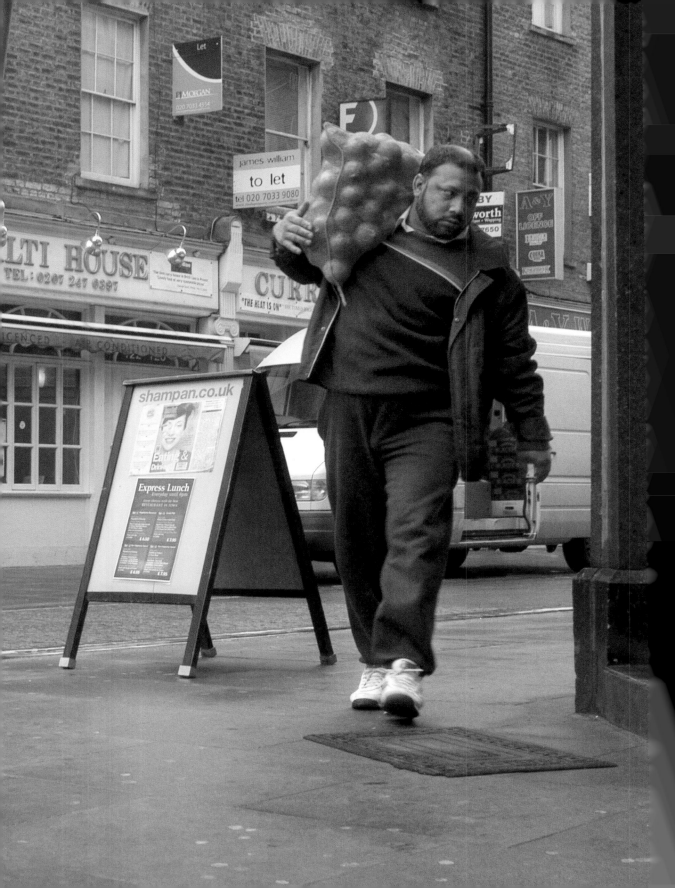

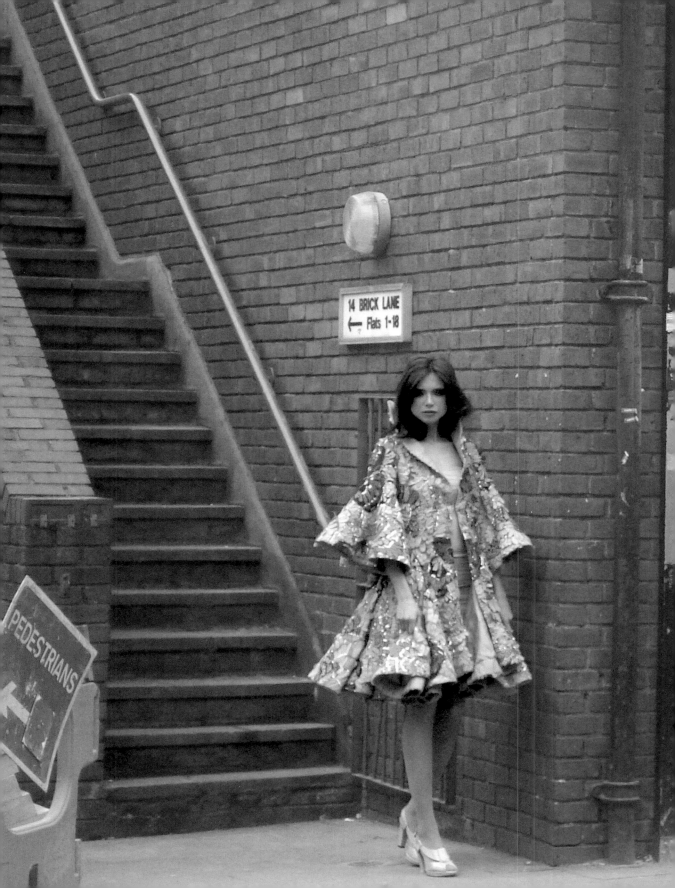

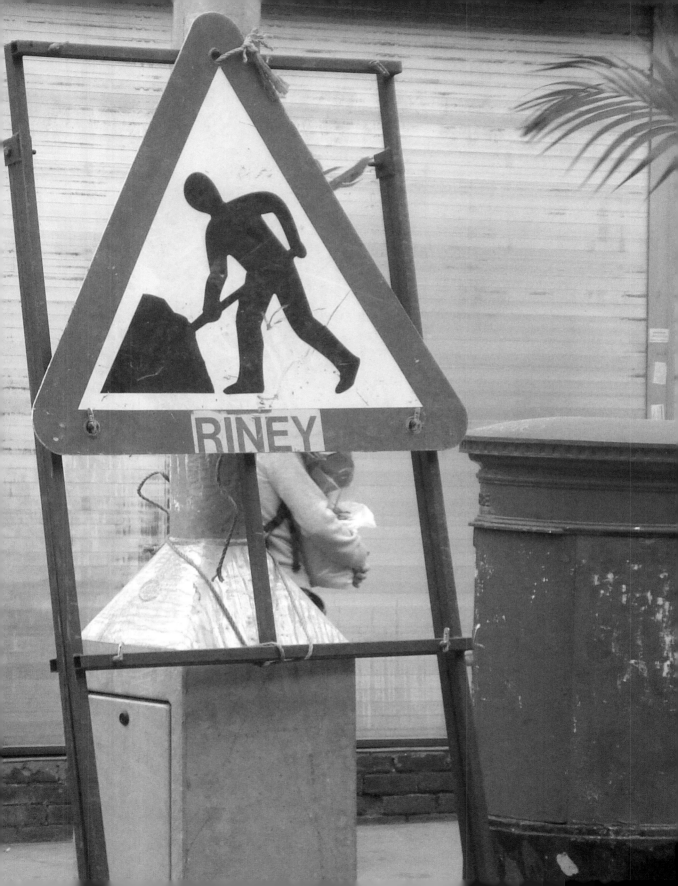

RINEY

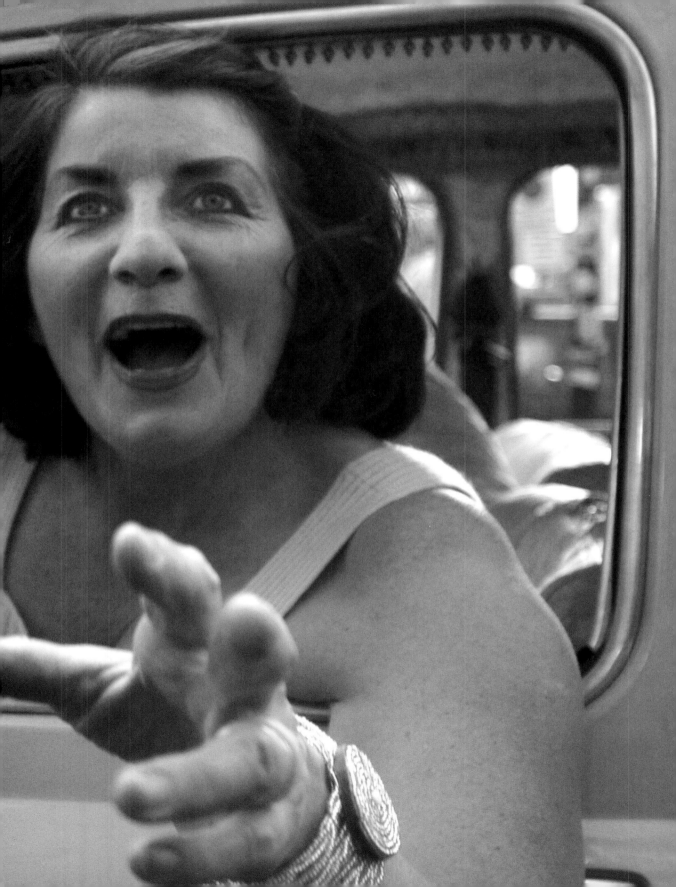

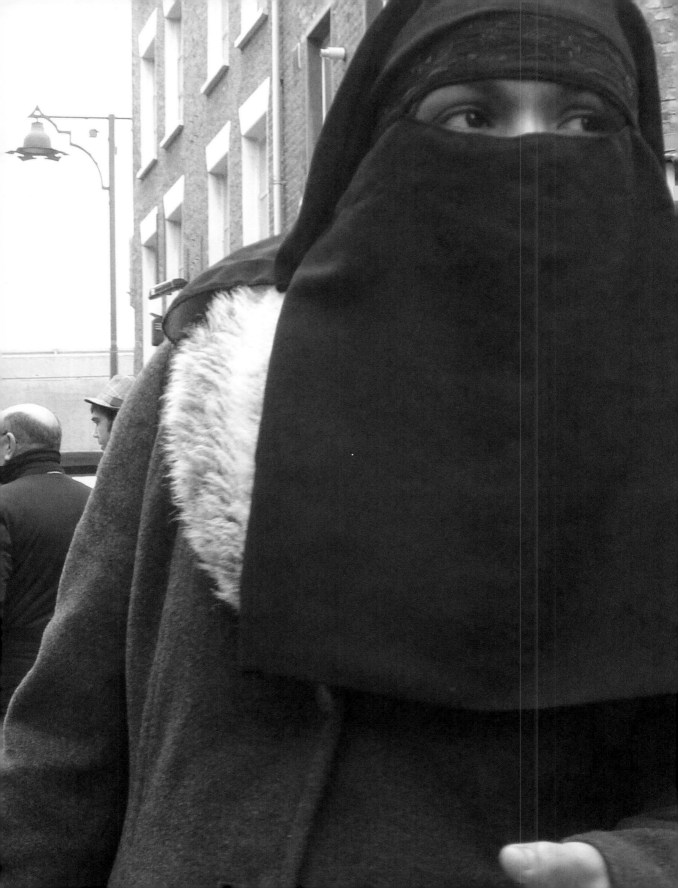

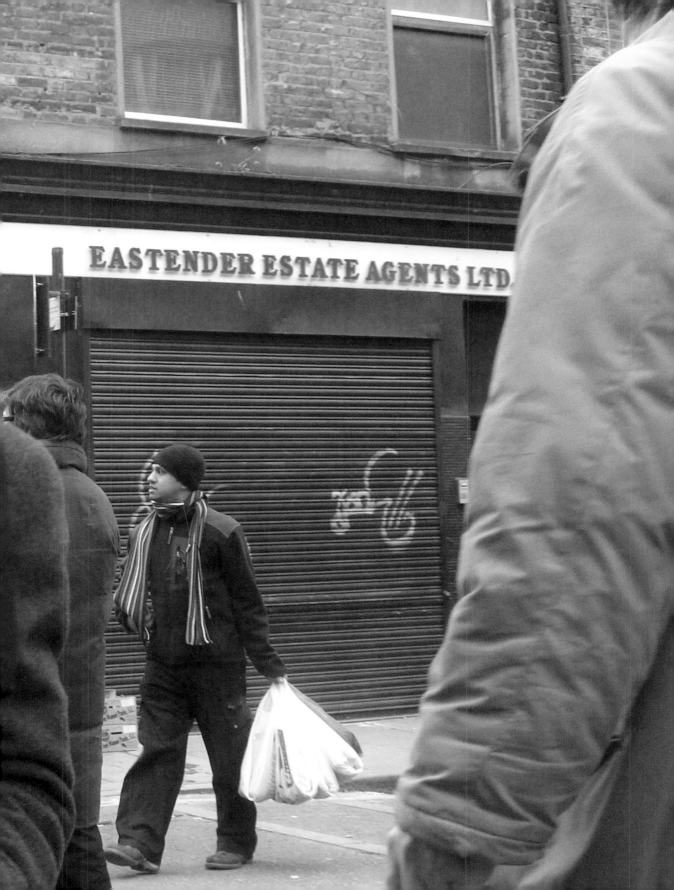

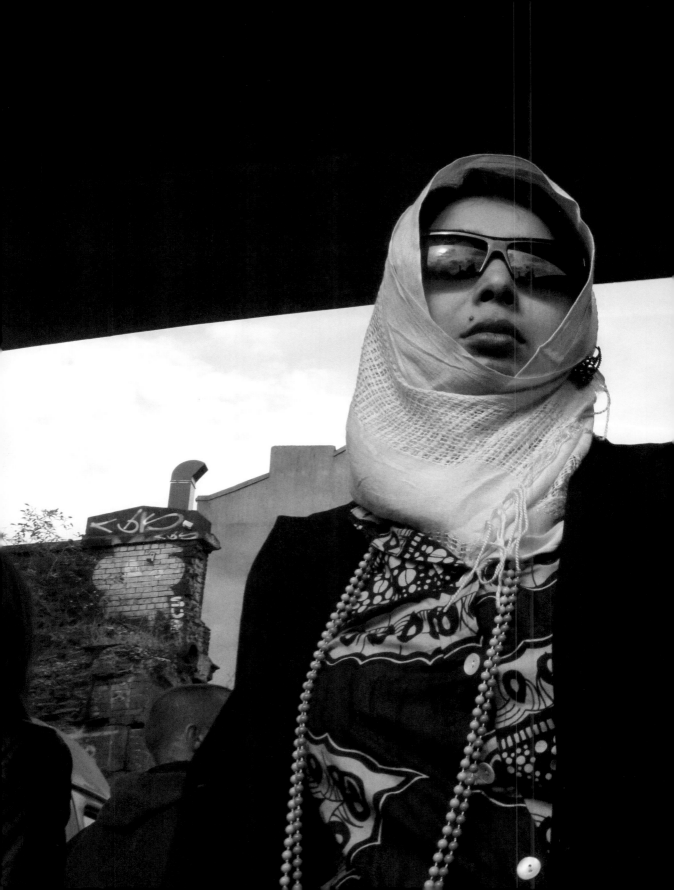

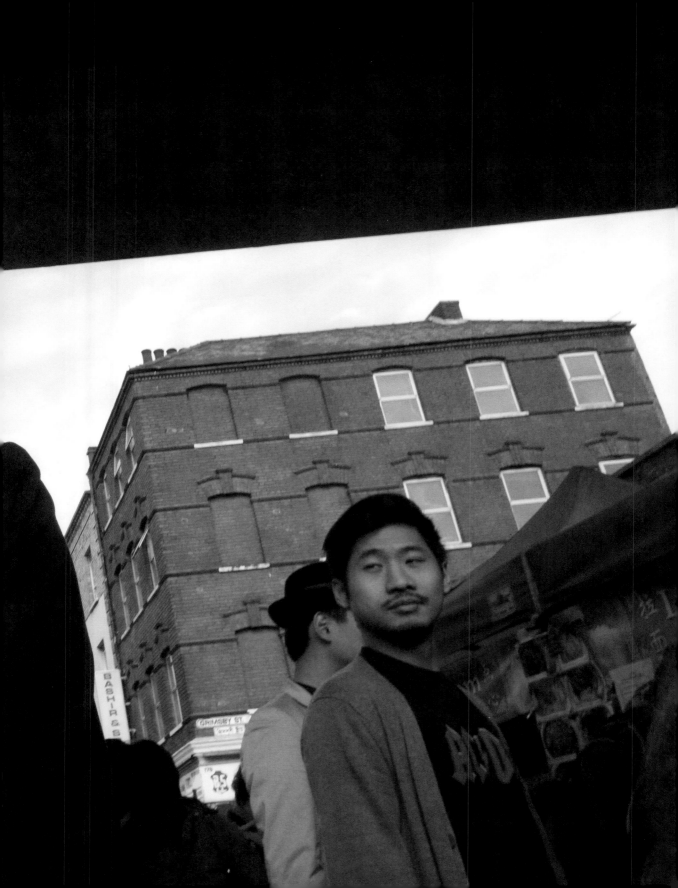

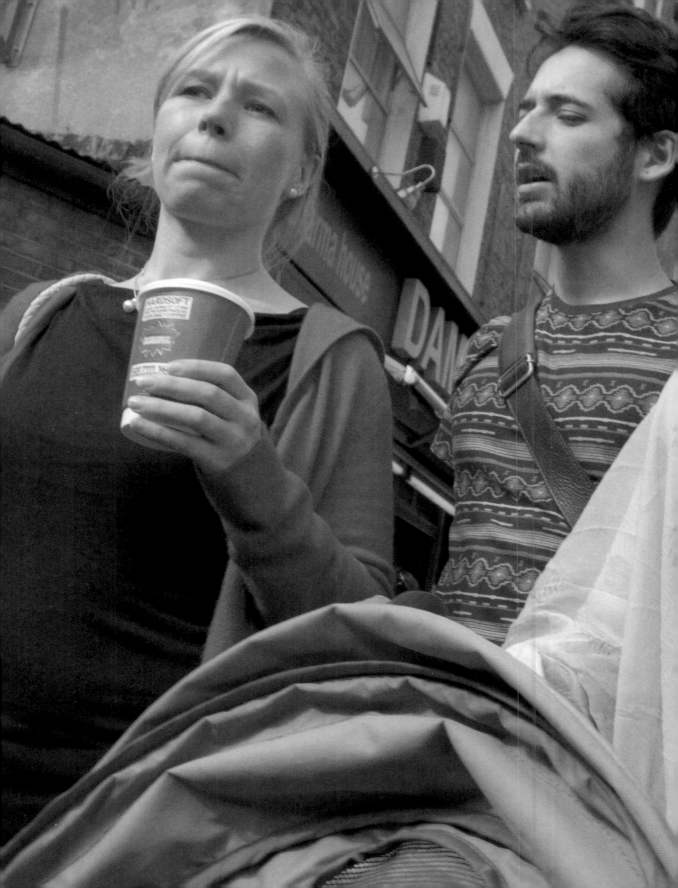

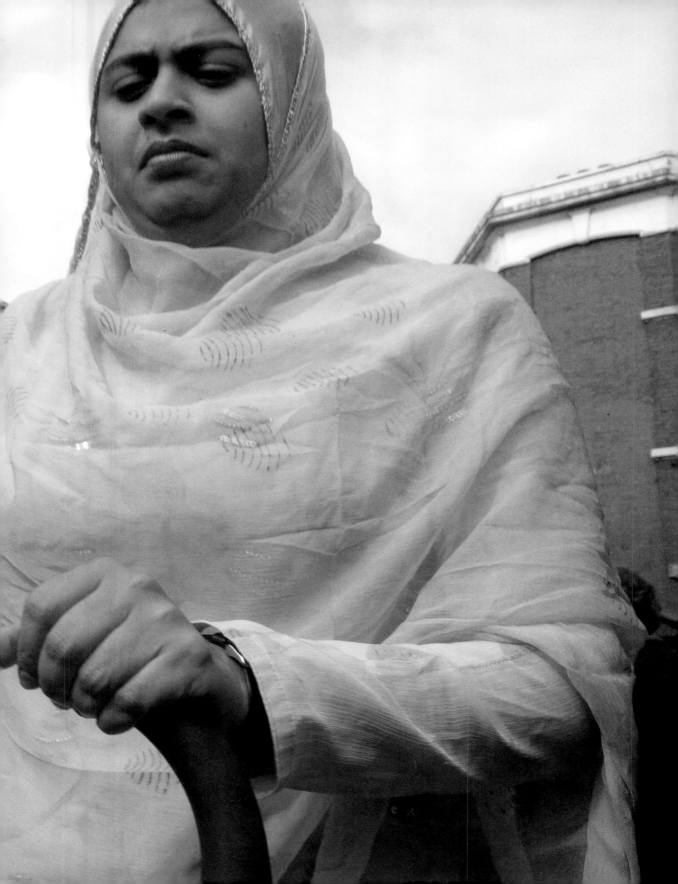

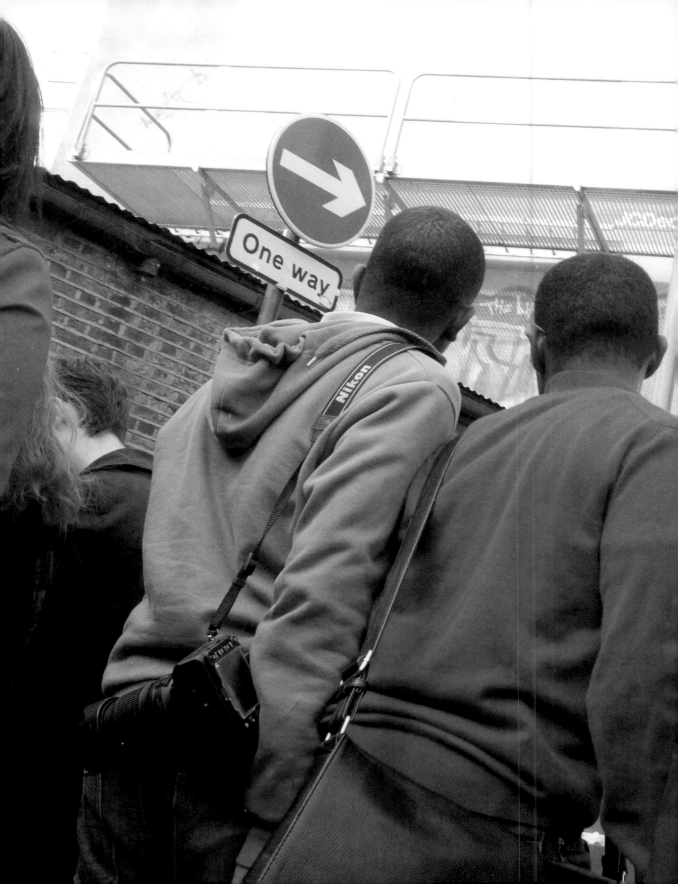

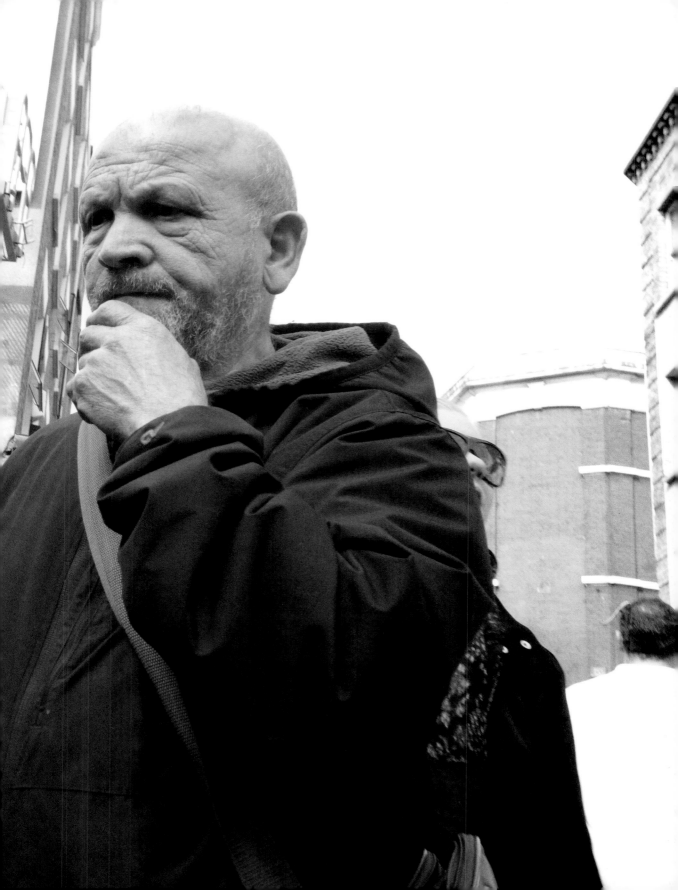

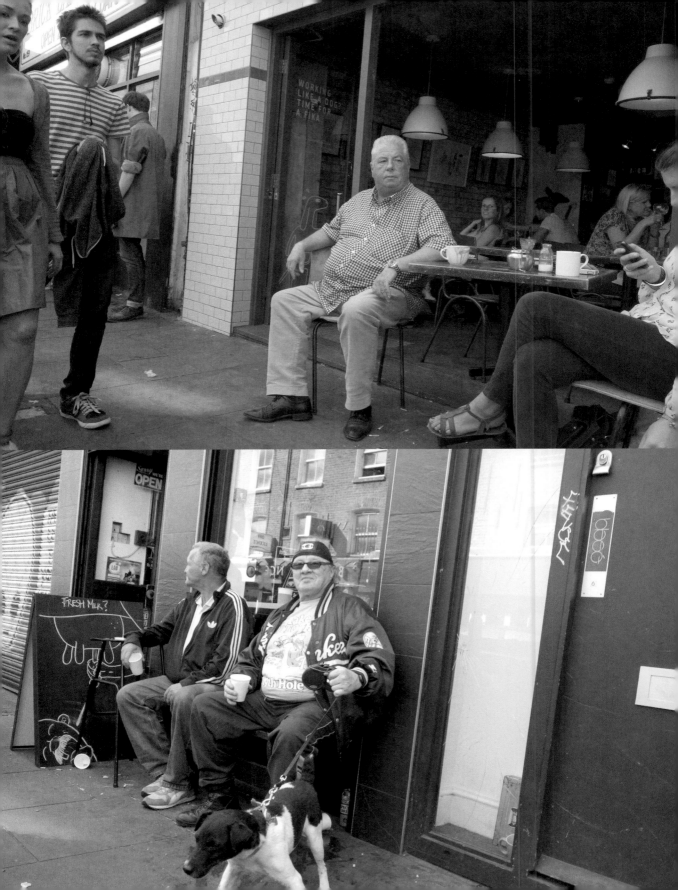

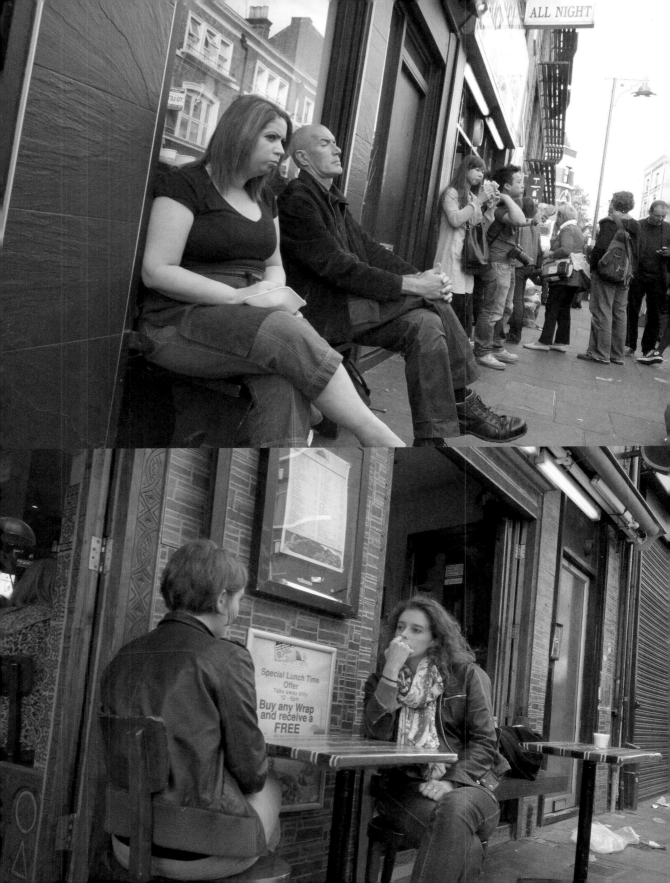

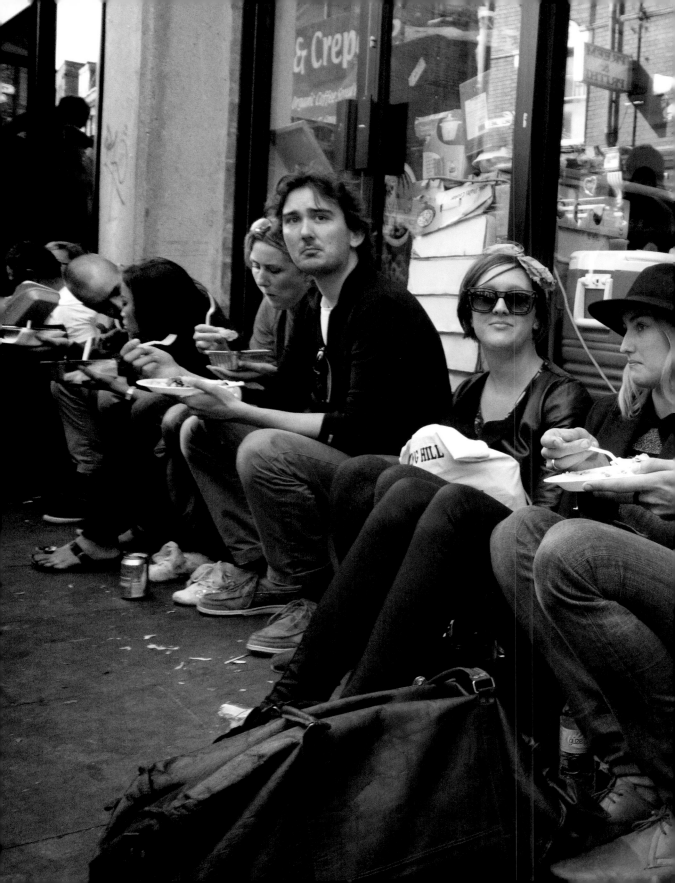

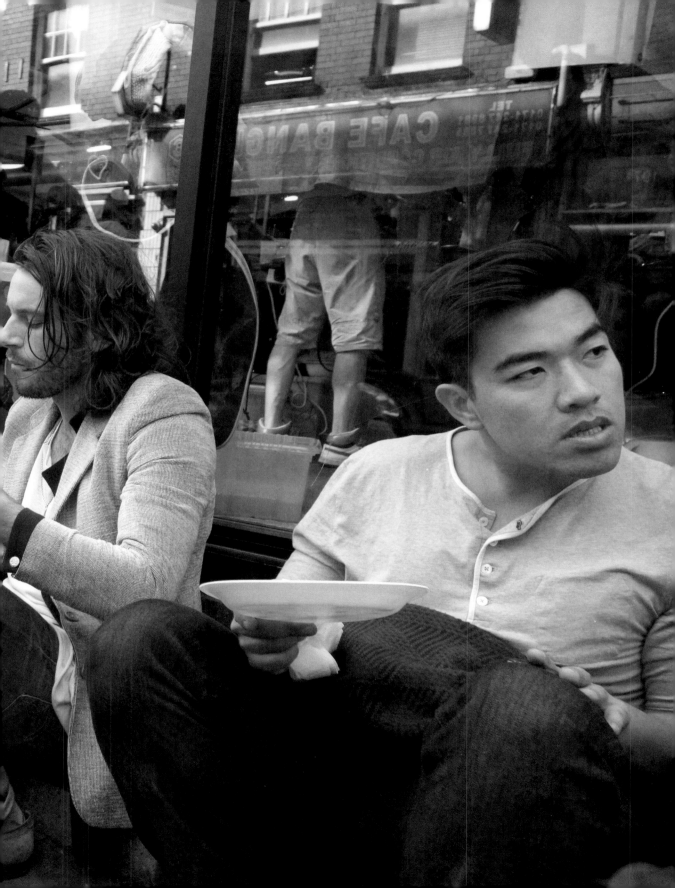

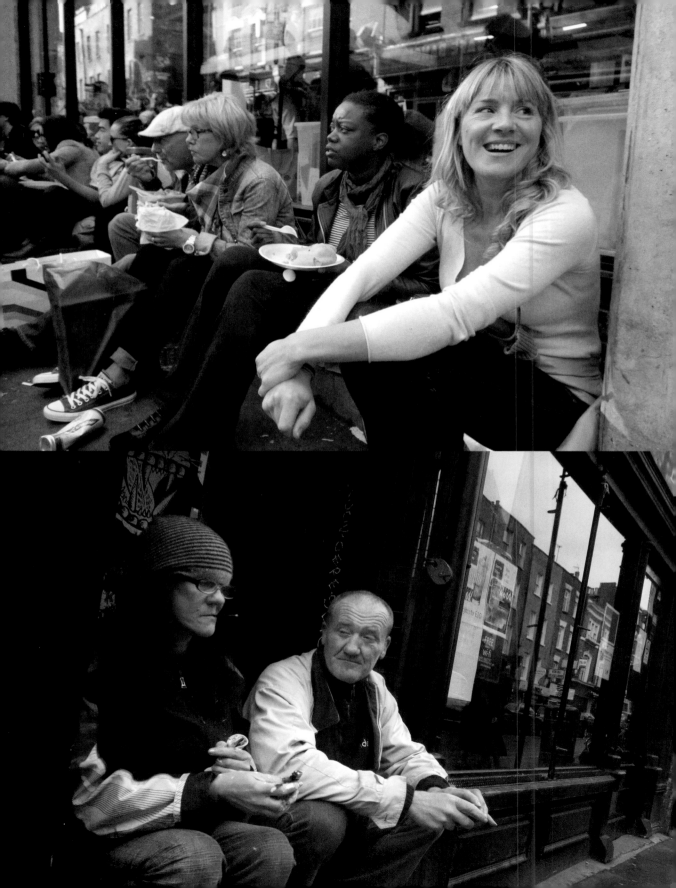

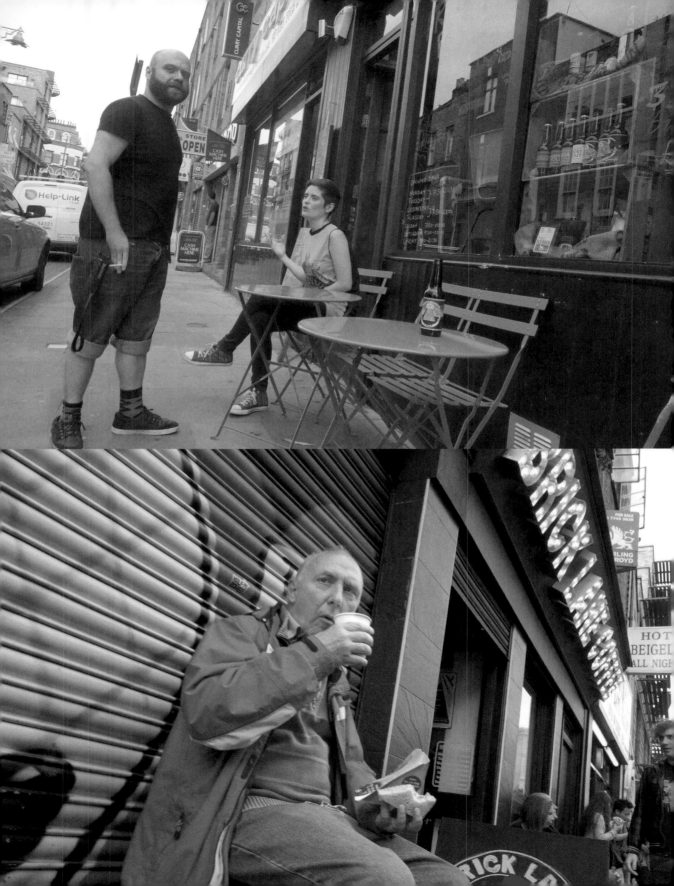

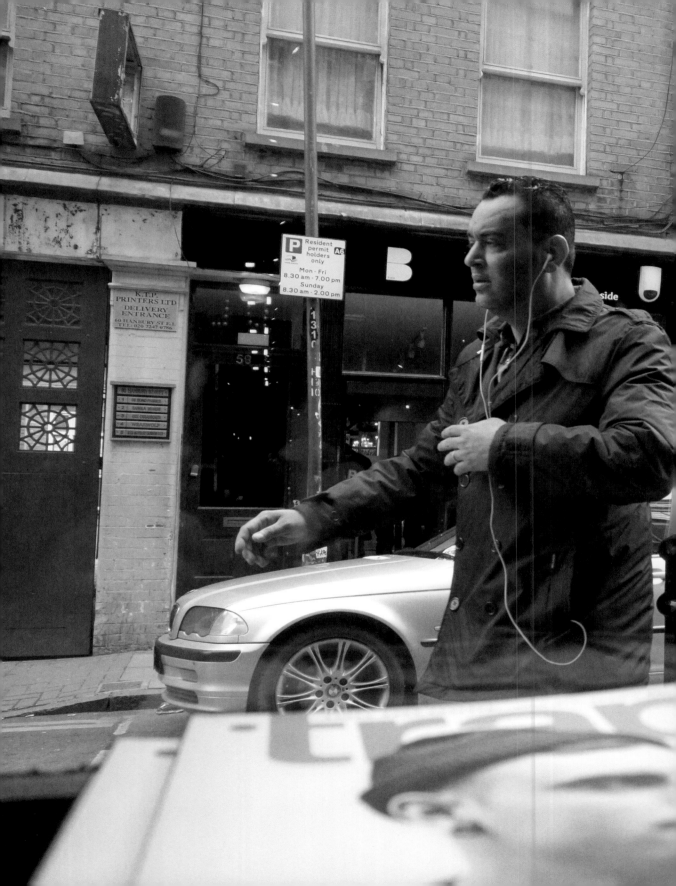

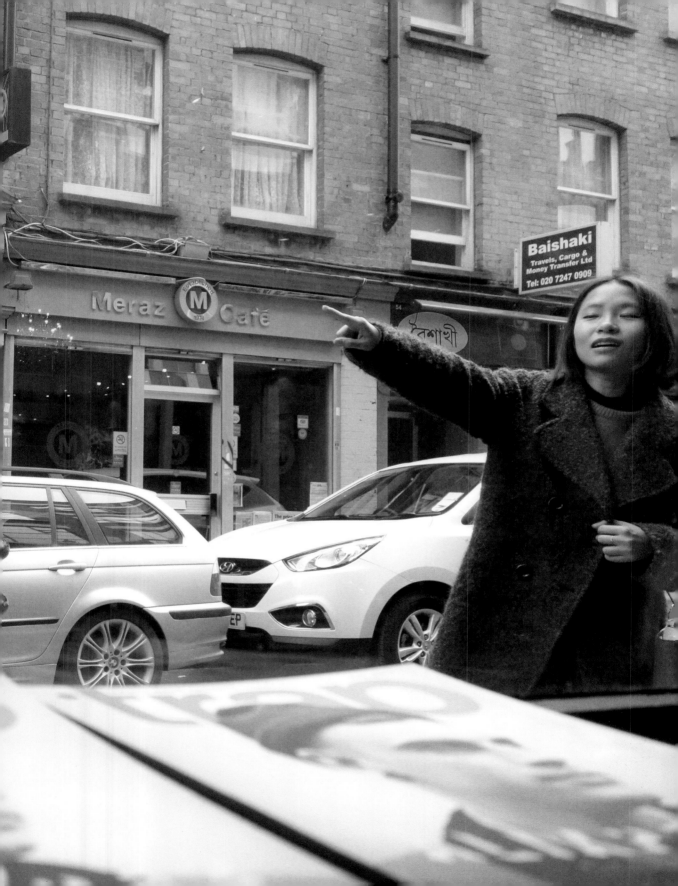

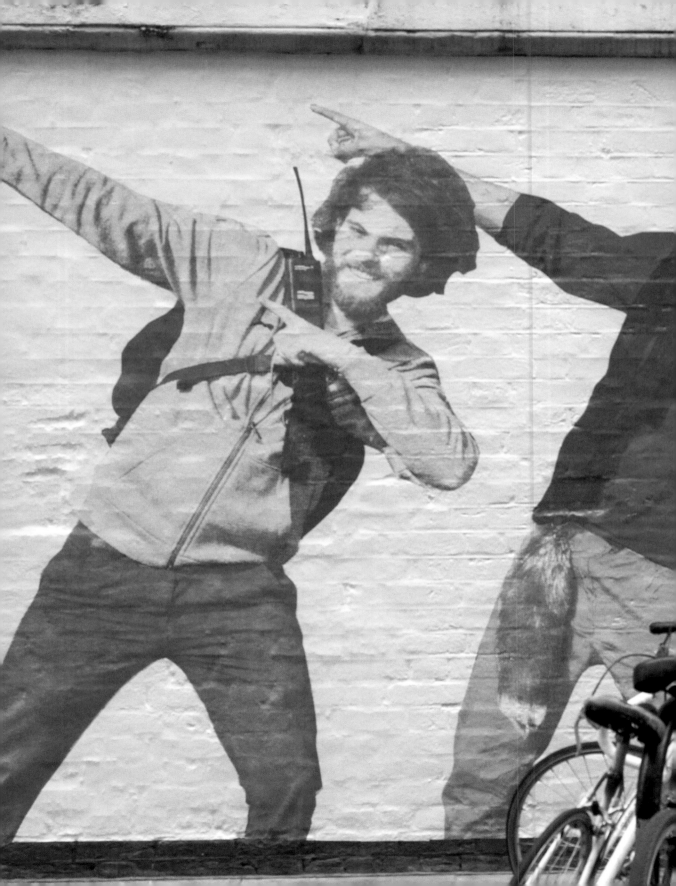

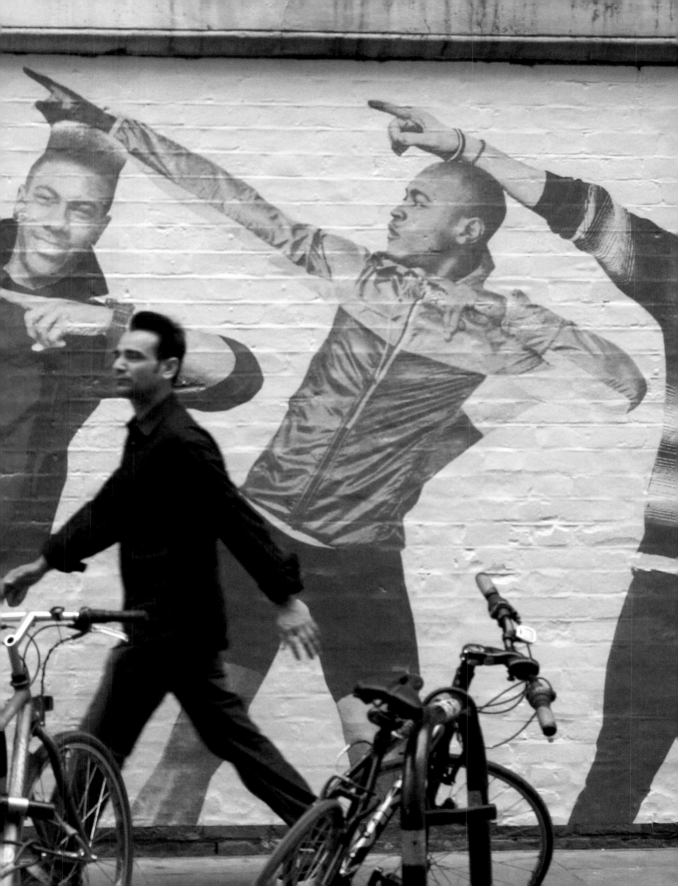

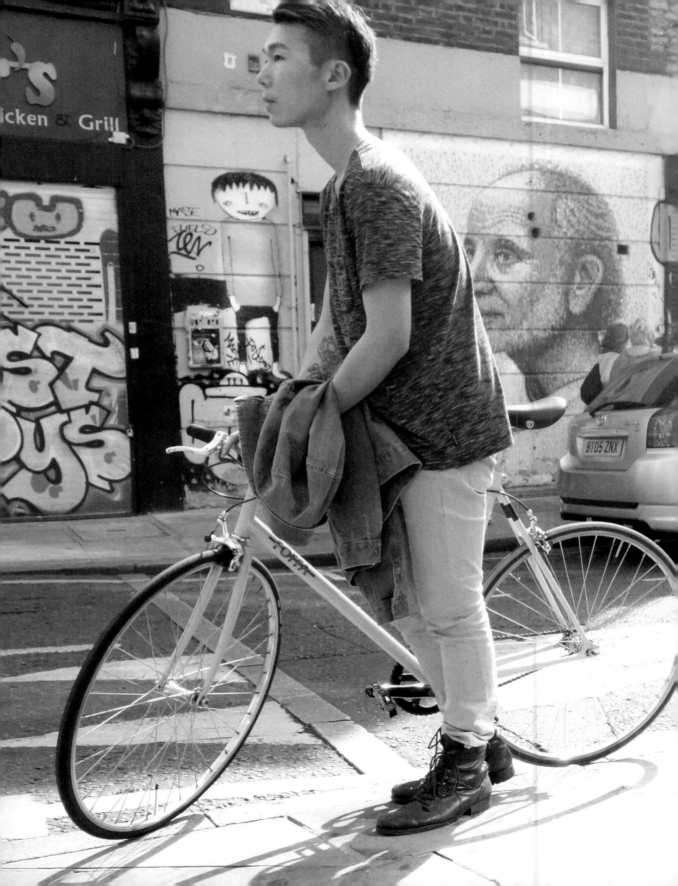

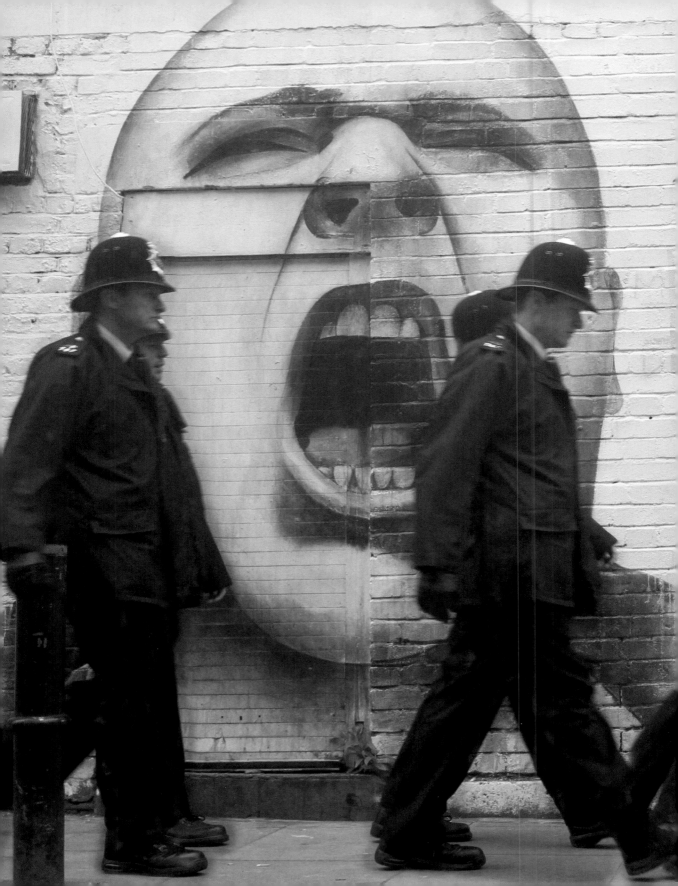

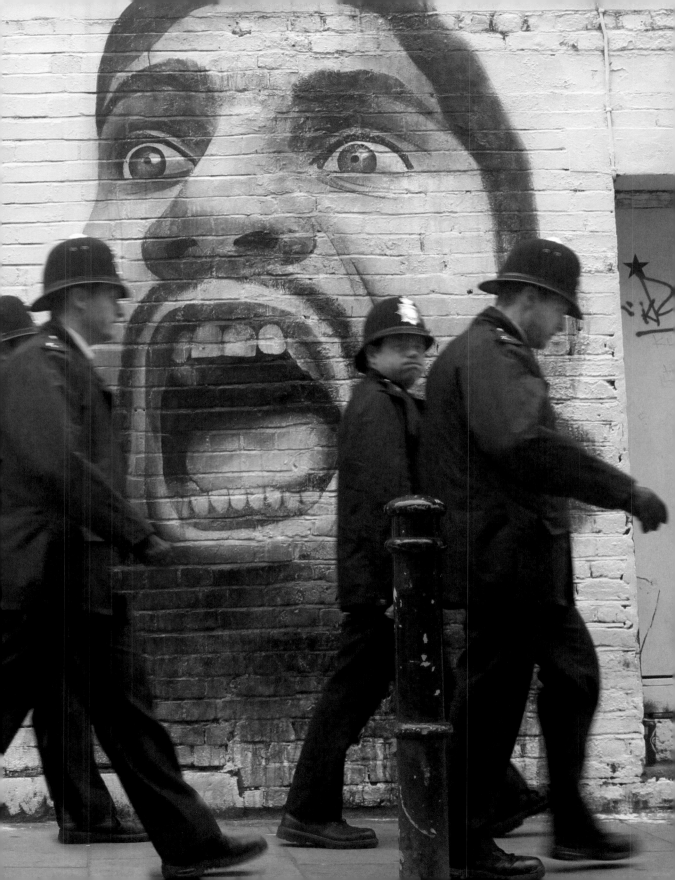

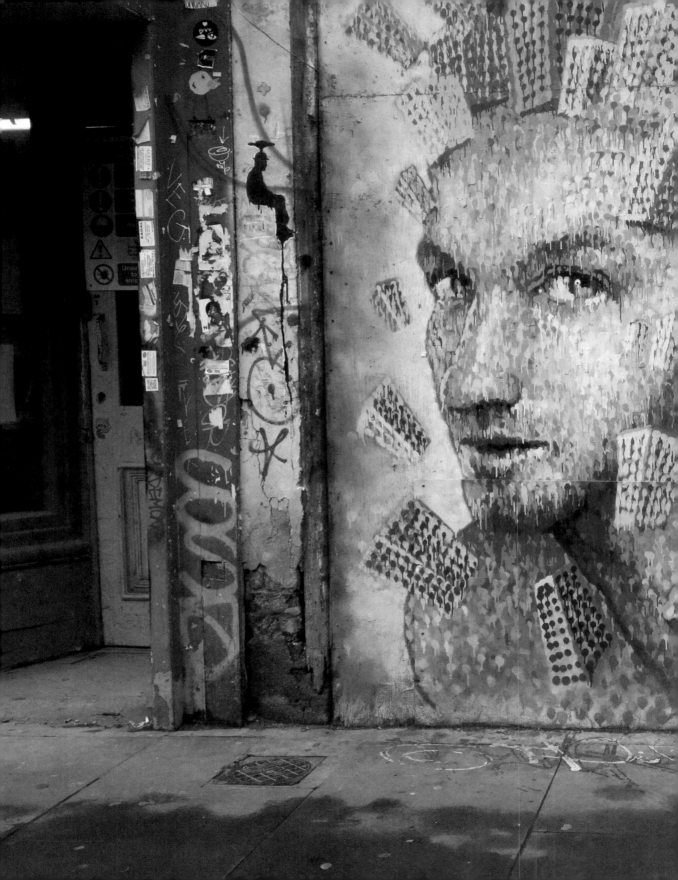

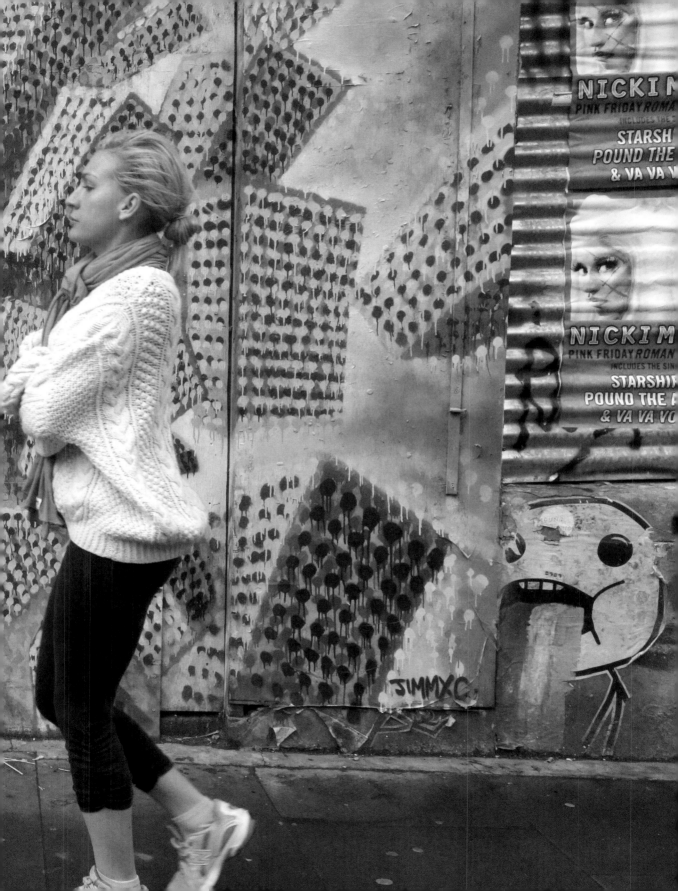

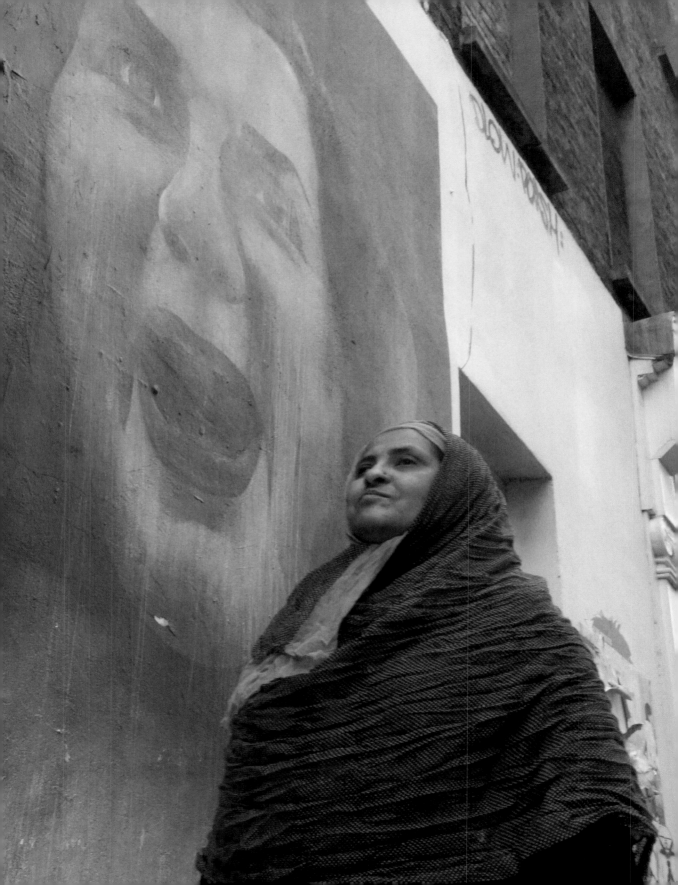

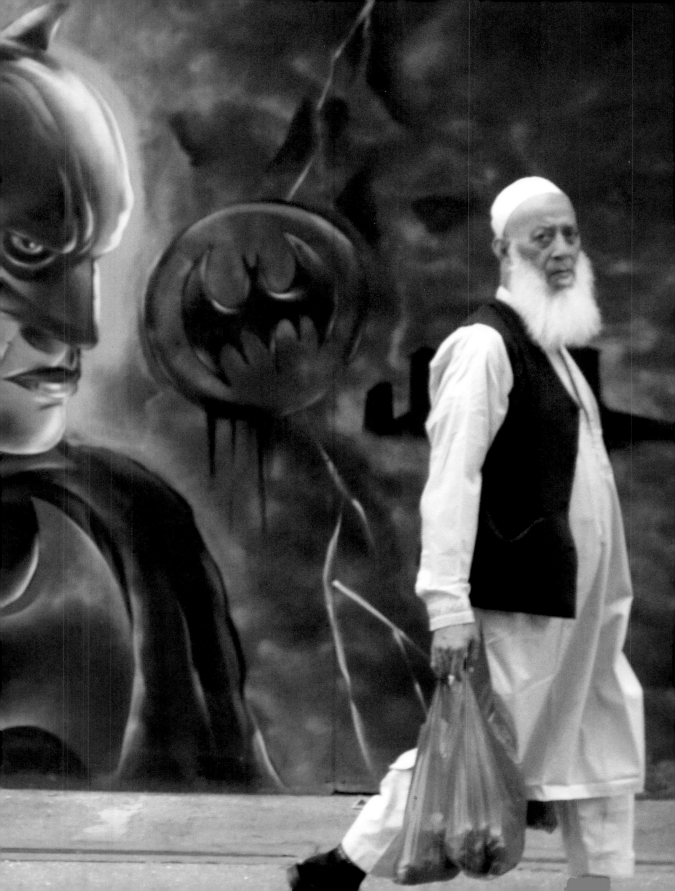

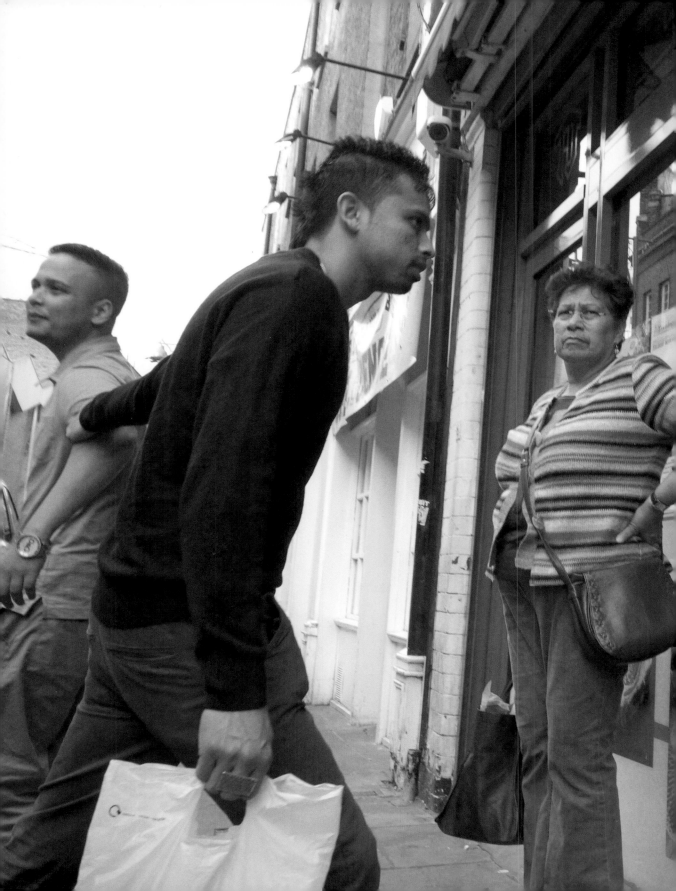

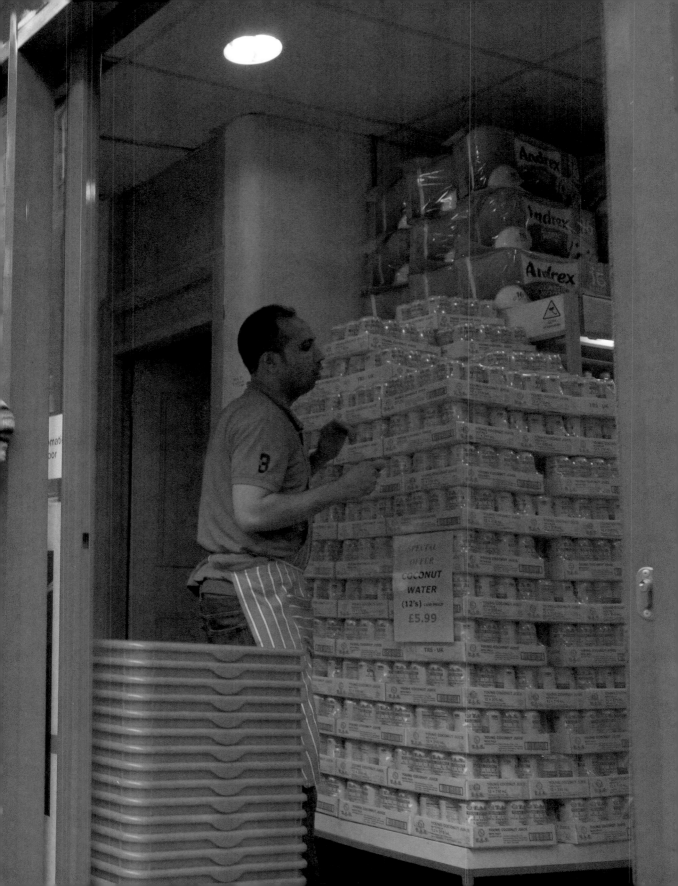

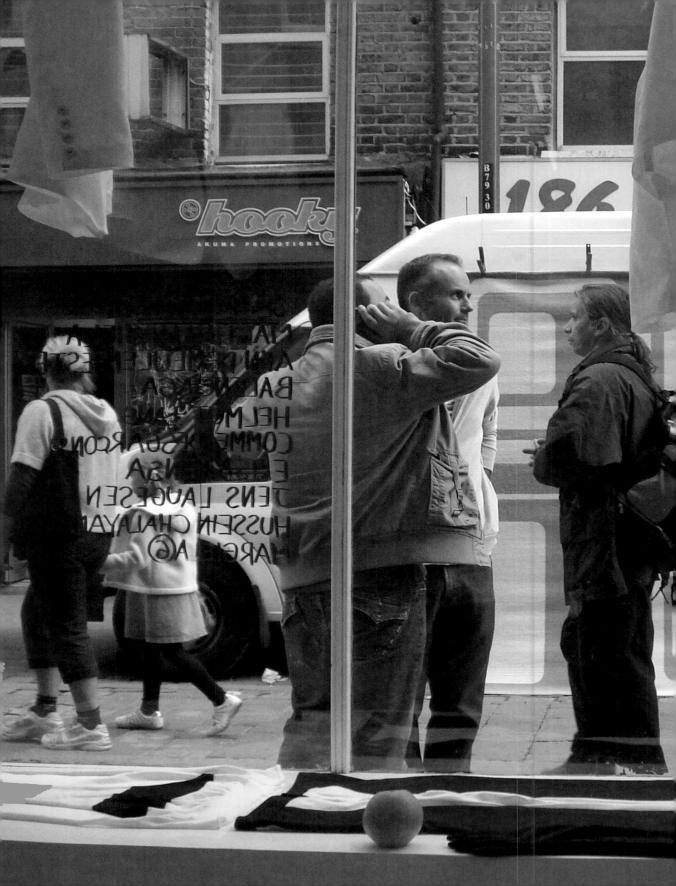

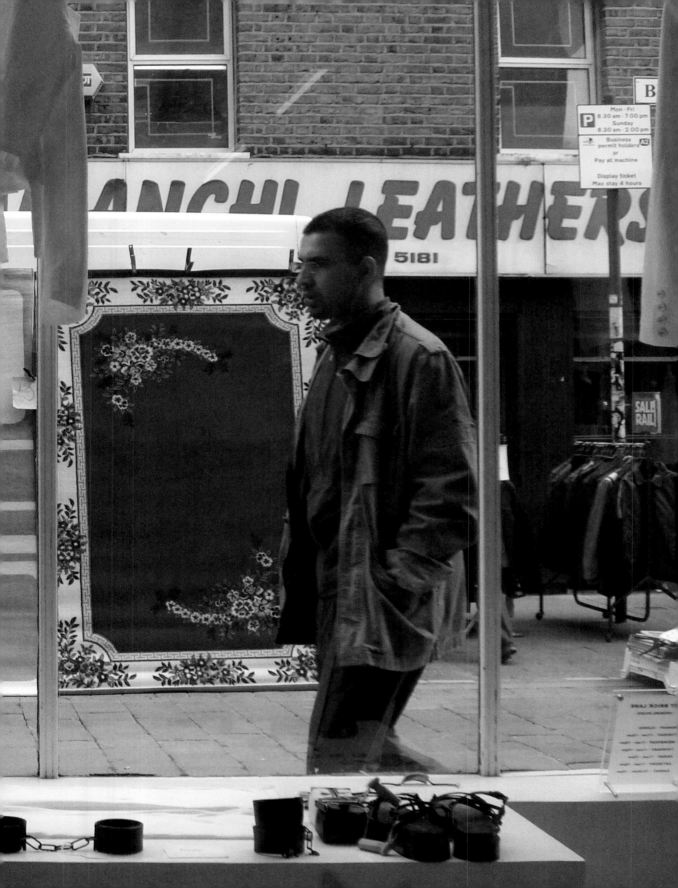

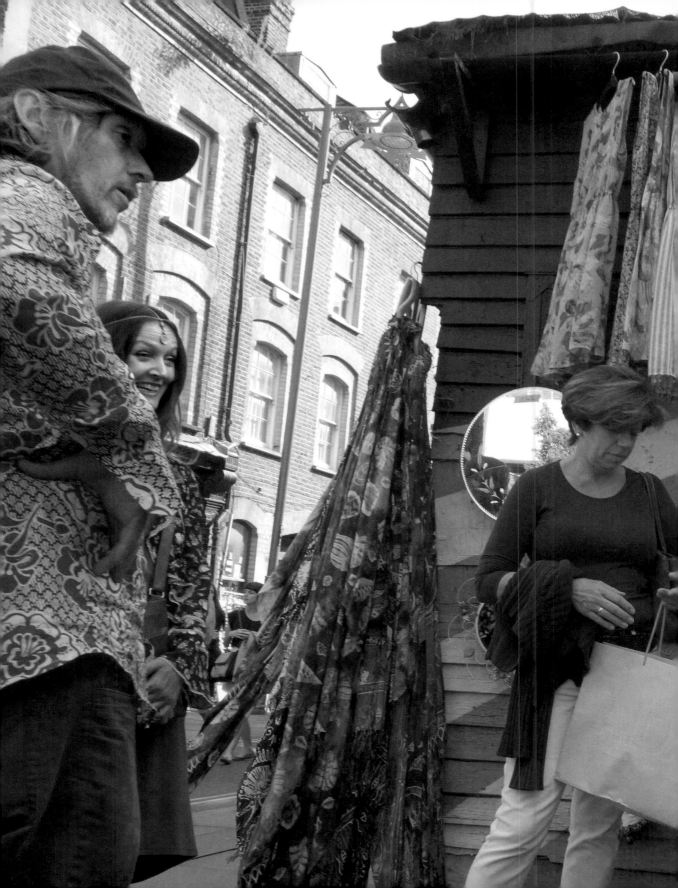

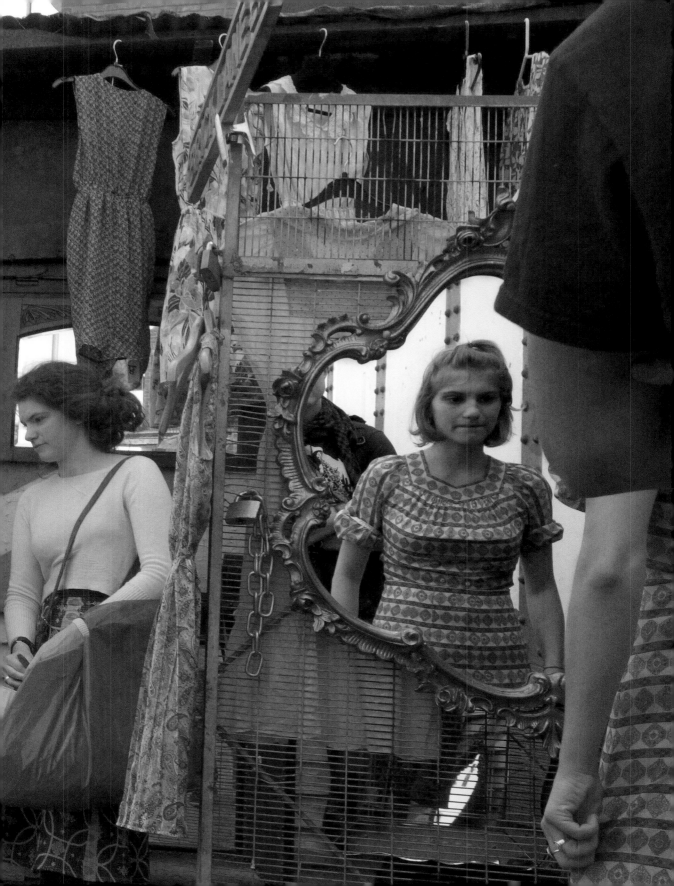

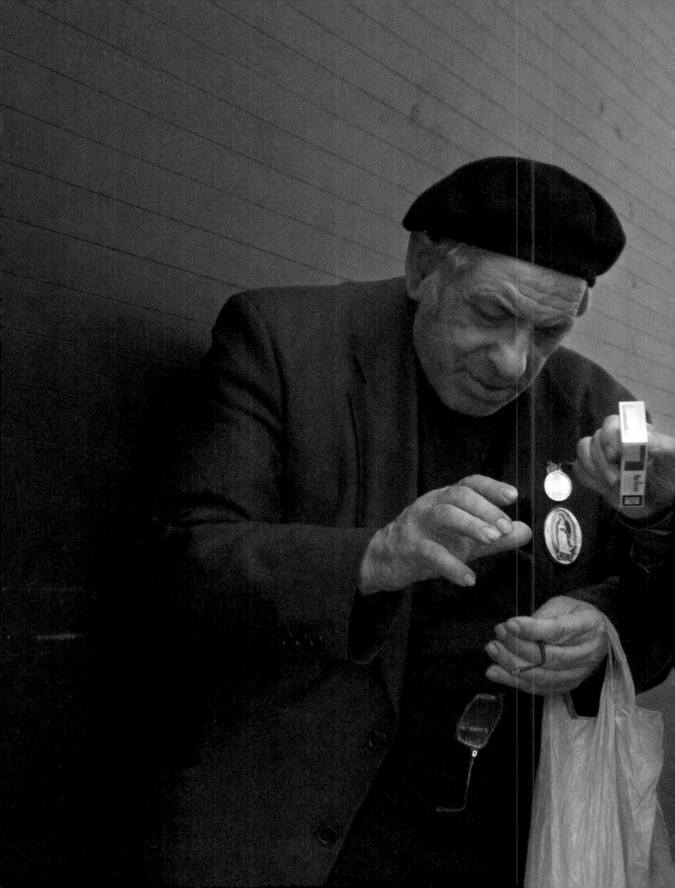

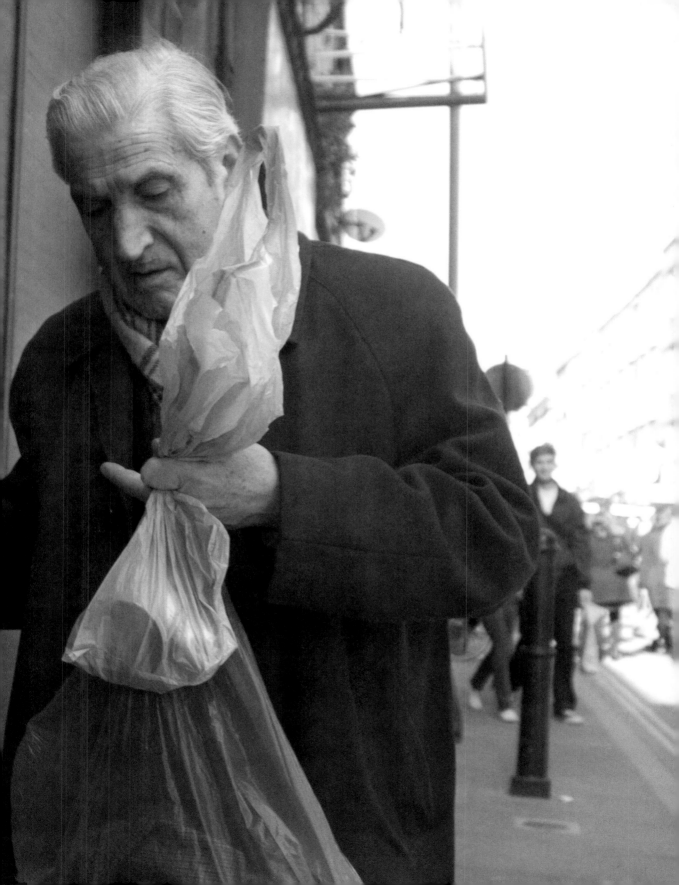

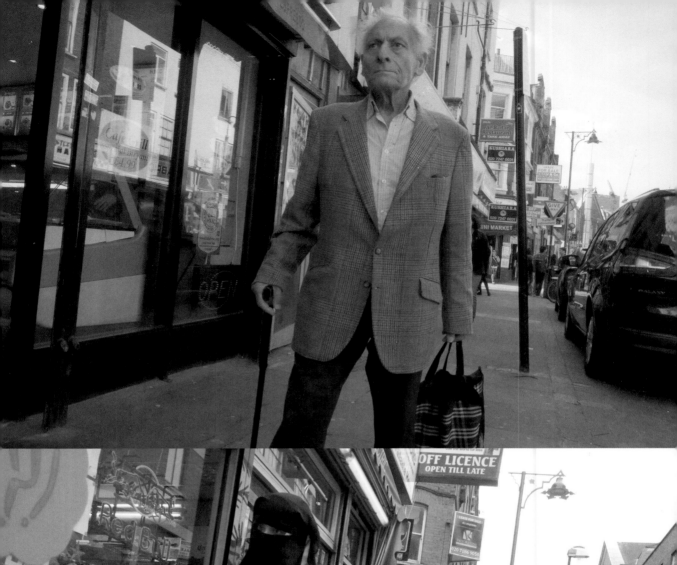
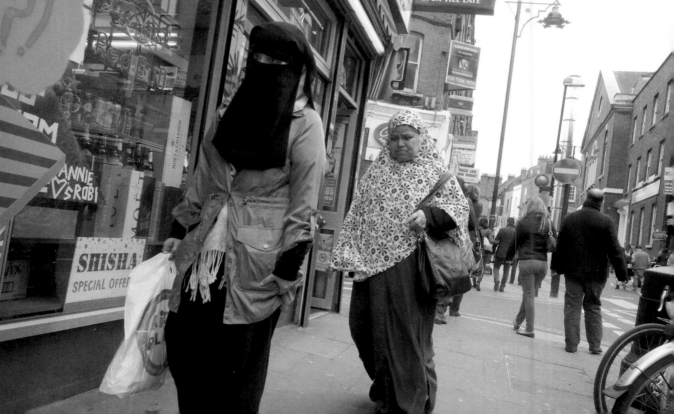

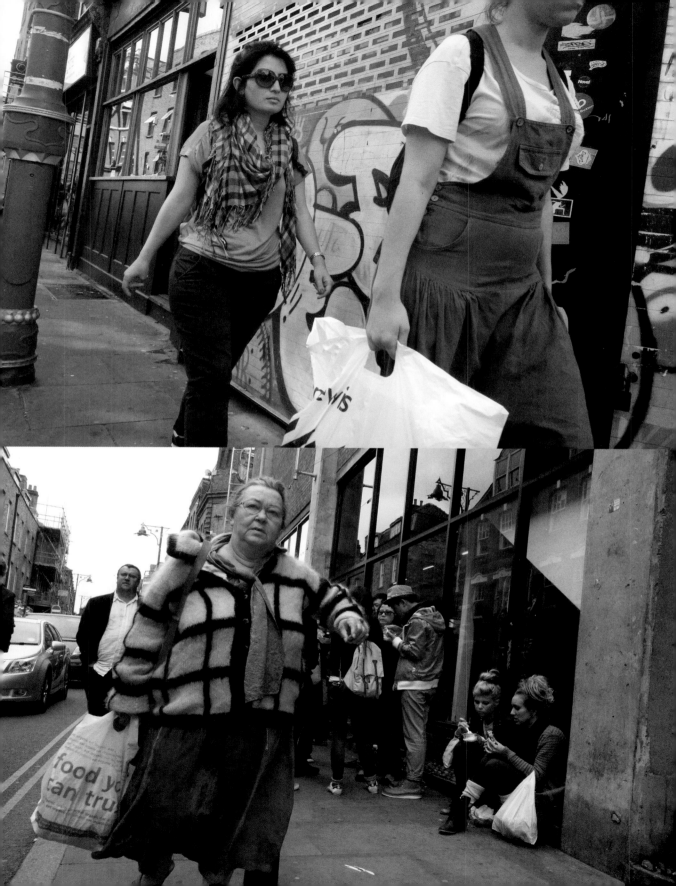

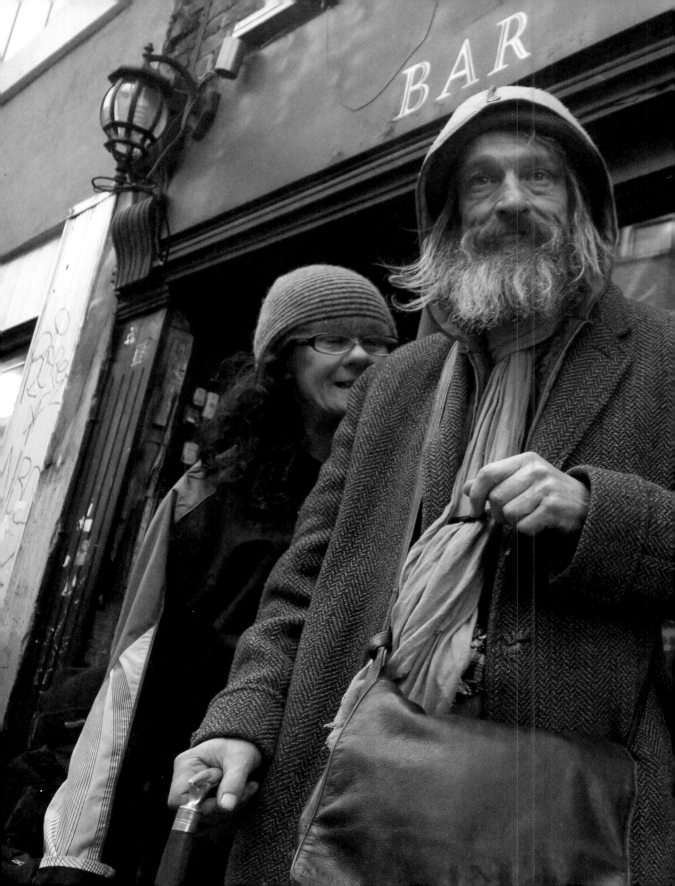

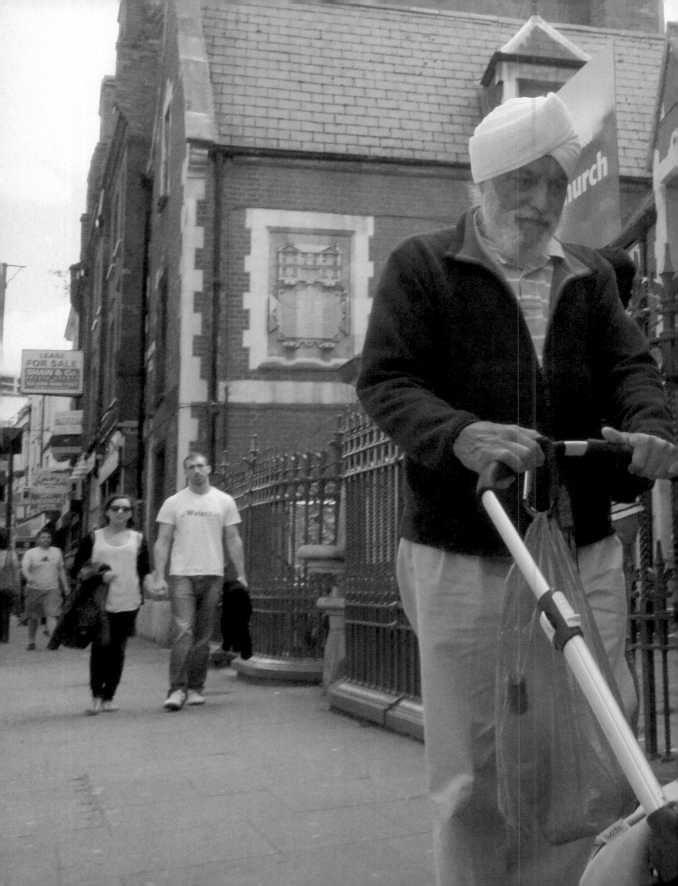

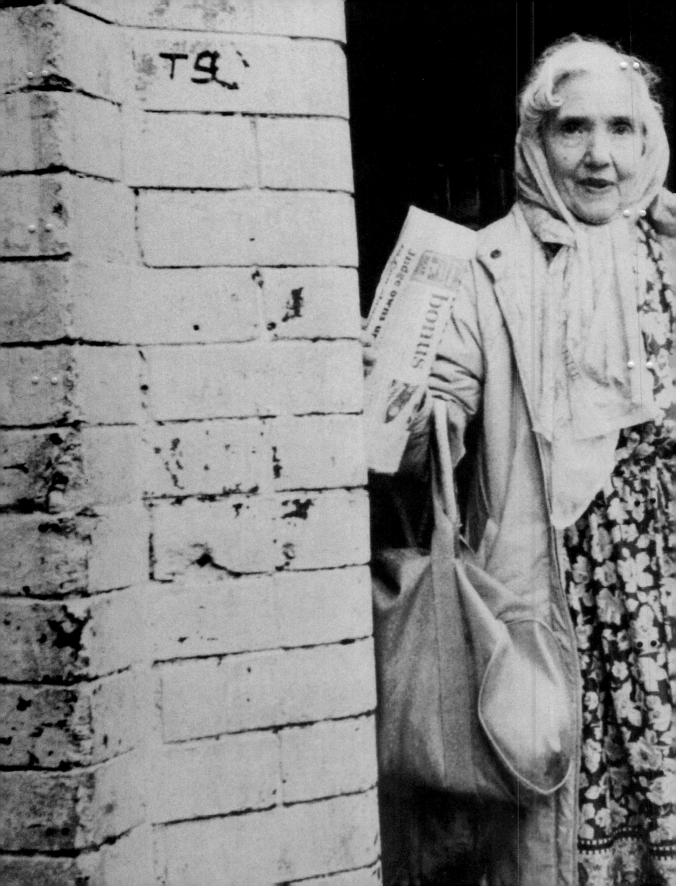

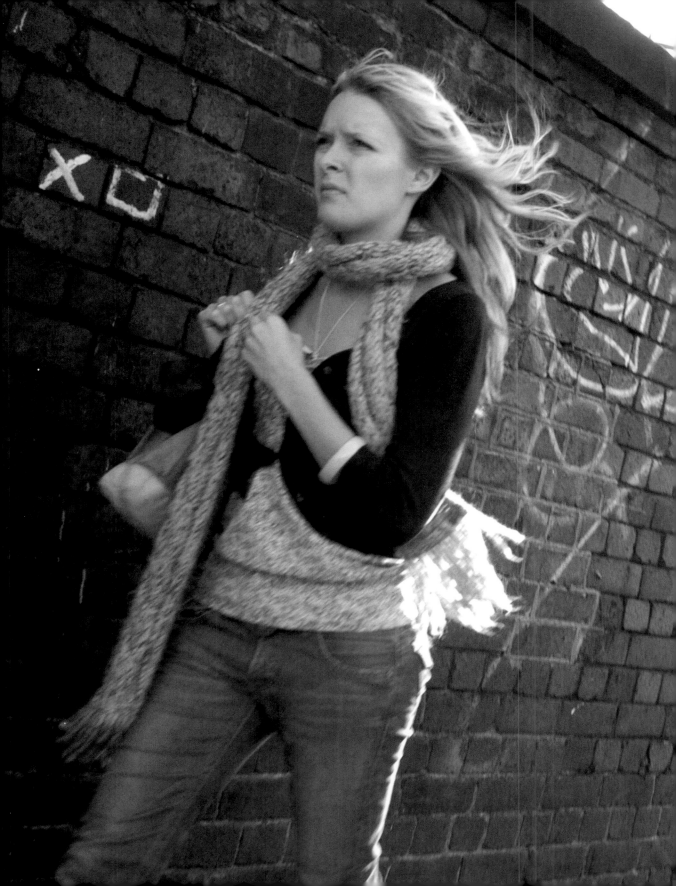

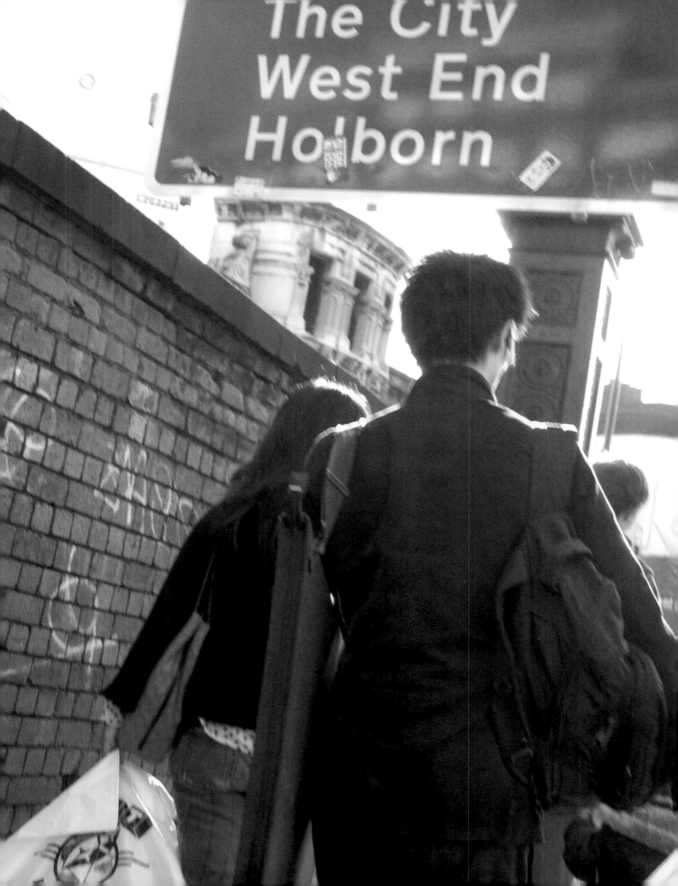

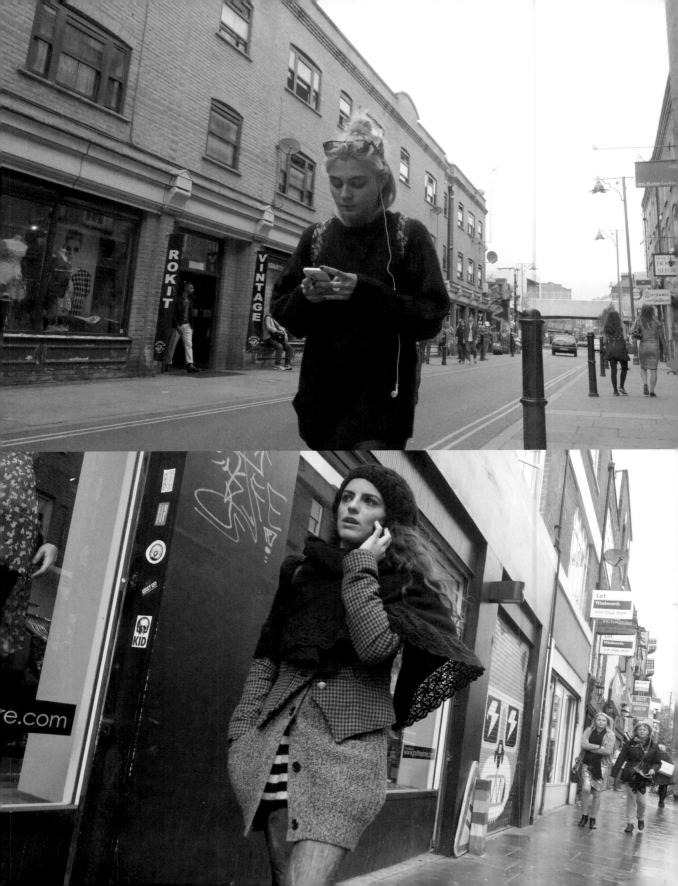

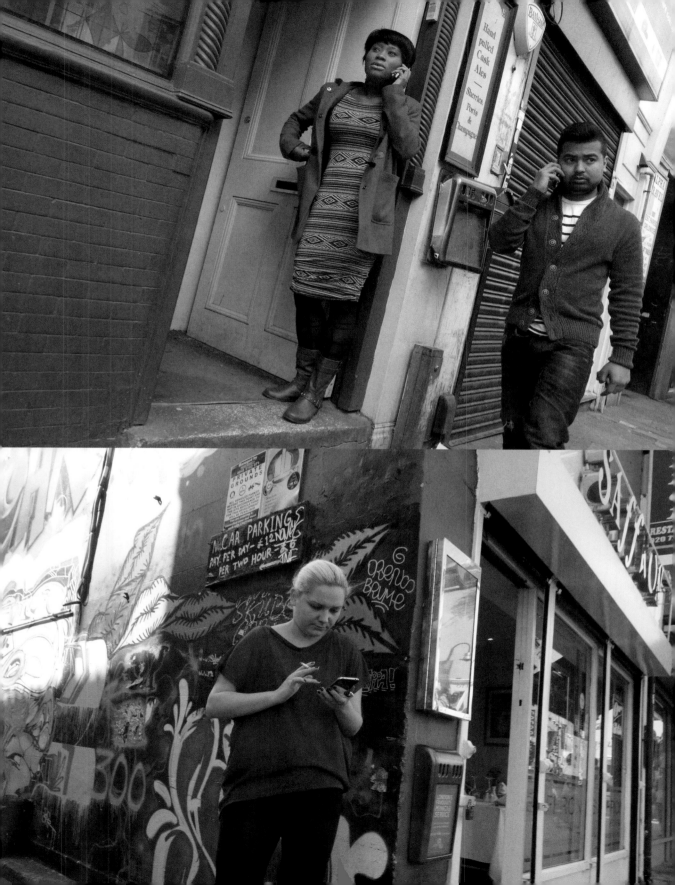

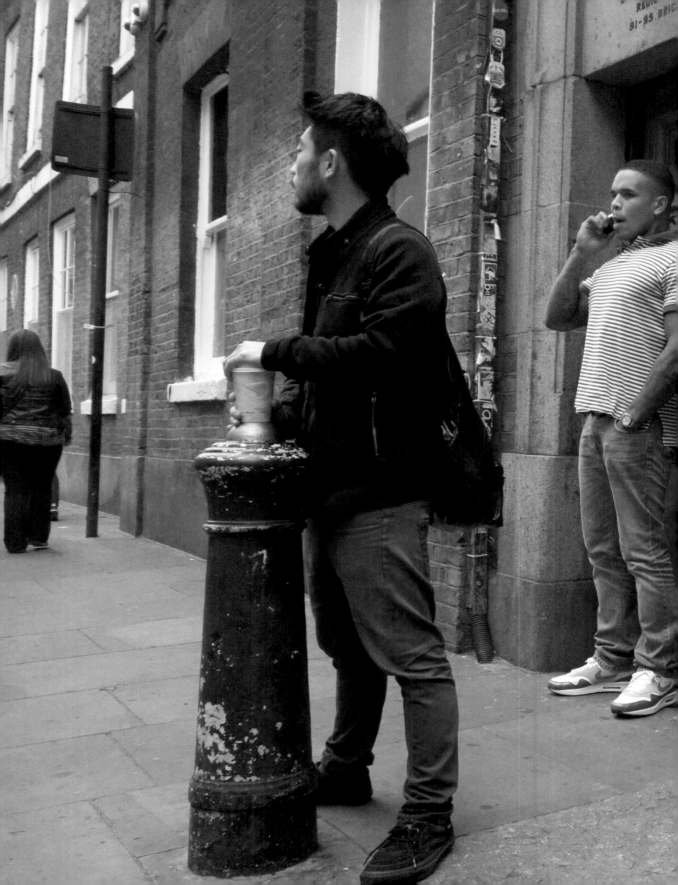

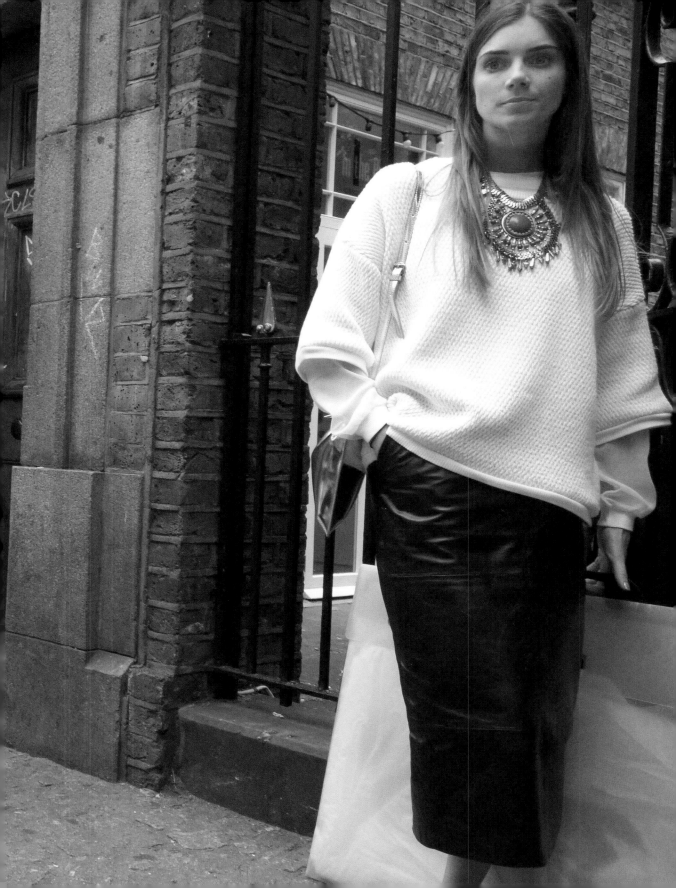

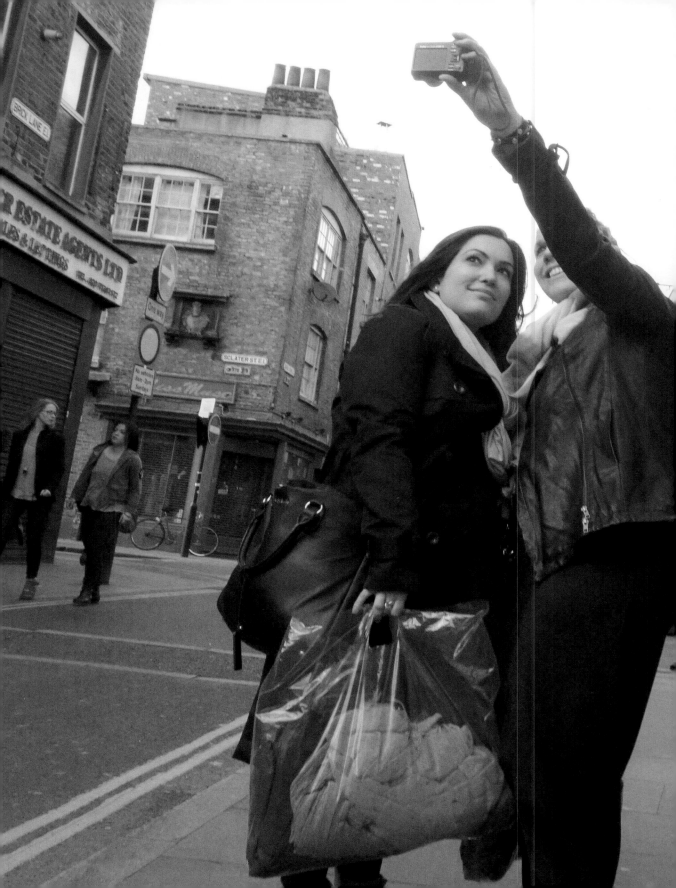

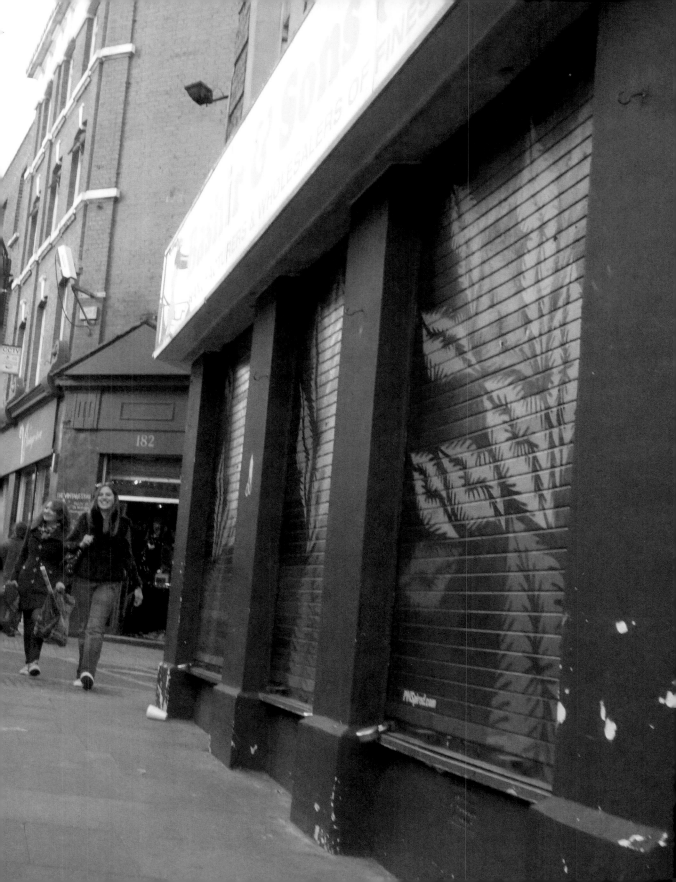

FOR HAZUAN HASHIM

This book is published with the generous investment of the following readers of *Spitalfields Life*:

Fiona Atkins, Rosemary Burton, Robson Cezar, Stephane Derone, Charlie de Wet, Sandra Esqulant, David Ethier, Diana Fawcett, Lynda Finn, Susie Ford & Jonathon Green, Libby Hall, Siri Fischer Hansen & Roger Way, Carolyn Hirst (on behalf of Rowland Hirst), Michael Keating, Martin Ling, Julia Meadows, Jack Murphy, Colin O'Brien, Jan O'Brien, Kate Phillips, Sian Phillips & Rodney Archer, Jonathan Pryce & Kate Fahy, Honor Rhodes, John Ricketts, Corvin Roman, Elizabeth Scott, Tim Sayer and Zoe Woodward.

First published in 2014 by Spitalfields Life Books

1

© Phil Maxwell 2014

The right of Phil Maxwell to be identified as the Author of the Work has been asserted in accordance with Section 77 of the Copyright, Designs & Patents Act 1988

A CIP catalogue for this book is available from the British Library

ISBN 978-0-9576569-2-5

A Spitalfields Life Book
Edited by
The Gentle Author

Designed by Friederike Huber

Printed by
Butler Tanner & Dennis Ltd
Caxton Rd
Frome
Somerset
BA11 1 NF

Spitalfields Life Books Ltd
16 Victoria Cottages
Spitalfields
London
E1 5AJ

www.spitalfieldslife.com
@thegentleauthor

www.philmaxwell.org